CORK
THE VIEW FROM ABOVE

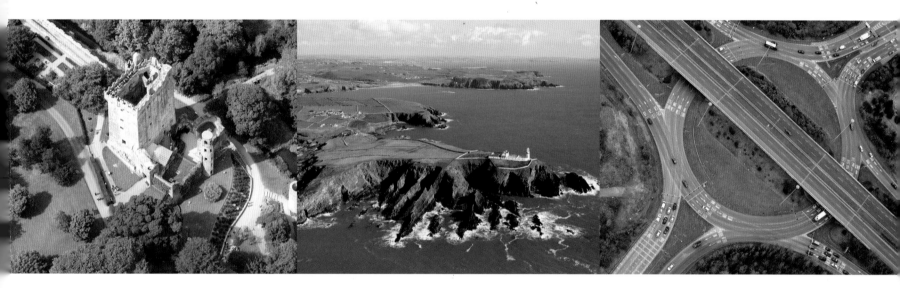

DENNIS HORGAN

FOREWORD BY JEREMY IRONS

The Collins Press

First published in 2014 by
The Collins Press
West Link Park
Doughcloyne
Wilton
Cork

Text by Marcus Connaughton

A CIP record for this book is available from the British Library.

Hardback ISBN: 978-1-84889-224-8

Design and typesetting by Inspire.ie

Typeset in ITC Avant Garde Gothic Std

Printed in Italy by Printer Trento

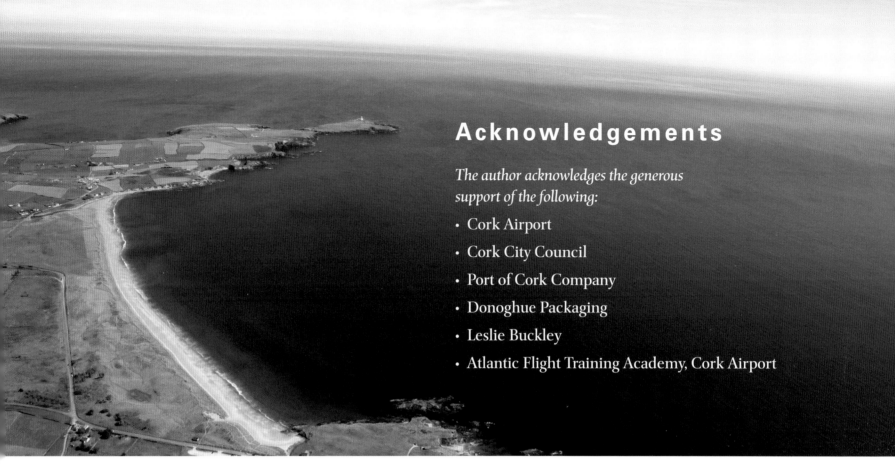

Acknowledgements

*The author acknowledges the generous
support of the following:*

- Cork Airport
- Cork City Council
- Port of Cork Company
- Donoghue Packaging
- Leslie Buckley
- Atlantic Flight Training Academy, Cork Airport

▲ The Long Strand at Castlefreke.

Thanks also to:

- Lord David Puttnam
- Jeremy Irons
- Dominic Dunne
- Capt. Mark J. Casey
- Capt. Emmanuel Hirth
- Capt. Angelo Cunningham
- Barry Twomey
- George Taggart
- Pat Horgan
- Owen O'Callaghan
- Edward Hallinan
- Kevin Cullinane

- Marcus Connaughton
- Gearoid O'Sullivan
- Michael Hogan
- Michael Sheehan
- John Horgan, O'Leary's Camera World
- Alan Keane
- Hackett Reprographics
- Finbarr O'Connell
- Dominic Daly
- Eddie O'Hare
- Caitriona & Erik Johansson, The Green Man Studio
- Deirdre, for her constant encouragement and advice

For my daughters - Aoife and Sarah - with love

I hope you enjoy the images in this book, all of which are available
to purchase on my website, **www.dennishorgan.ie.**

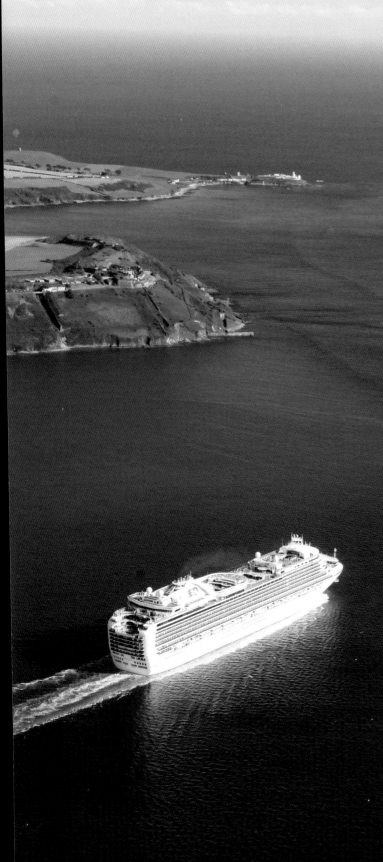

Foreword

When I first blew in to Cork at the beginning of the last decade of the last century I was quite unnerved that such a place could exist without me and a great many other people being aware of its hidden and quite deserted beauty.

That I, my family and my dogs could explore and find such beauty with nary another creature in sight seemed some days a miracle, but always a privilege. Its coves and coastal paths, its ruins and hilltops with views to take your breath away, and on stormy days, fill your lungs with spume-laden gusts, never ceased to evoke a pleasure somewhere deep within us.

Slowly we built up our catalogue of magical walks and precious places, noting what particular weather conditions and wind directions were suited to each excursion. And as the Tiger started to bite, we still found, despite people having more cash about them, that our favourite haunts remained ours and ours alone.

I have always enjoyed maps, and spend much time poring over them looking for clues that might give away something spectacular on the ground waiting to be discovered.

Dennis Horgan, in his long career as a photographer, has been observing from the sky the many public, as well as secret wonders, and here in this magnificent collection we can see some of the marvels that surround us in the county. From the air they take on a perspective that few of us get to see. Whether they be pre-Christian, medieval, ascendancy or modern, their patterns spread across the page, reminding us of both man's ingenuity and the overwhelming natural beauty that lies on our doorstep.

This volume advertises the existence of these glories of Cork, and while it may serve as a delightful armchair companion to some, I suspect it could well act as a clarion call to the spirit of adventure in others.

Selfishly, I hope not too many, so that at least a few of these places will remain as lonely as I have got used to finding them.

Jeremy Irons
2014

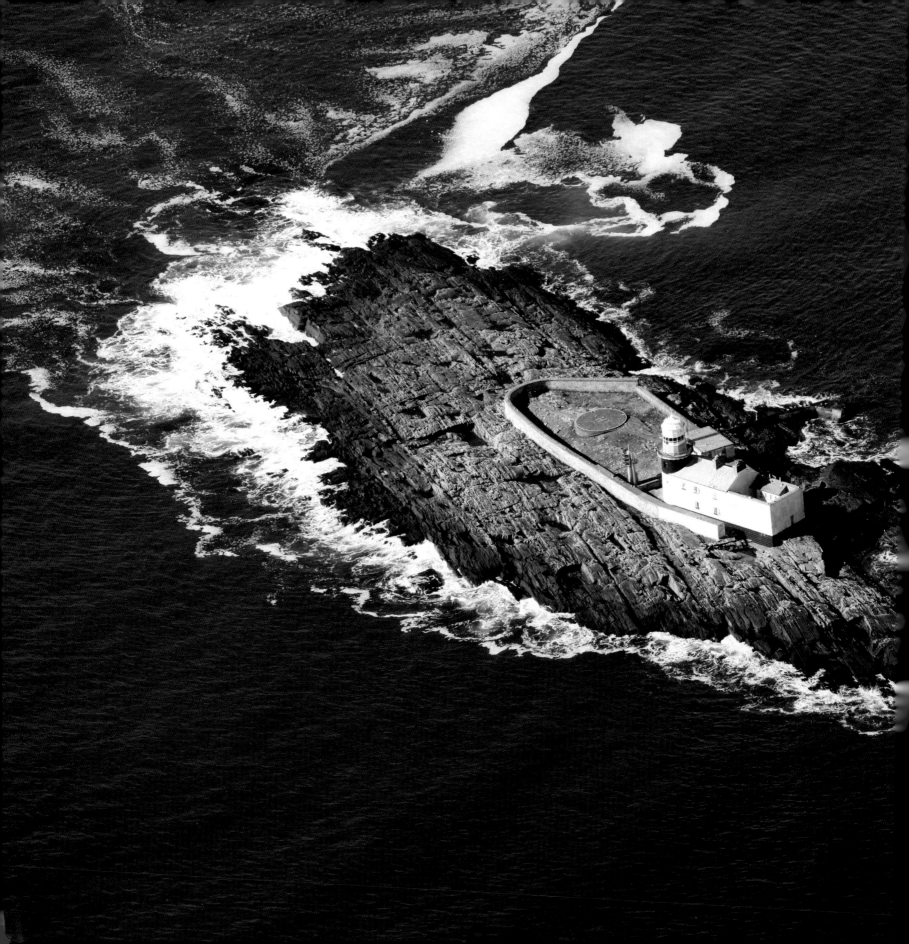

INTRODUCTION

For most of my life I have
had a passion for two things
– photography and aviation.
I got my first camera when
I was 18 years old and I
was hooked.

For most of my life I have had a passion for two things - photography and aviation. I got my first camera when I was 18 years old and I was hooked.

In 1962 Cork Airport became operational and from then on I developed a lifelong love of anything to do with aircraft. I fell into aerial photography quite by chance some years ago when a friend asked me to take a photo of his farm during a helicopter flight over west Cork. Things progressed from there and I now do aerial photography work for a variety of clients.

Cork, Ireland's largest county, is a wonderful place, rich in scenery and full of interesting places to visit. However, taking aerial pictures is always a challenge as one is constantly at the mercy of the weather. I have on occasions waited for many weeks for the weather to change and when it did, I was rewarded with fine days, of which I took full advantage.

The images in this book were compiled over a period of years and captured during the course of my normal aerial work from heights varying from 1,000-8,000/ft. I flew in both helicopter and fixed-wing aircraft, usually with a door removed to get clearer shots and unobstructed camera angles. A little scary at first, but very thrilling when I got used to it. The collection is not meant to be definitive and there are many places in Cork which I would like to have captured, but weather conditions or air traffic restrictions did not allow me to do so at the time. Some of the images were planned and others were ones that surprisingly presented themselves during my various flights. I used a Canon EOS 5D mk. 2 with the 24-105 lens doing most of the general views and a 70-200 f.2.8 zoom for the close-in shots.

I feel privileged to see views of Cork that most people only catch a fleeting glimpse of when flying on commercial aircraft. Above the land, the variety of the scenery is stunning. From sandy beaches to mountains, lakes, historic sites, parkland, rivers, harbours and imposing architecture, Cork has all of these and more. Finally, I have to pay tribute to the pilots of Atlantic Flight Training Academy at Cork Airport, who have taken me aloft and given me a platform from which to take these images - I never cease to be amazed by their skill and professionalism.

Whether you are a Corkonian or a visitor, I hope you enjoy looking at these photographs as much as I did taking them. If you have never been to Cork , maybe these images will tempt you to come and visit.

Dennis Horgan

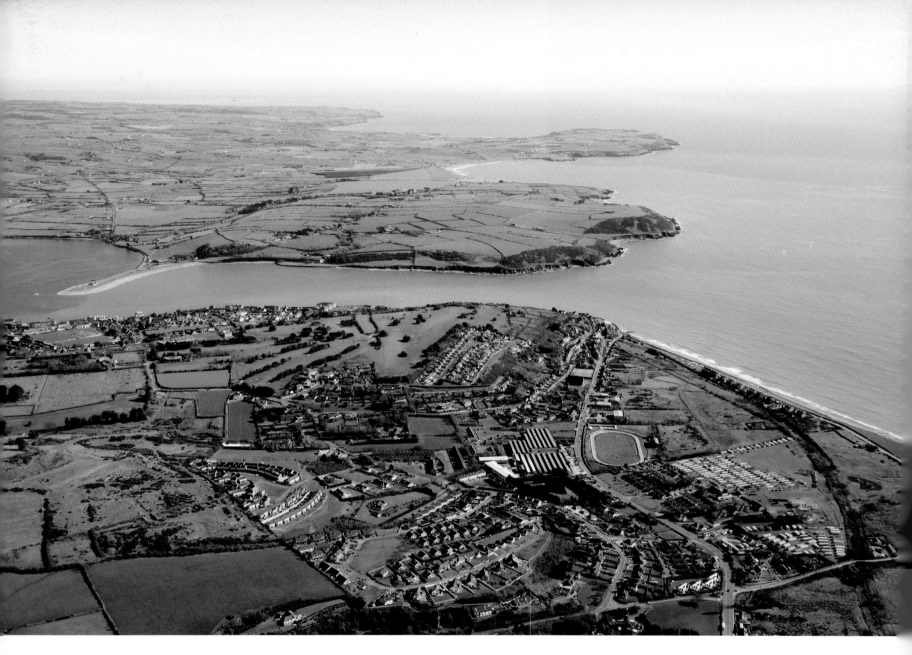

A north-easterly perspective of the town of Youghal where the film *Moby Dick* was shot in 1952.

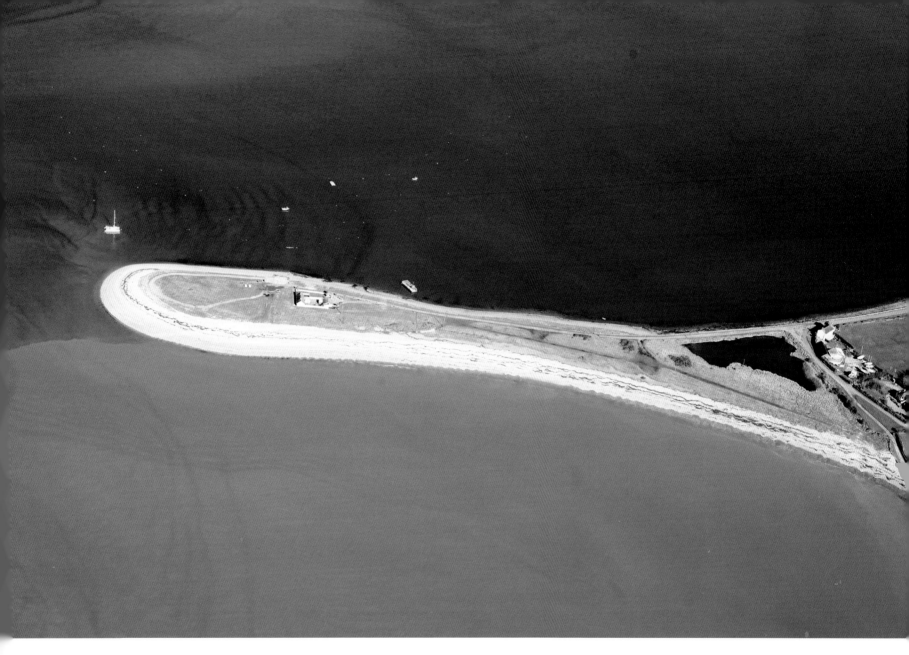

A finger of sand protrudes into Youghal Harbour at Ferry Point. The contrasting shades of blue are caused by the varying depth of the water.

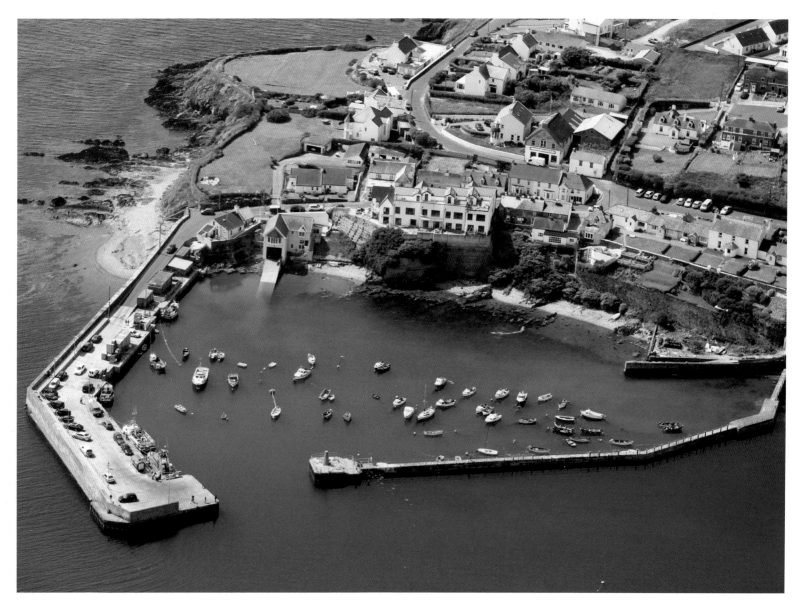

The safe, walled harbour in the east Cork fishing village of Ballycotton is home to one of the oldest lifeboat stations in Ireland.

Ballycotton Lighthouse, sited on an island just south of Ballycotton village.

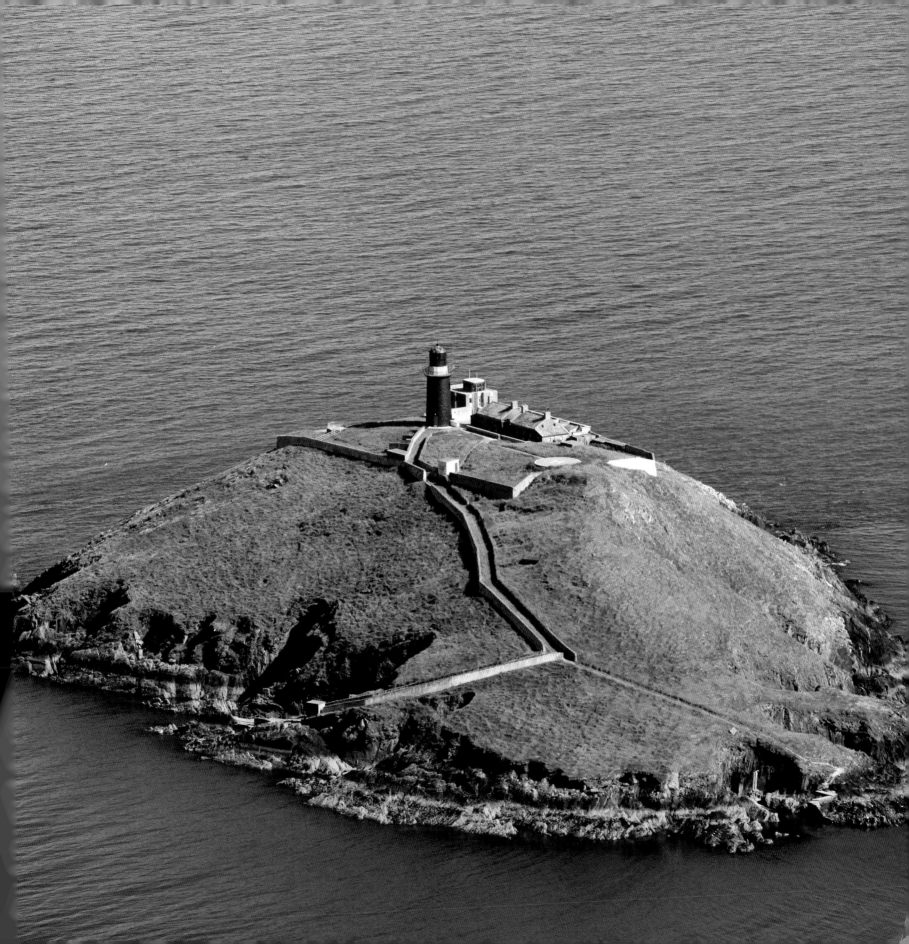

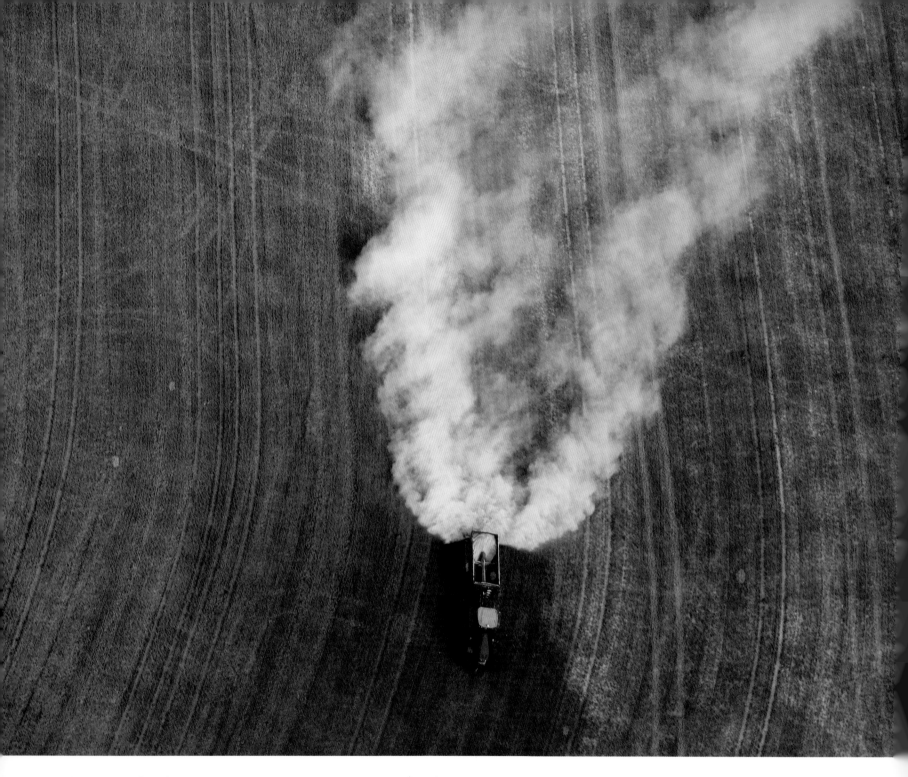

▲ An east Cork farmer spreads lime on his land in preparation for planting.

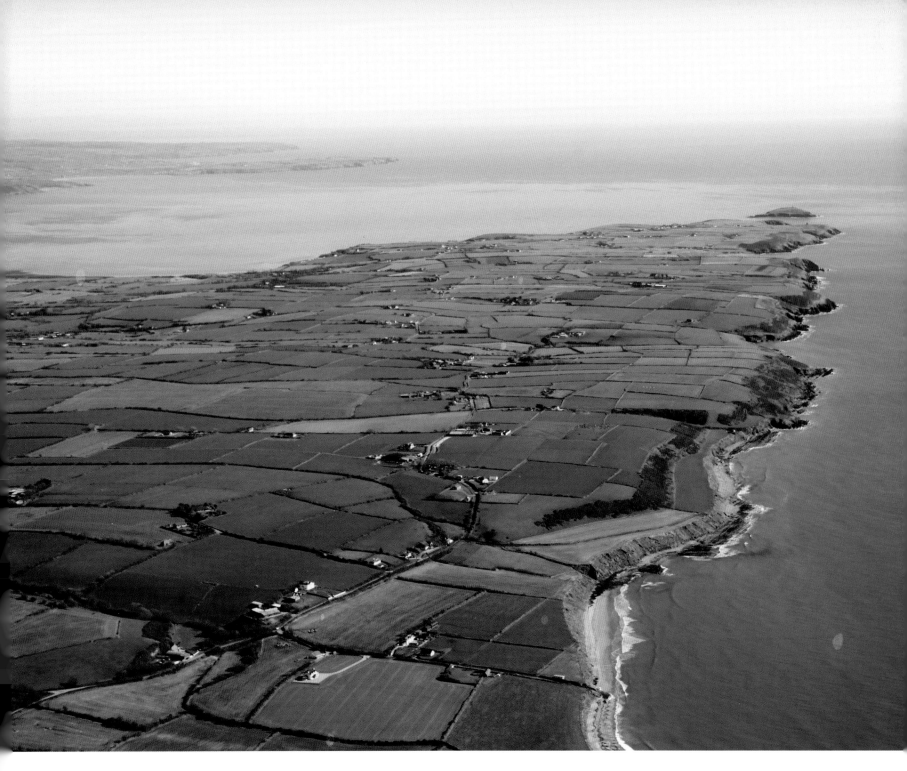

Looking south from Garryvoe to Knockadoon on a clear day.

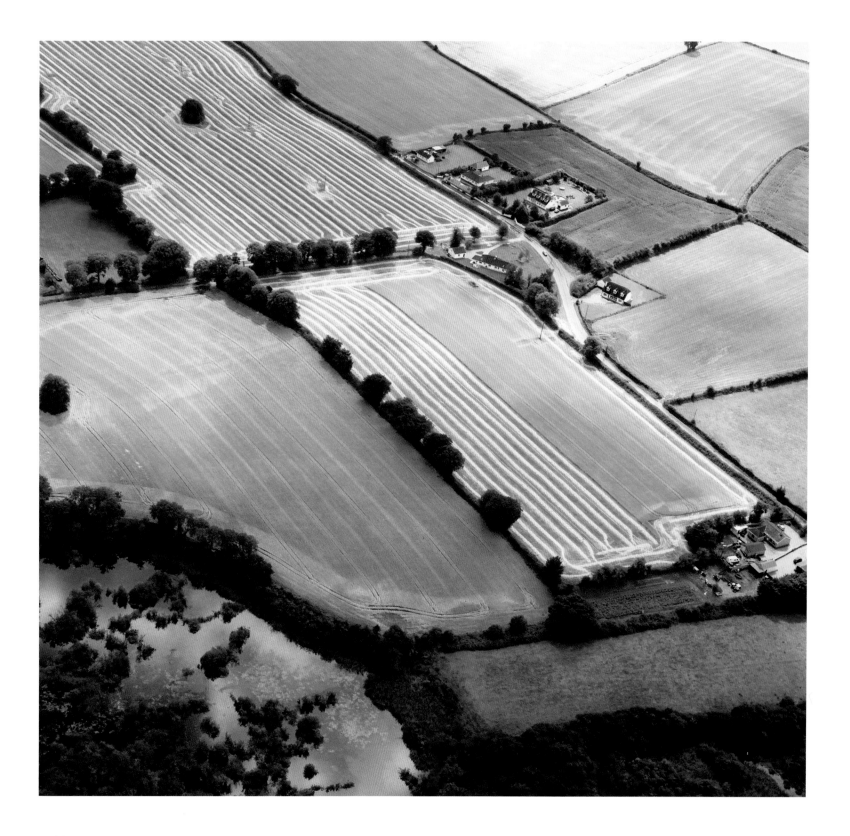

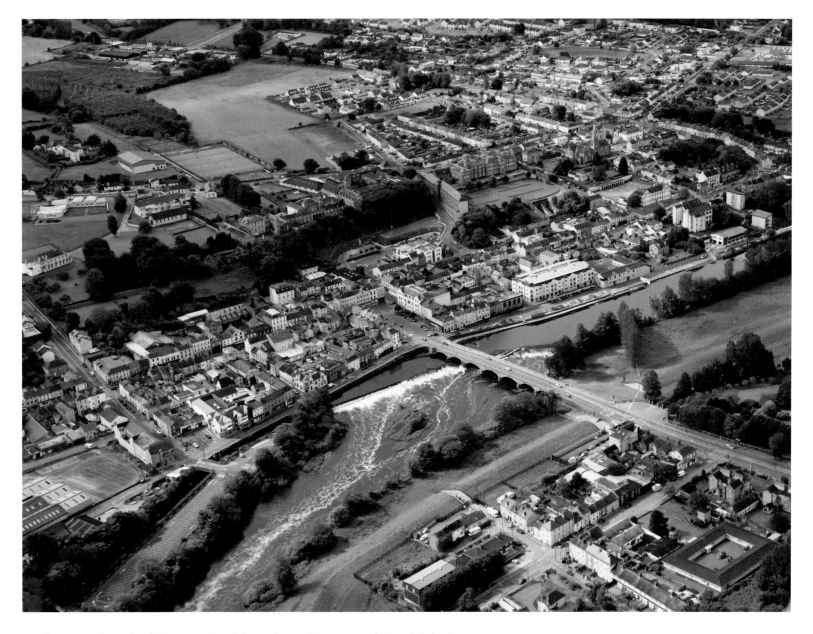

Fermoy – from the Irish meaning 'Monastery of the men of the plain', where a
Cistercian Abbey was founded in the 13th century – is now a busy provincial town.

Rolling fields near Castlemartyr. Approaching Ballintotis, the fields'
colour varies from green to gold.

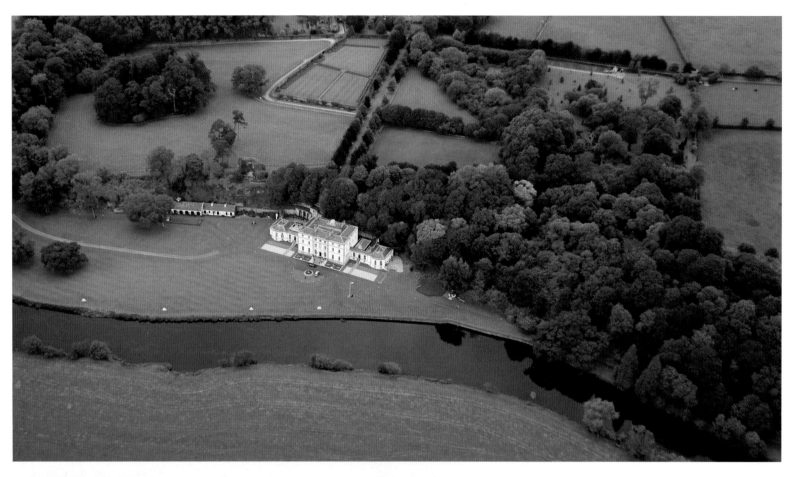

Castlehyde House: this 18th-century Palladian-style house on the banks of the River Blackwater has been restored to its original grandeur in recent years and is now a private residence.

The 169km-long River Blackwater flows through three counties in Munster. It is internationally renowned for its salmon fishing.

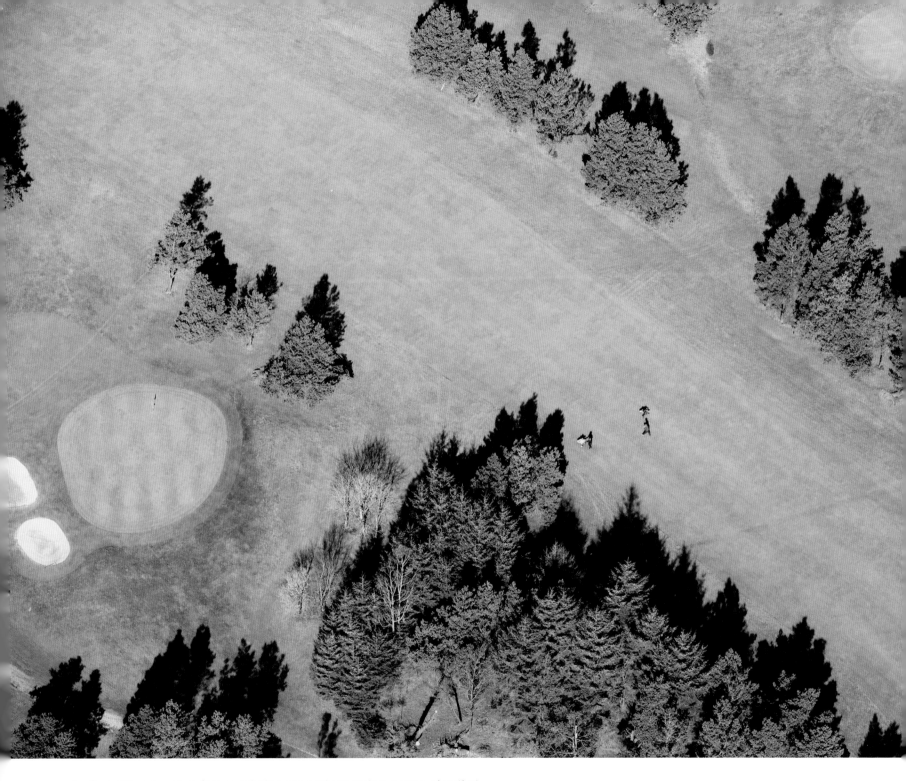

Two players walk a fairway during an early morning game of golf at
Fermoy Golf Club.

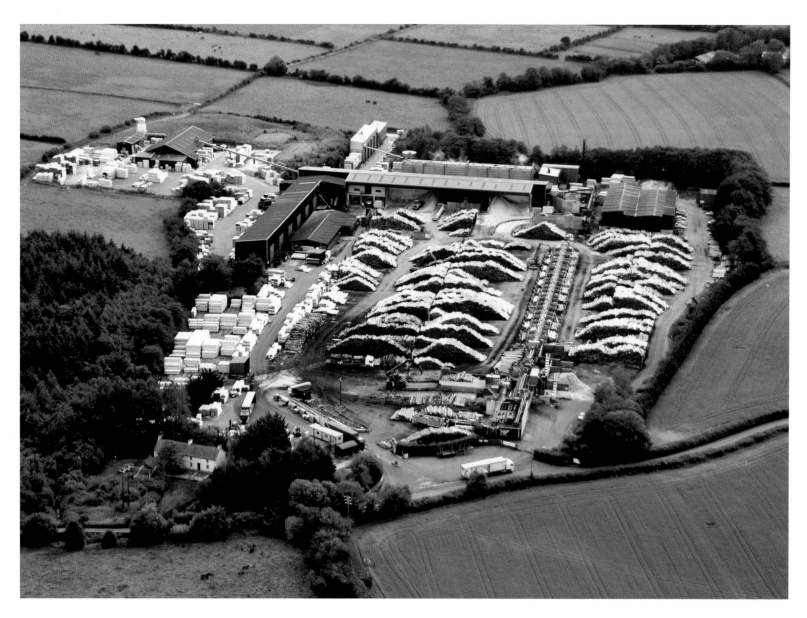

Irish timber is processed at this large sawmill outside Fermoy. Forestry is an important industry with many plantations throughout the county.

Aspiring Grand Prix drivers have this racetrack facility at Watergrasshill to hone their early skills.

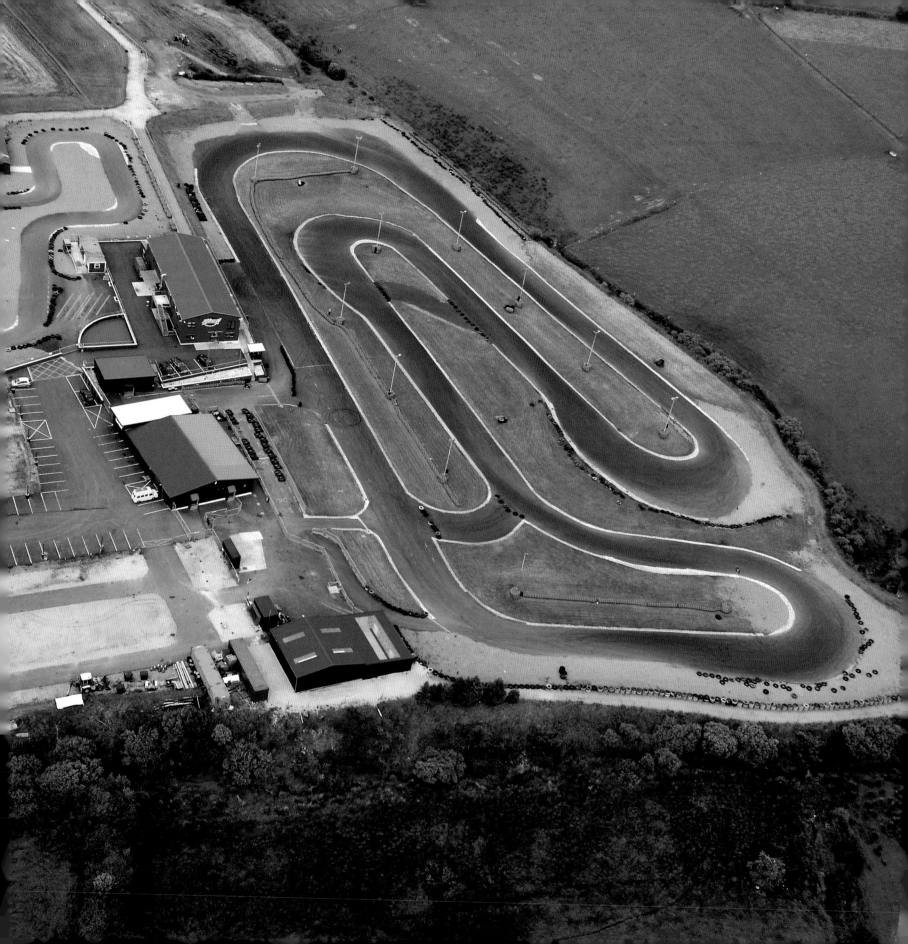

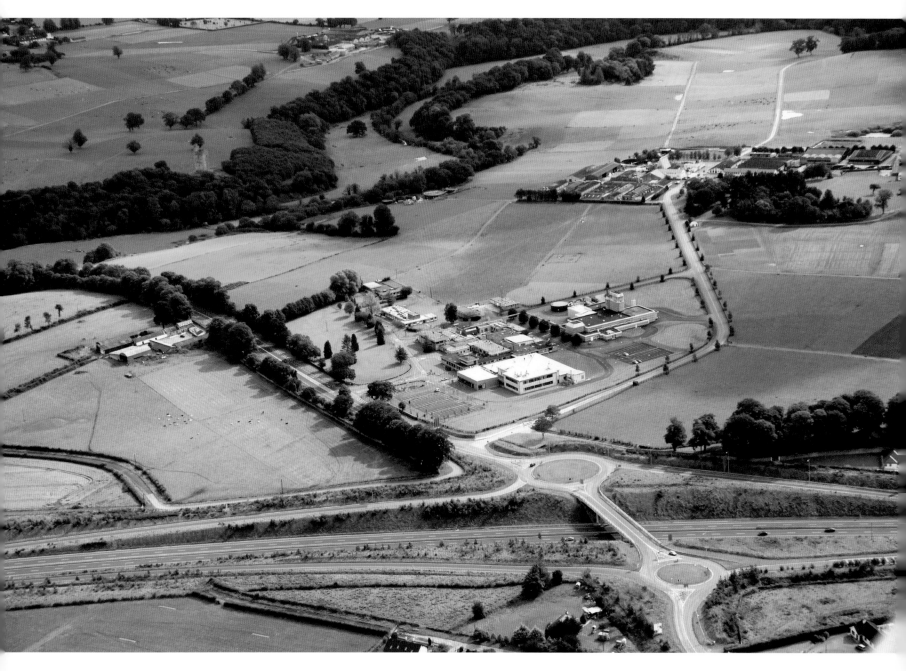

▲ Moorepark, an agricultural research facility off the M8, is one Europe's leading research centres and its large campus extends over a wide area.

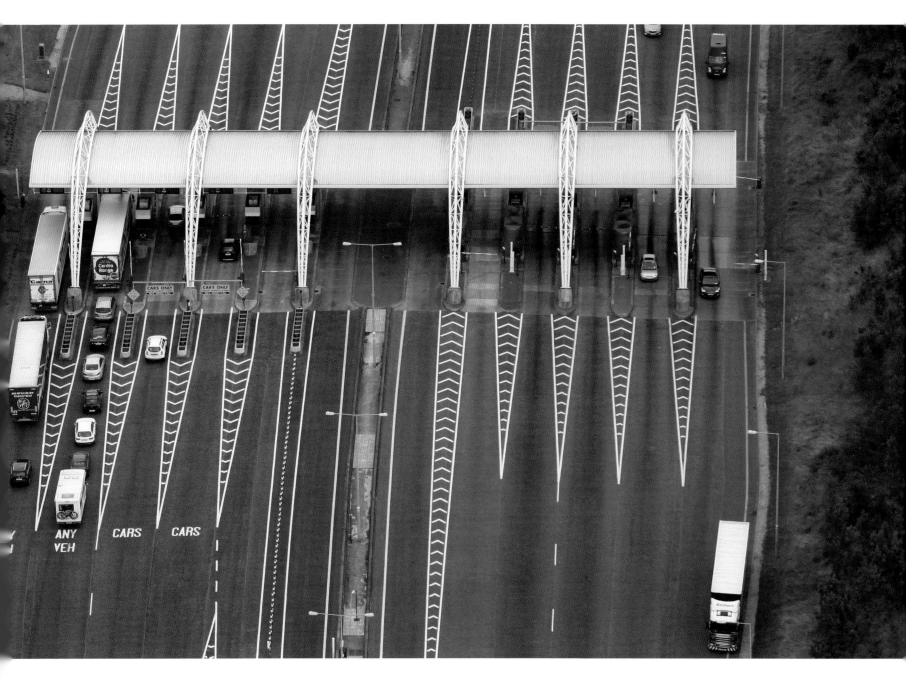

Toll plaza on the M8: this modern motorway route from Cork to Dublin has cut journey times dramatically.

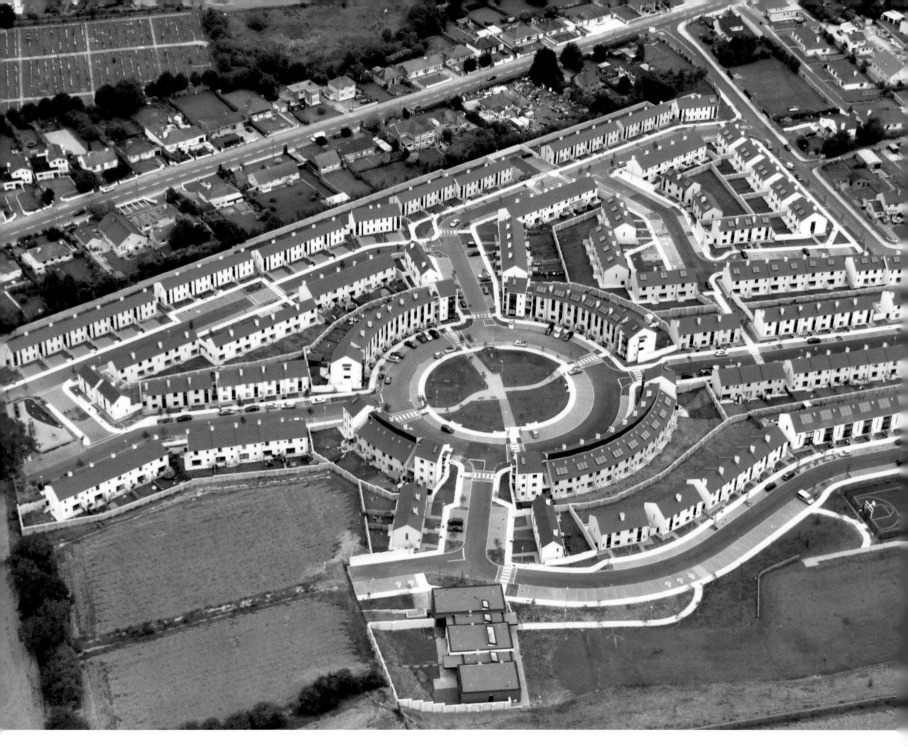

▲ Housing estate, Mallow: viewed from above this group of houses takes on a maze-like appearance.

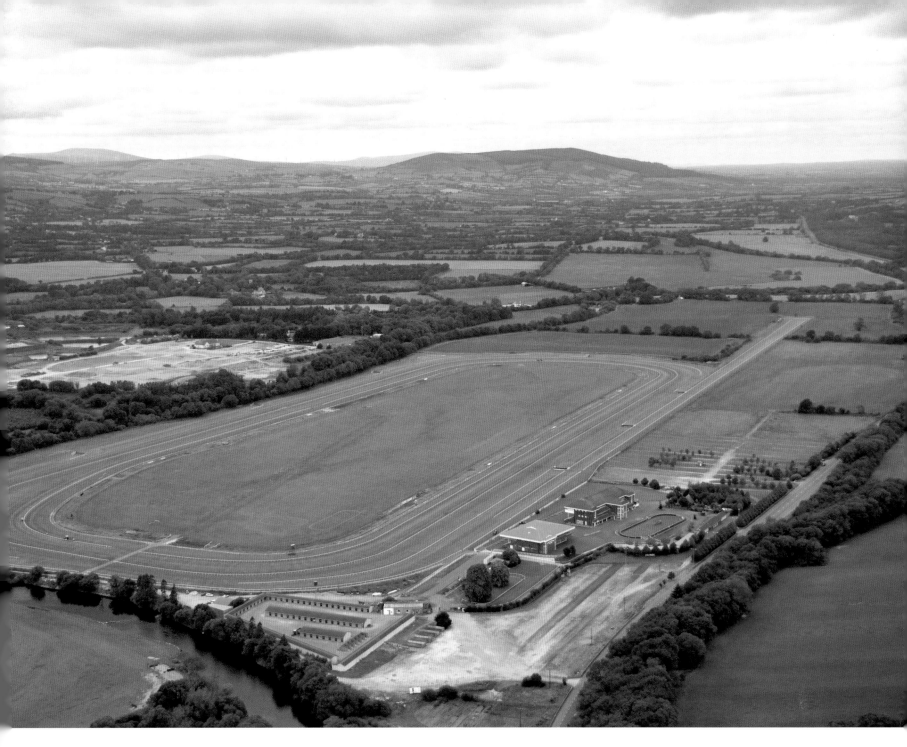

Cork Racecourse: close to where steeplechasing originated in the 18th century in Mallow, north Cork, this racecourse has been in existence since 1924. The course was redeveloped and upgraded in the late 1990s.

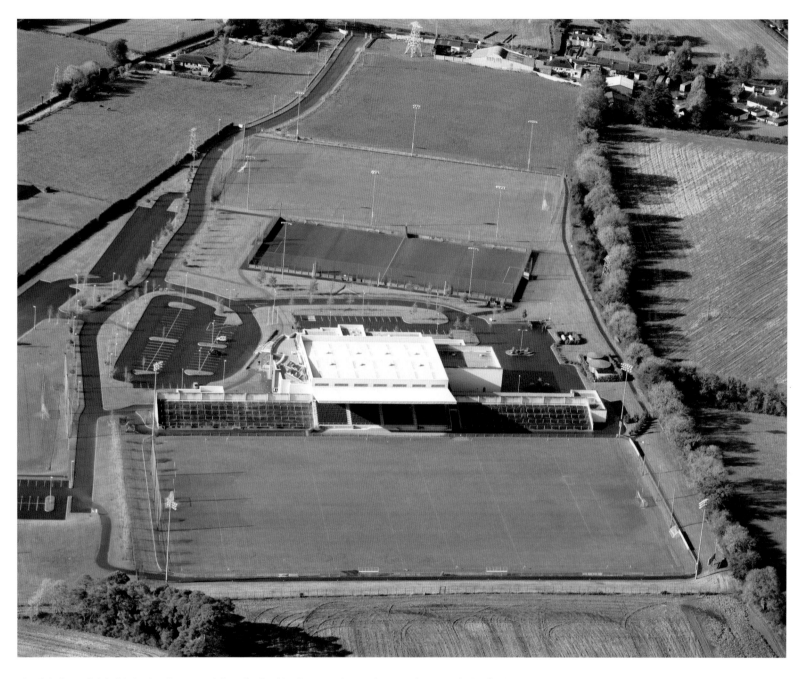

Mallow GAA Club: hurling and Gaelic football are extremely popular sports in Cork.
The Mallow club boasts one of the largest and most modern facilities in the country.

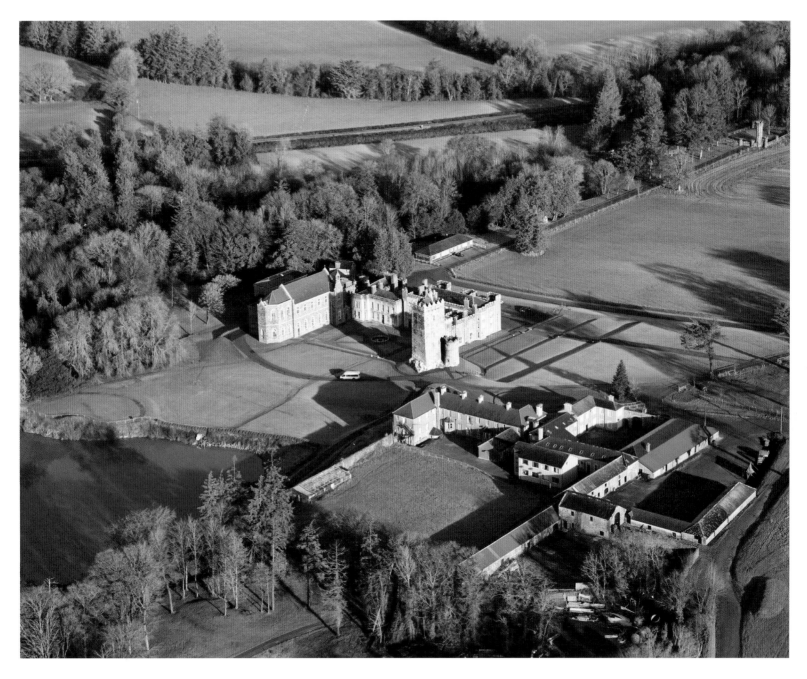

Drishane Castle, Millstreet: built in the mid-15th century, by Dermot McCarthy, the Lord of Munster, this building became a convent boarding school in the early 20th century. It closed in 1992.

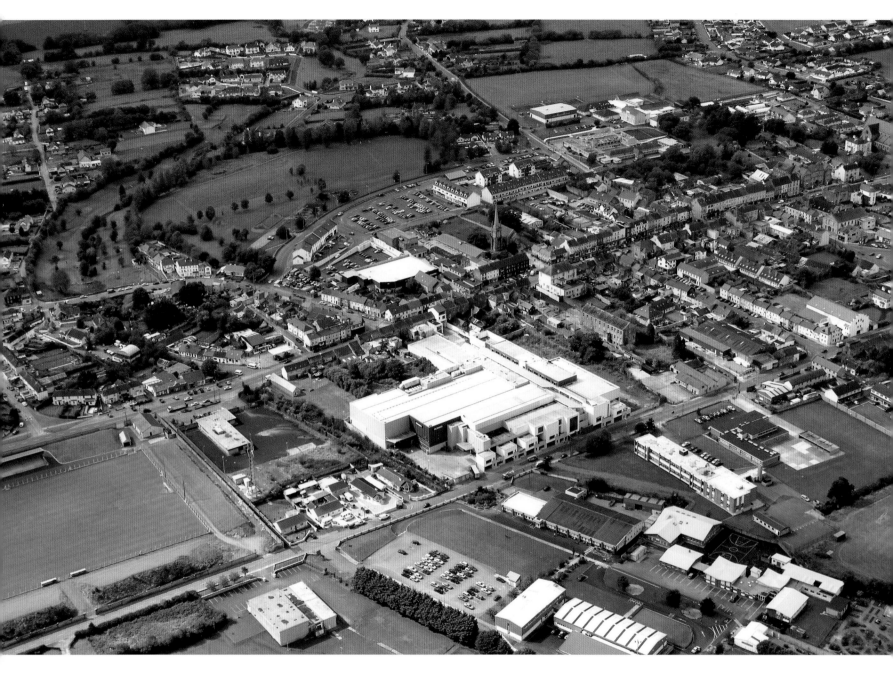

At the edge of the Golden Vale and bordering on Limerick, Charleville is a thriving agricultural town noted for its cheese production.

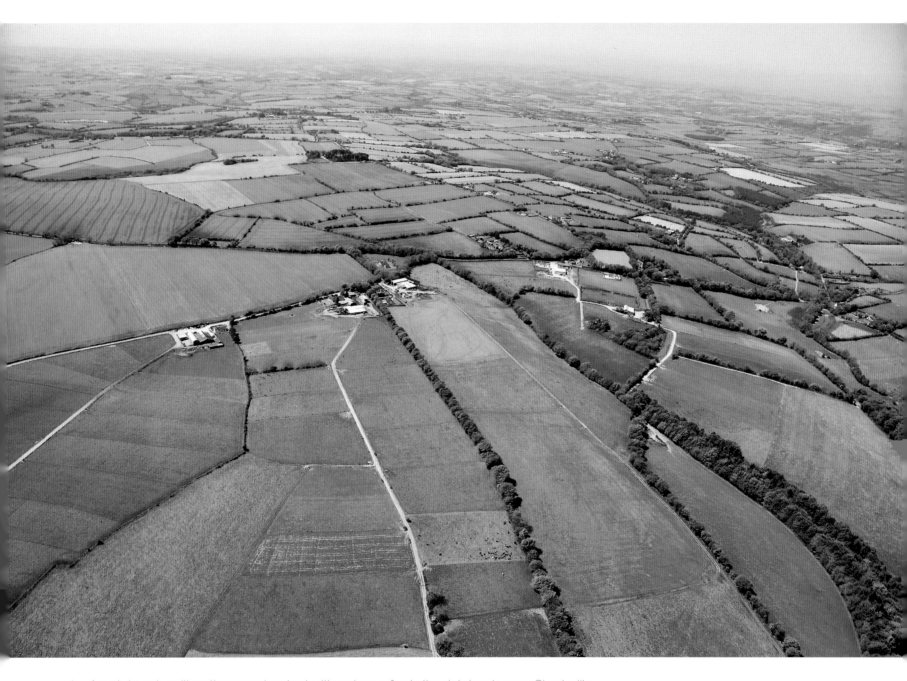

A patchwork-quilt pattern resplendent with colour reflects the rich lands near Charleville.

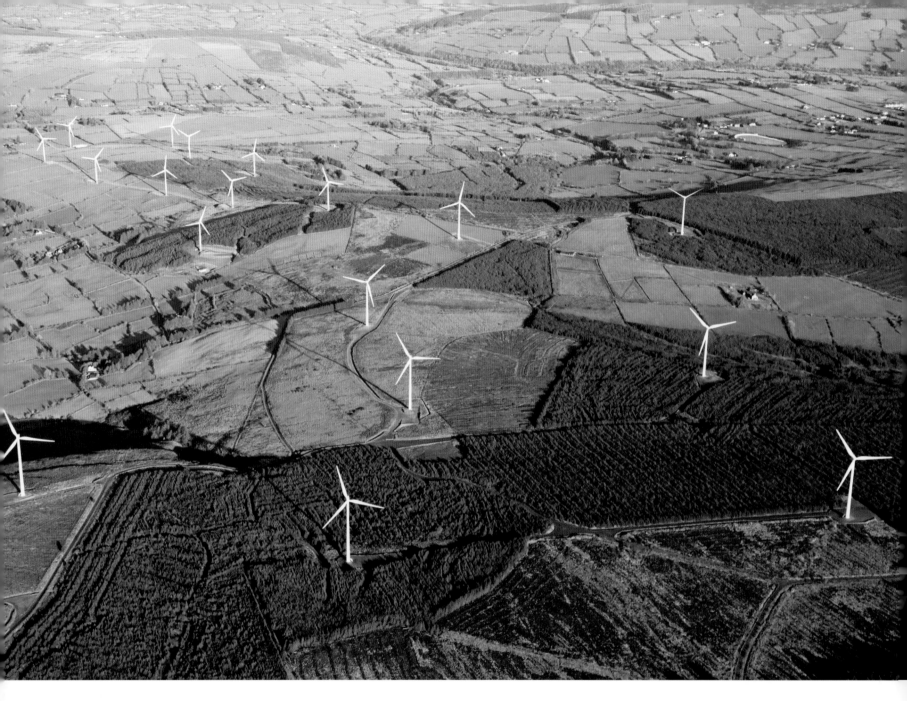

▲ Wind farm, Lyre, north Cork. In common with our European neighbours. Ireland is seeking alternative energy sources and these wind turbines generate power with great efficiency.

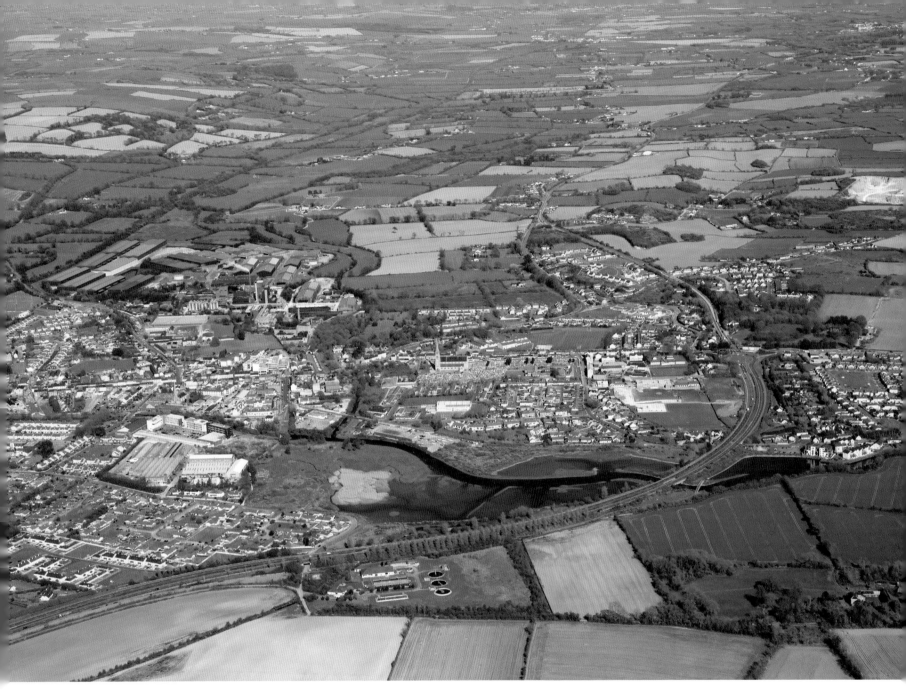

Midleton, the county town of east Cork just off the N25, is noted for its whiskey production. One of Europe's largest distilleries is located here, exporting its products to the far corners of the globe.

A field of commercially grown flowers at Mogeely captures the eye from above.

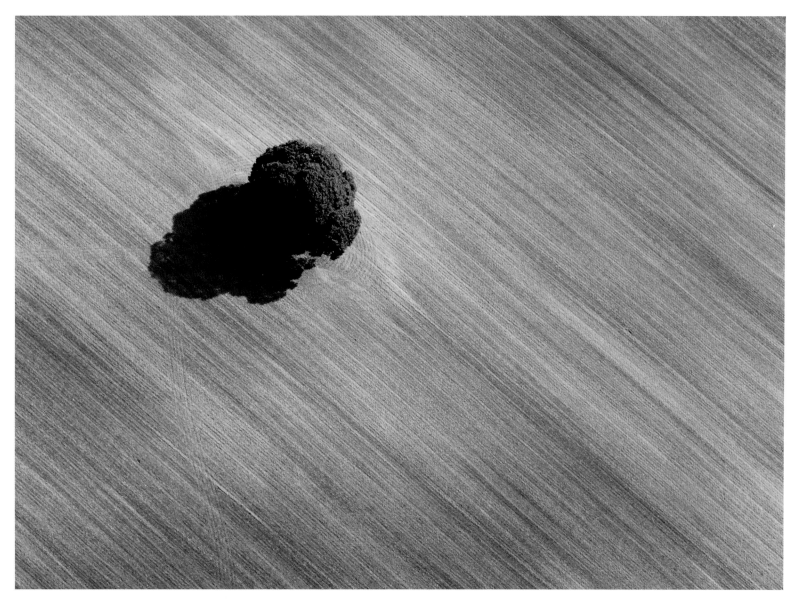

A lone tree in a field near Mogeely in late autumn.

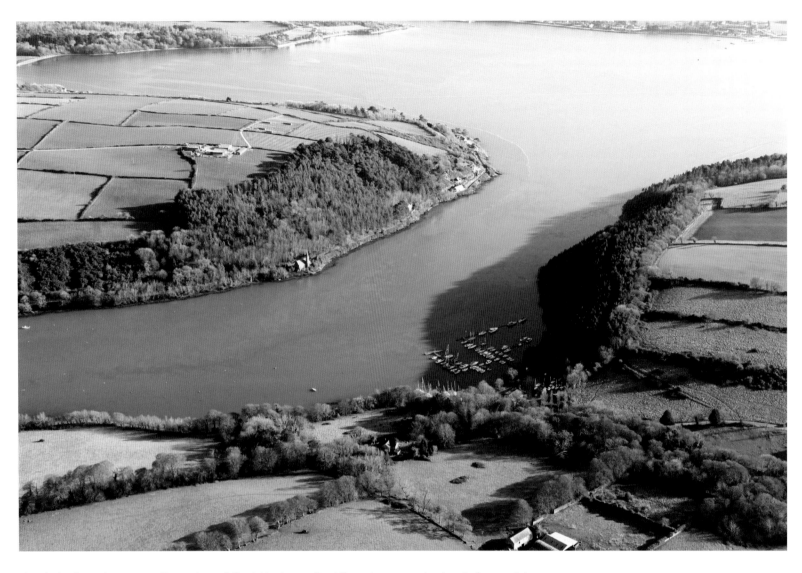

A sheltered cove on the edge of Cork Harbour, East Ferry is a popular berth for yachts.

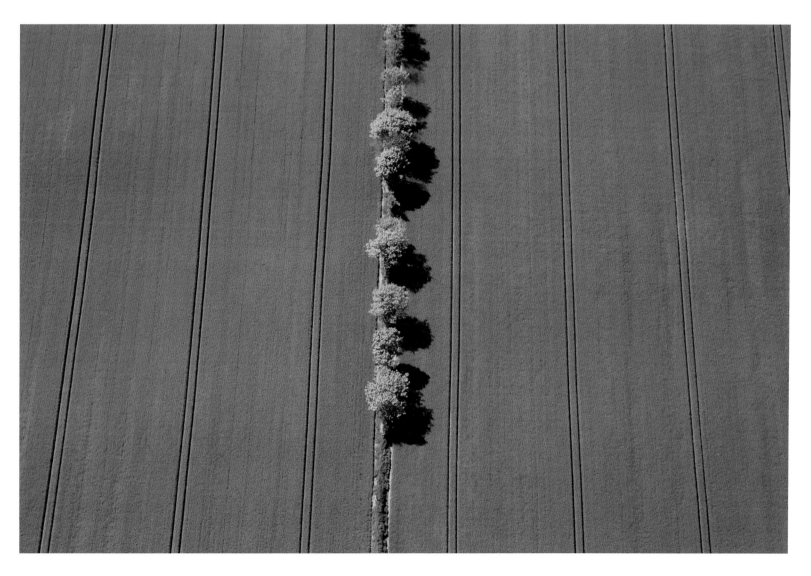

A carpet of green is bisected by a row of young trees.

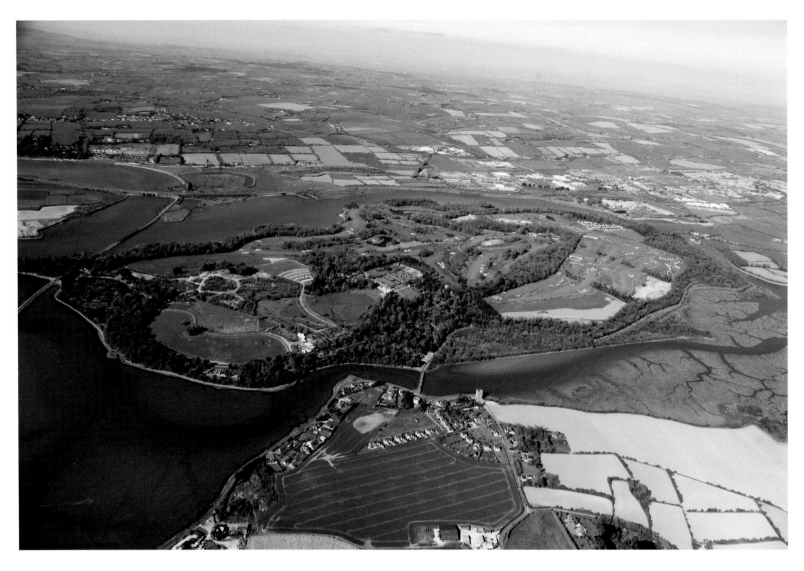

Fota Island and Belvelly Bridge: the island is home to Fota Wildlife Park and Fota House and is connected to the mainland by Belvelly Bridge, in the foreground.

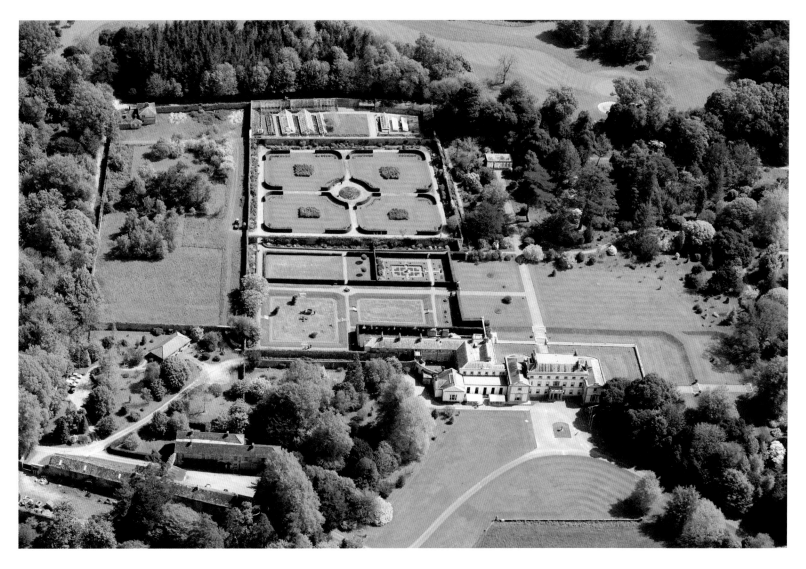

Fota House, with its stunning arboretum and ornate gardens, is a beautifully restored Regency-style mansion on extensive grounds. It is managed by the Irish Heritage Trust and is open to the public.

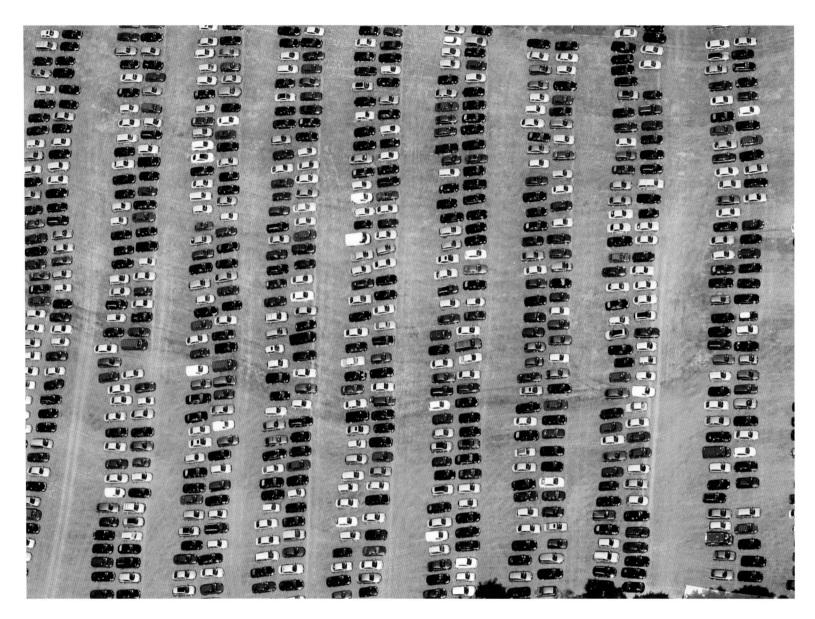

Cars parked during a major golf tournament at Fota Island. ▲

Spectators enjoy the Irish Open at Fota Island Golf Club. ▶

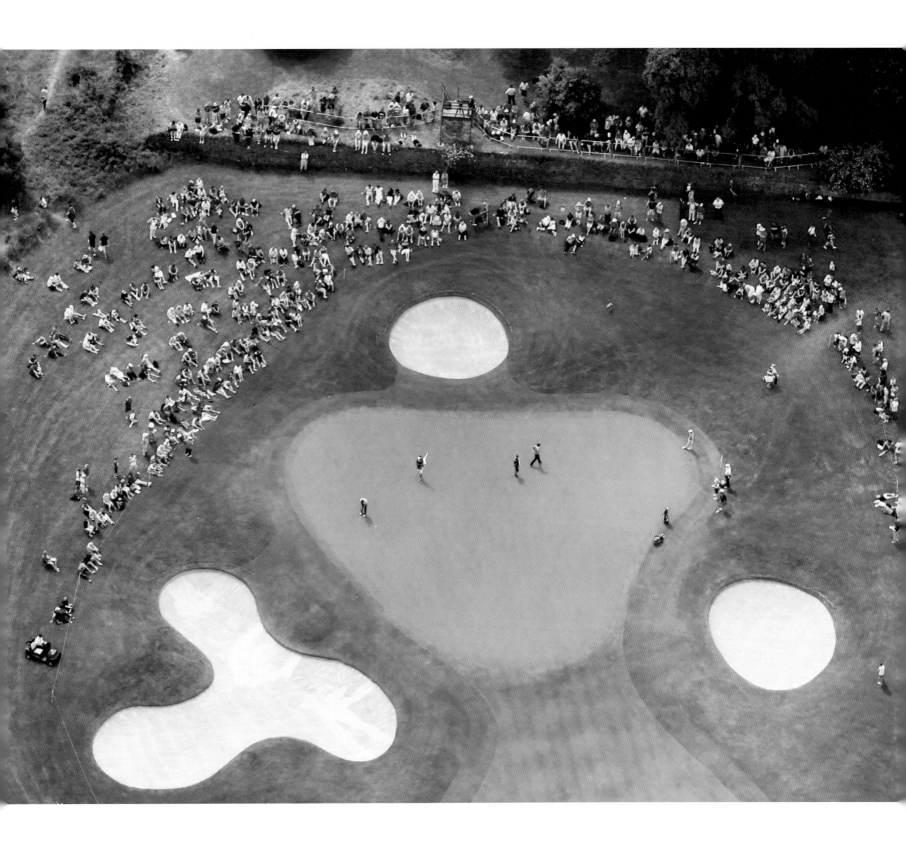

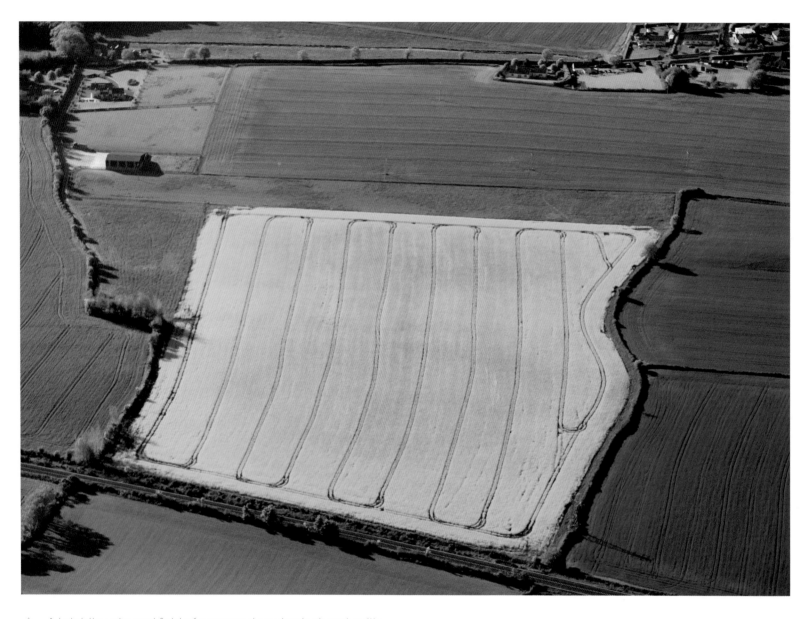

A brightly coloured field of rapeseed contrasts sharply with the green of its surroundings.

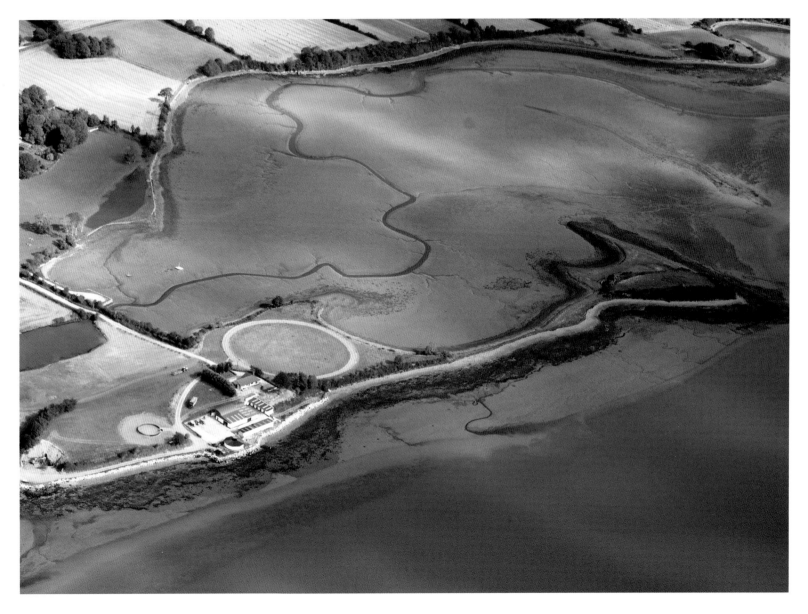

Brown Island: a distinctively shaped isthmus of land which protrudes into the Belvelly Channel near Fota.

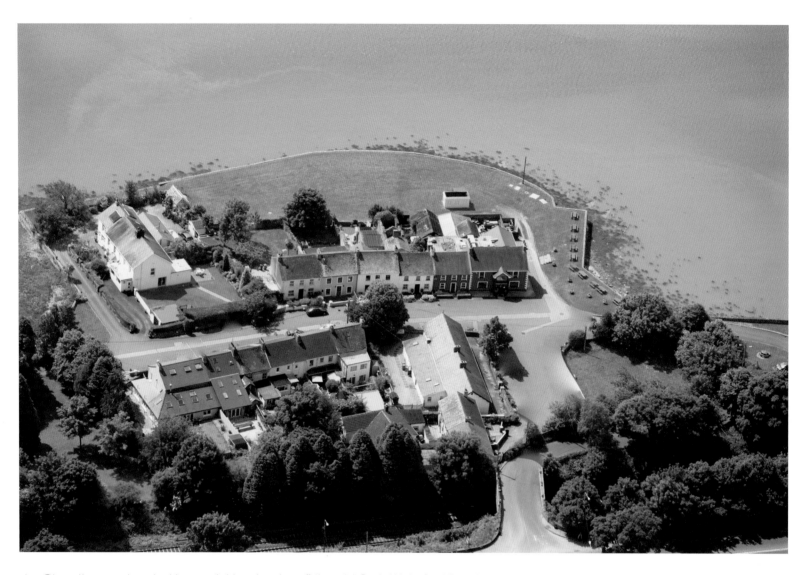

▲ Glounthaune: located in a quiet backwater off the old Cork–Waterford Road, this quaint village has an old-world feel to it and has changed little outwardly over the years.

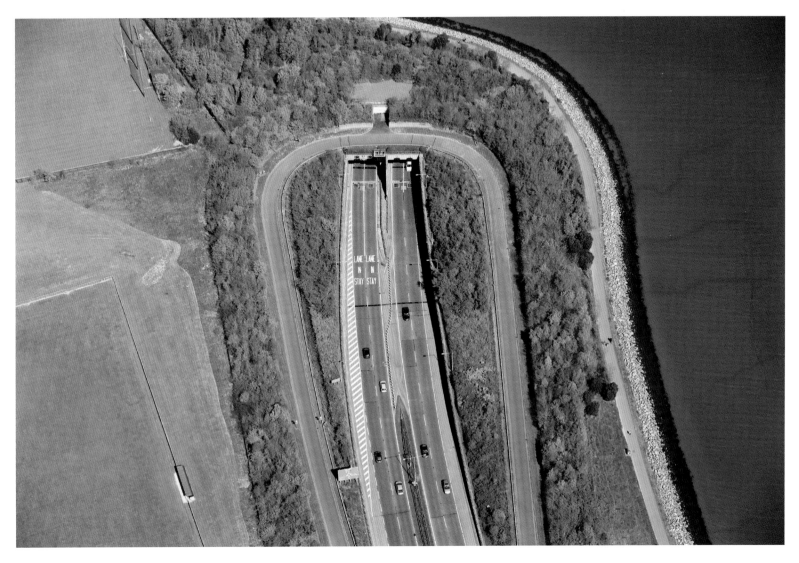

The southern entrance to the Jack Lynch Tunnel. Completed in 1999, the tunnel carries heavy volumes of traffic under the River Lee. It extends from Mahon on the south end to Dunkettle on the north.

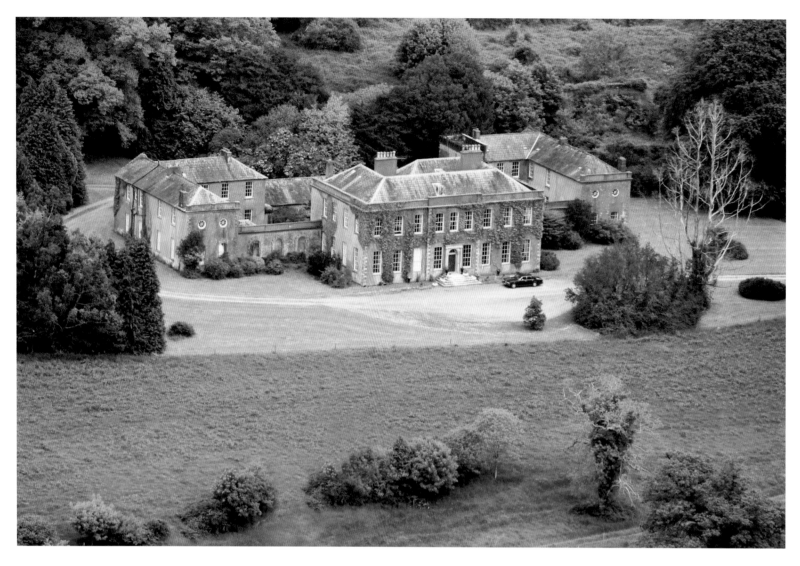

▲ Built in 1785, Dunkettle House was designed in the Palladian style and overlooks the River Lee.

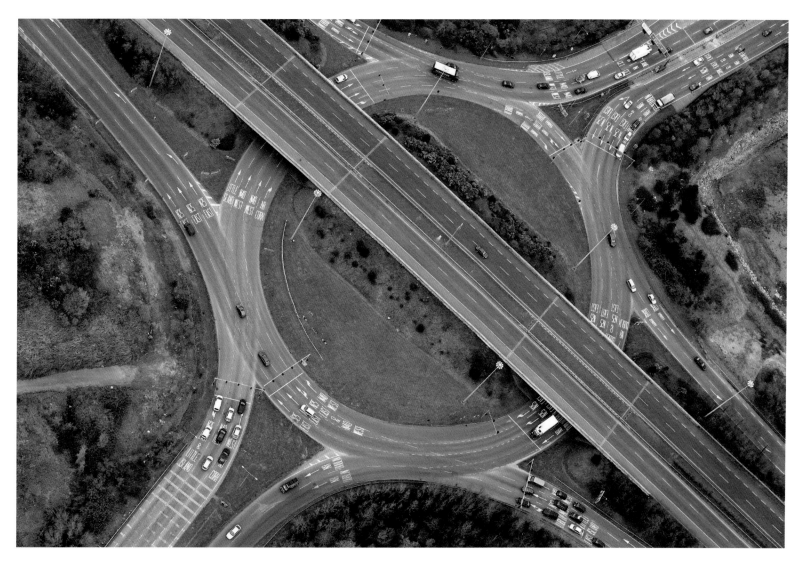

▲ The Dunkettle Interchange: the complexities of this road network are apparent from above.

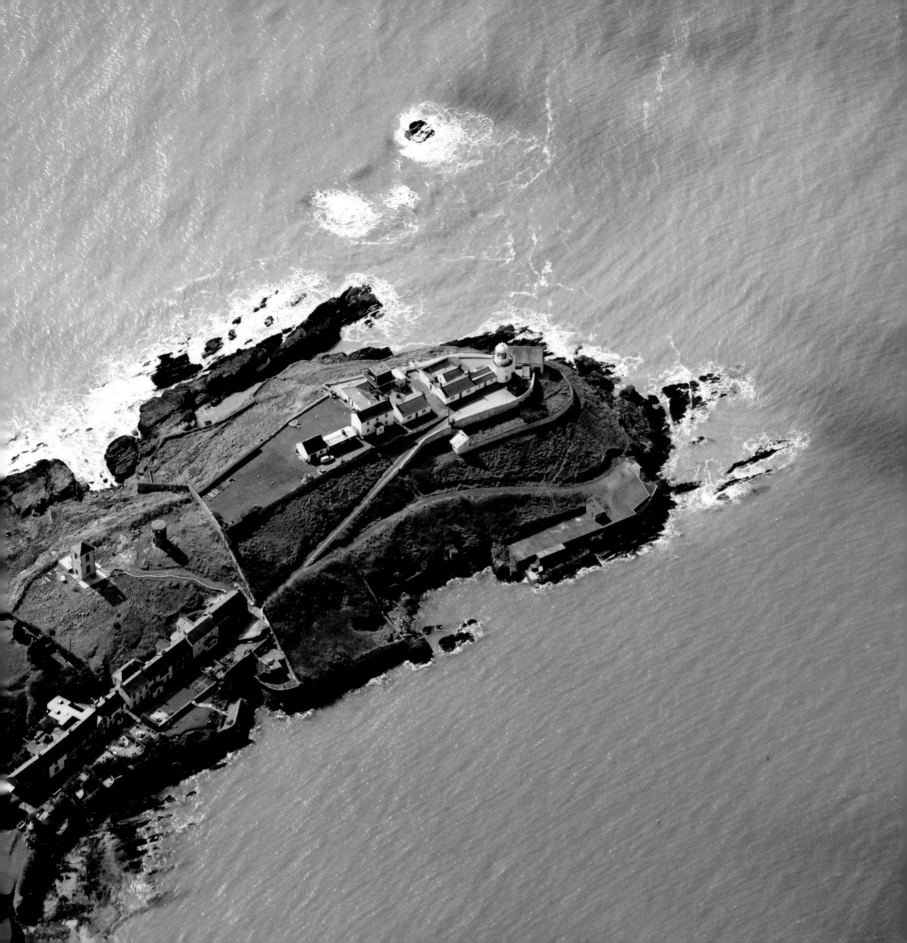

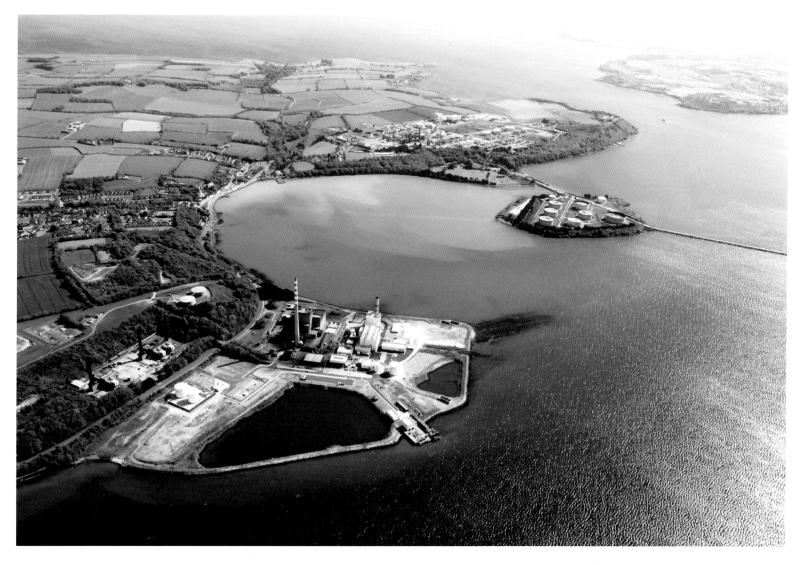

The generating station at Aghada, on the eastern side of Cork Harbour, is a significant producer of power for the national grid.

Standing at the entrance to Cork Harbour and built in 1817, Roche's Point lighthouse was once manned, but like all Irish lighthouses it is now automatic.

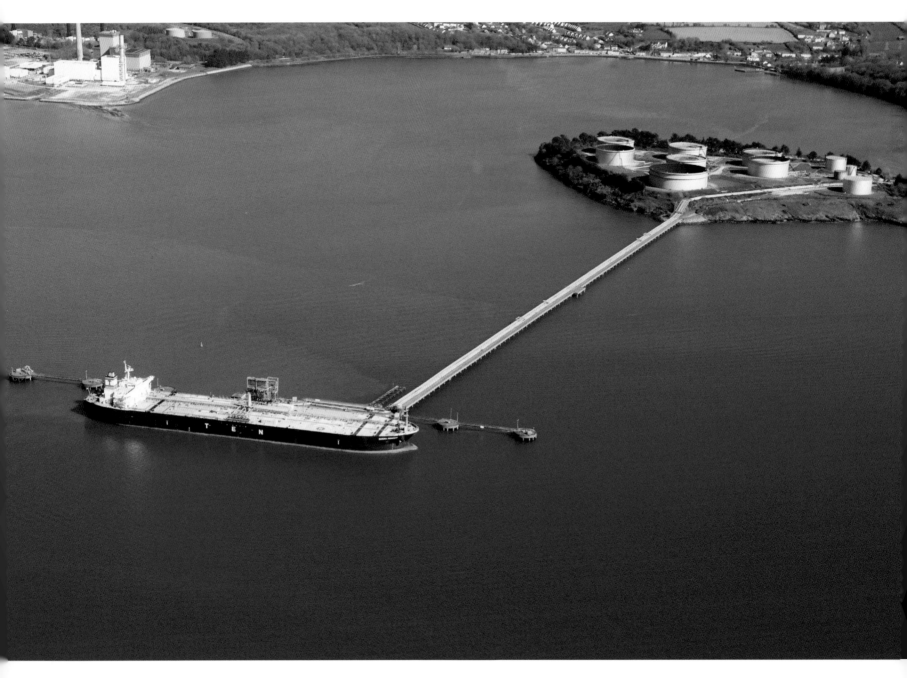

A tanker unloads its cargo of crude oil at Whitegate refinery in the inner harbour.

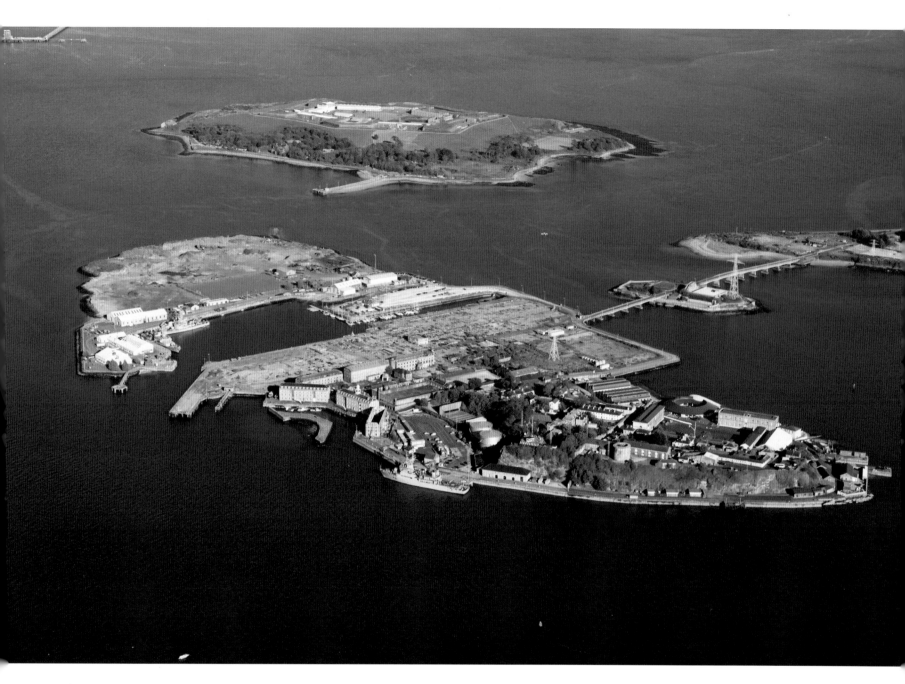

The headquarters of the Irish Naval Service are located on the island of Haulbowline.

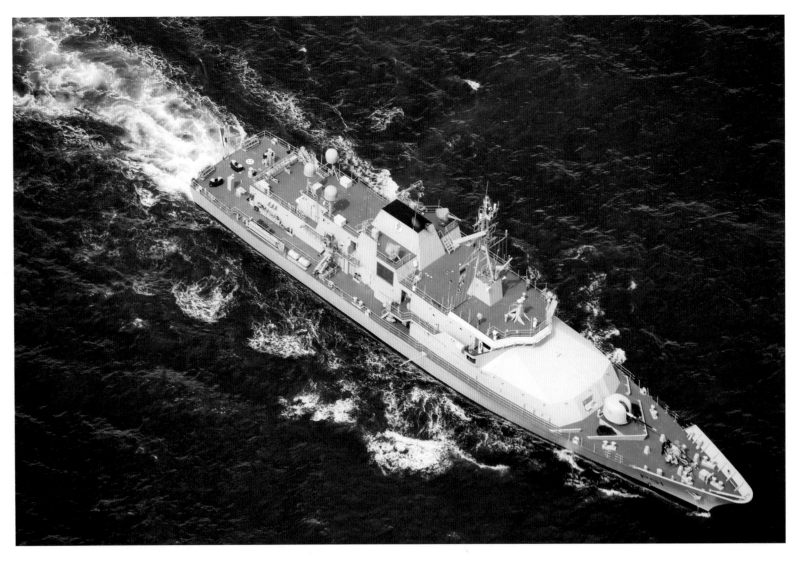

LÉ *Róisín*, one of the Naval Service's larger vessels, seen here off Kinsale. Fishery protection is one of its key roles. ▲

A ploughed field at Whitegate. ▶

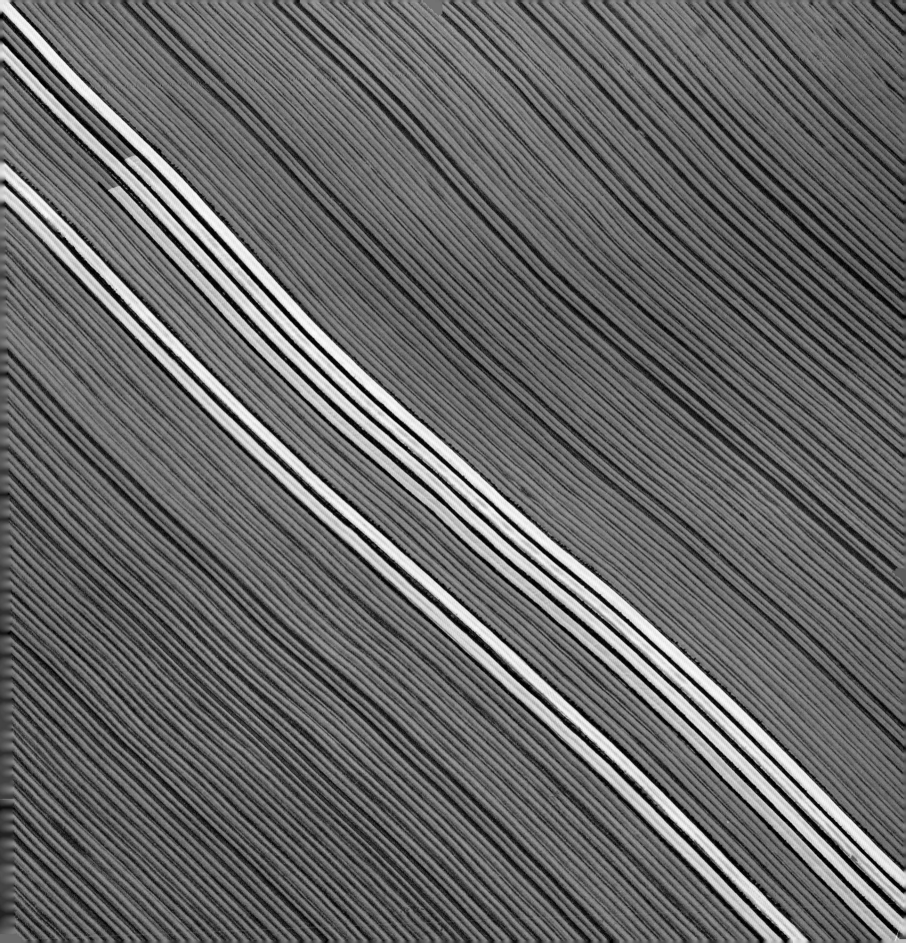

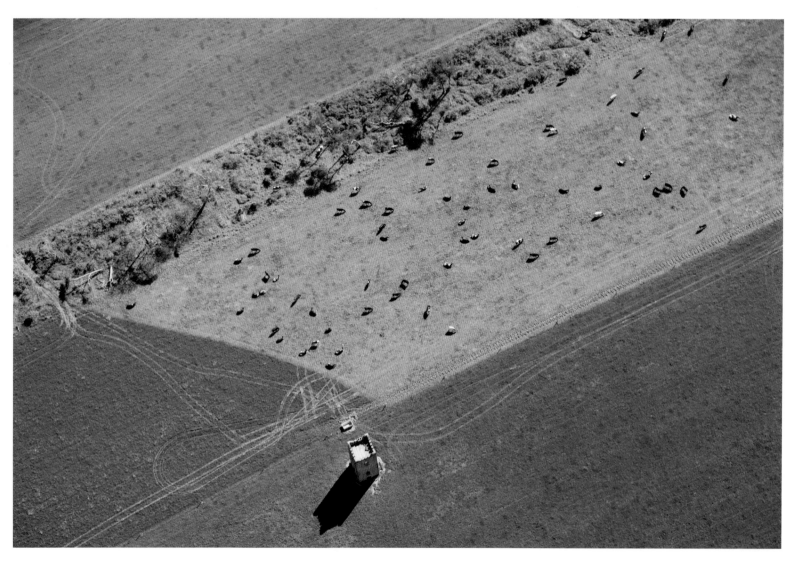

▲ Cows grazing near Carrigaline.

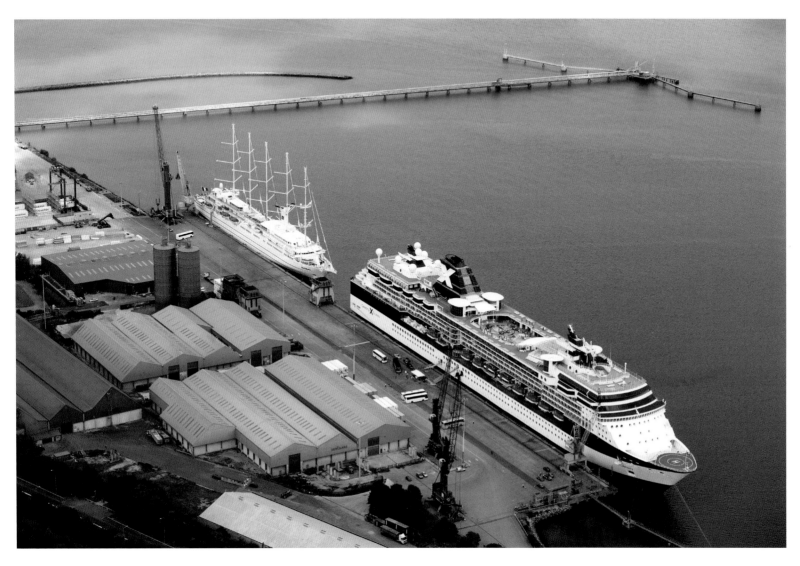

Cruise liners at Ringaskiddy: *Celebrity Infinity* and *Club Med 2* berthed together at the deep-water port. *Club Med 2* has seven computer-controlled sails. It is one of the largest sailing cruise liners afloat.

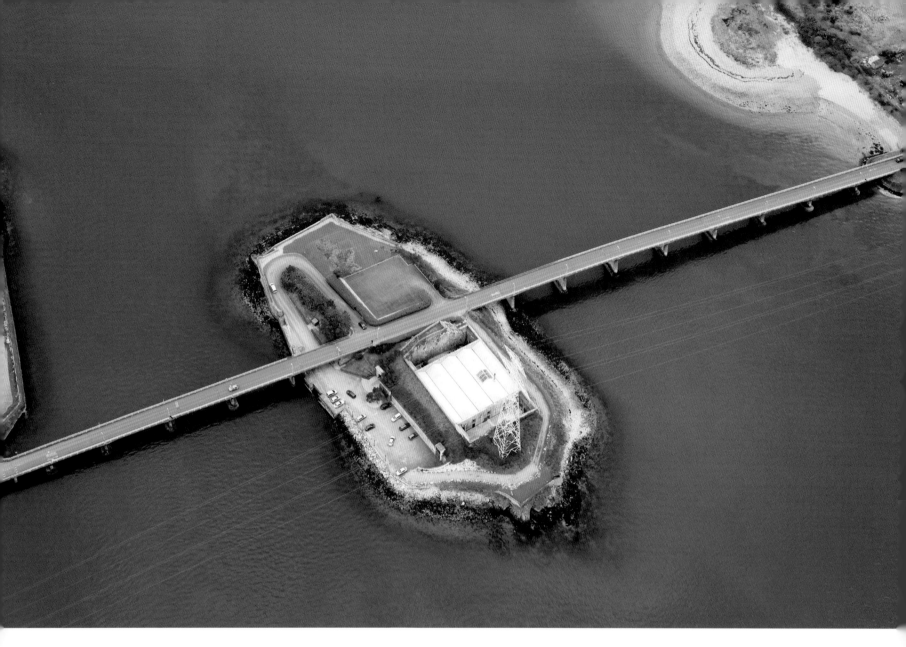

Situated between the mainland and Haulbowline, Rocky Island was originally a gunpowder magazine in the 19th century. The island has been transformed architecturally in recent years and now houses a crematorium.

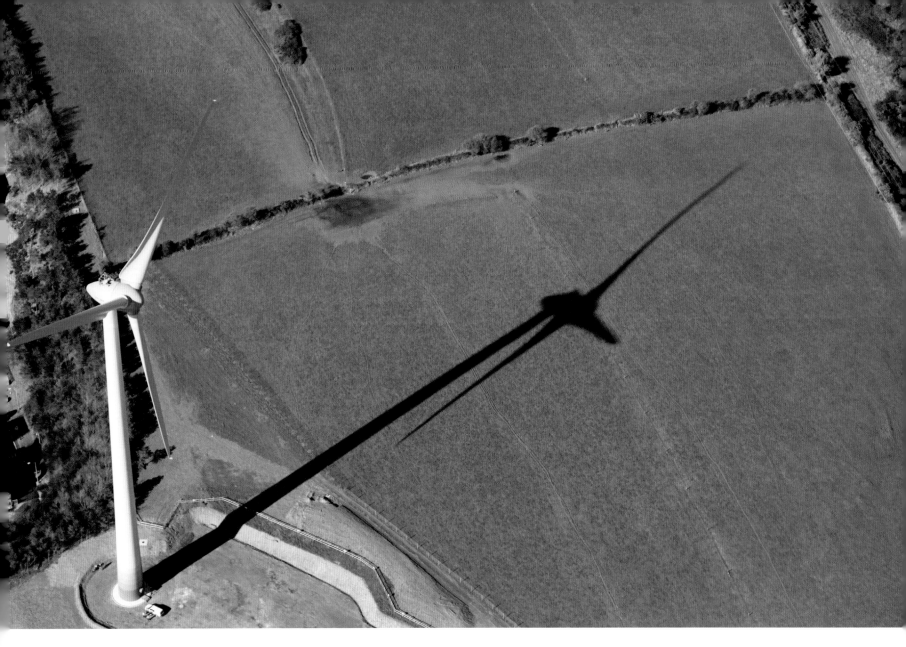

At over 128 metres high, this wind turbine at Ringaskiddy dominates the skyline. It services the energy needs of a large pharmaceutical plant in Cork Harbour and also feeds power into the national grid.

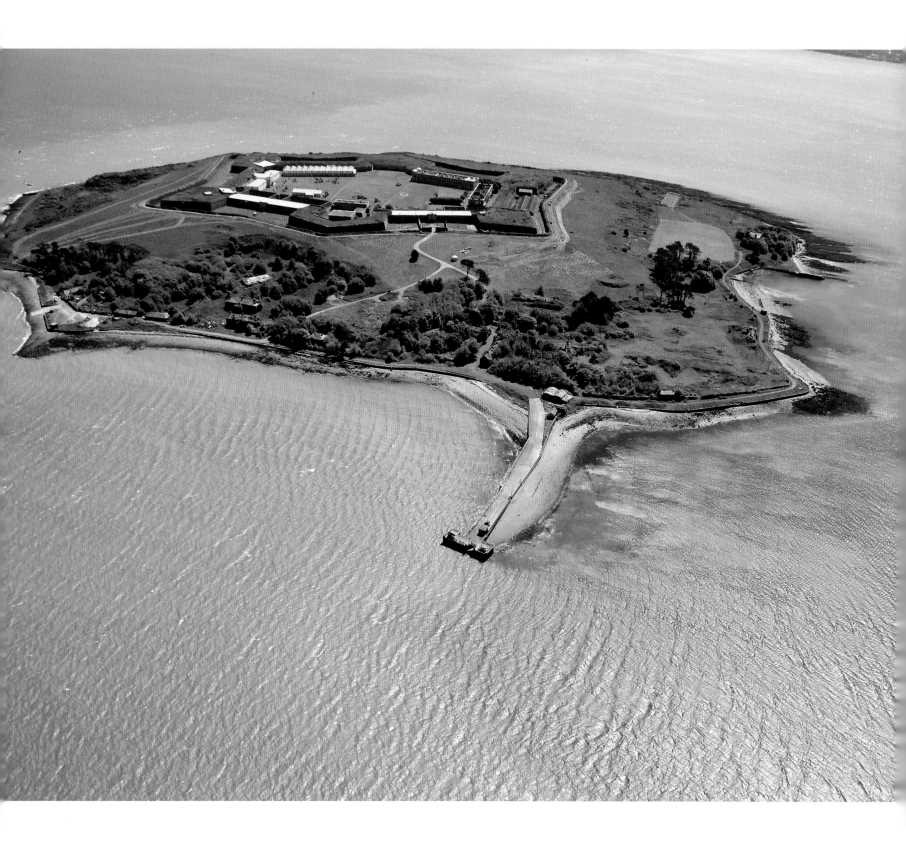

The site of a former monastery, Spike Island has also been used as a military barracks and a prison in recent years. It has now been granted heritage status by the Irish government and is a popular sightseeing destination.

This panoramic view shows Ringaskiddy's deep-water terminal with Haulbowline and Spike Island in the distance. The terminal can accommodate extremely large vessels and the ferry services to and from France are based here.

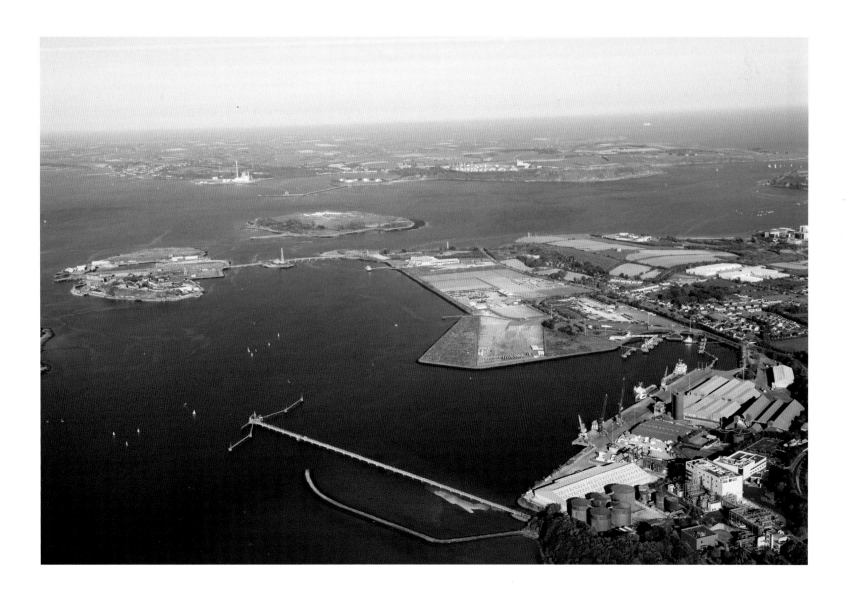

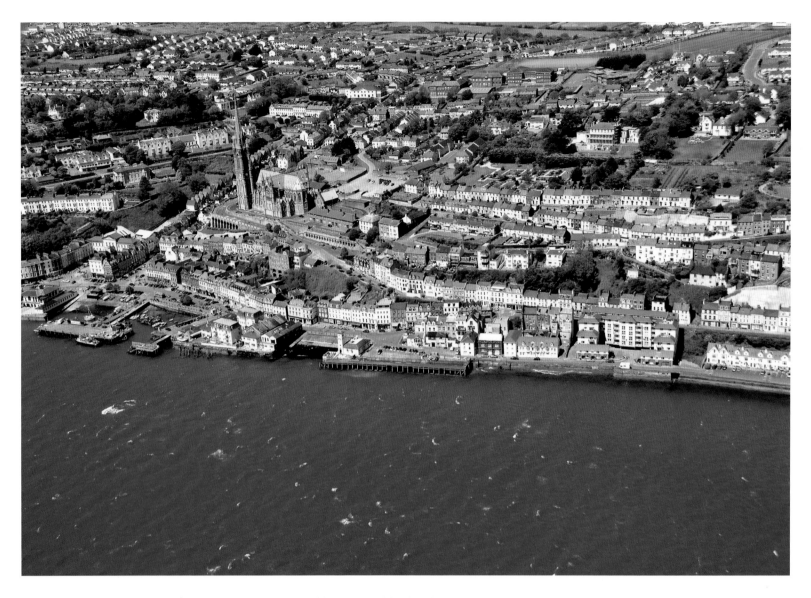

Formerly Queenstown, Cobh is steeped in naval history and is closely associated with the ill-fated liner RMS *Titanic*. Many Irish people emigrated from Cobh to make new lives for themselves in the USA.

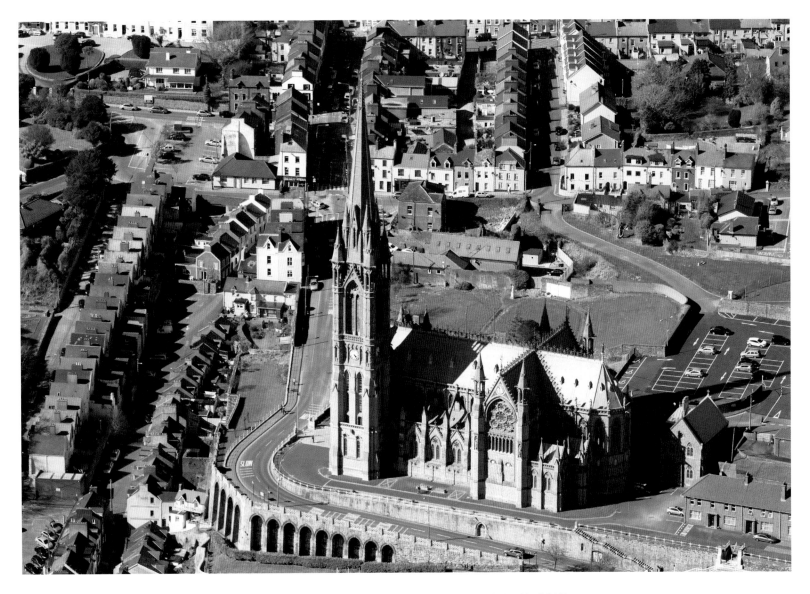

Standing high above Cobh, the neo-Gothic St Colman's Cathedral was completed in 1915.

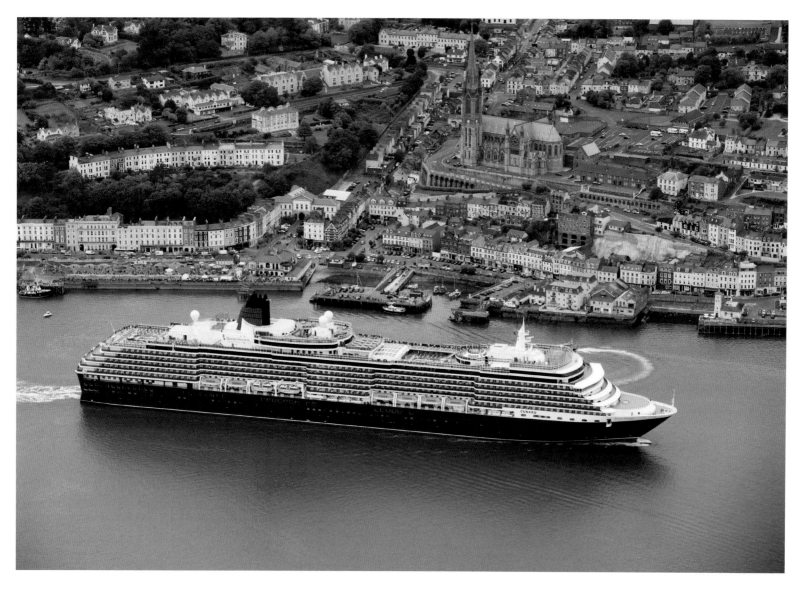

▲ The cruise liner *Queen Victoria* departs Cobh after one of her frequent calls. Ireland's only dedicated cruise terminal is located here and is operated by the Port of Cork Company. Cruise liner traffic to Cobh has grown steadily over the years.

▲ Geometric patterns in fields of ripening barley.

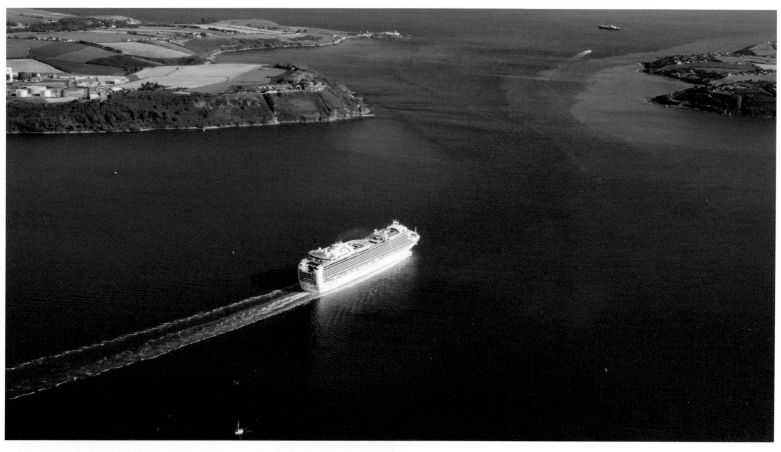

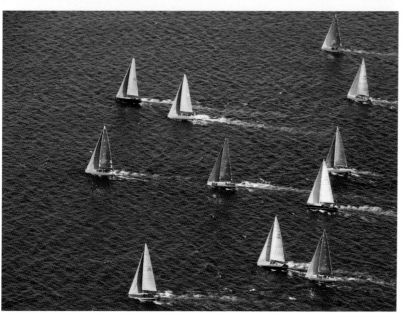

The cruise liner, *Ruby Princess*, at the mouth of Cork Harbour. These giants of the sea carry thousands of passengers in great style and comfort and their visits are a welcome boost to the local economy.

Yachts racing in Cork Harbour during Cork Week. This event has been held biennially since 1978 and is an important event in the yachting calendar, with boats from Ireland, the UK, Europe and the US taking part.

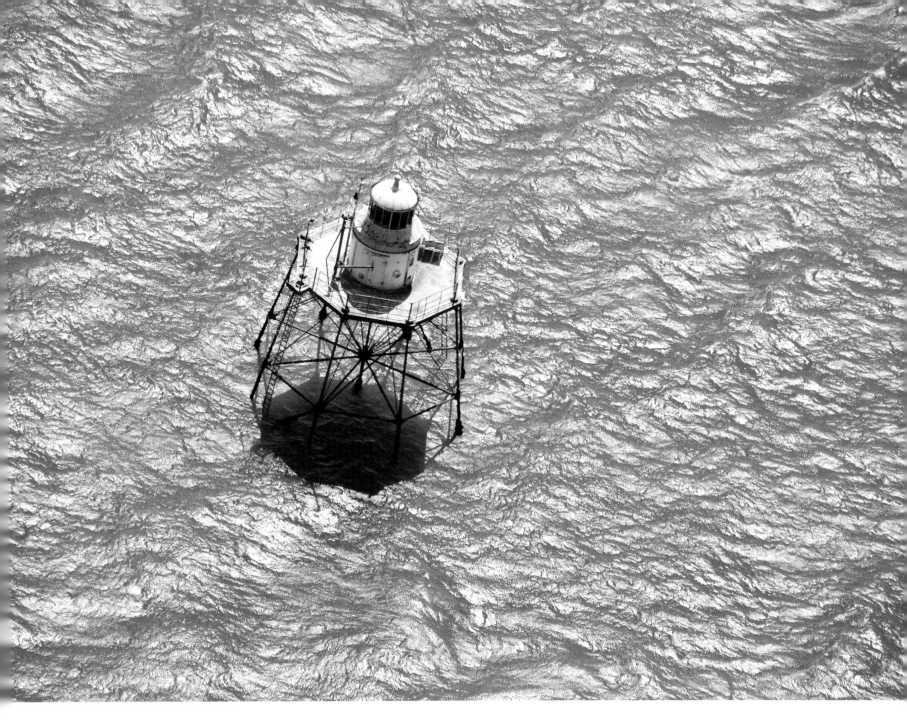

The Spit Bank Light: known locally as 'The Spit', the light is one of the best-known marks in Cork Harbour and set at the end of a long mudbank.

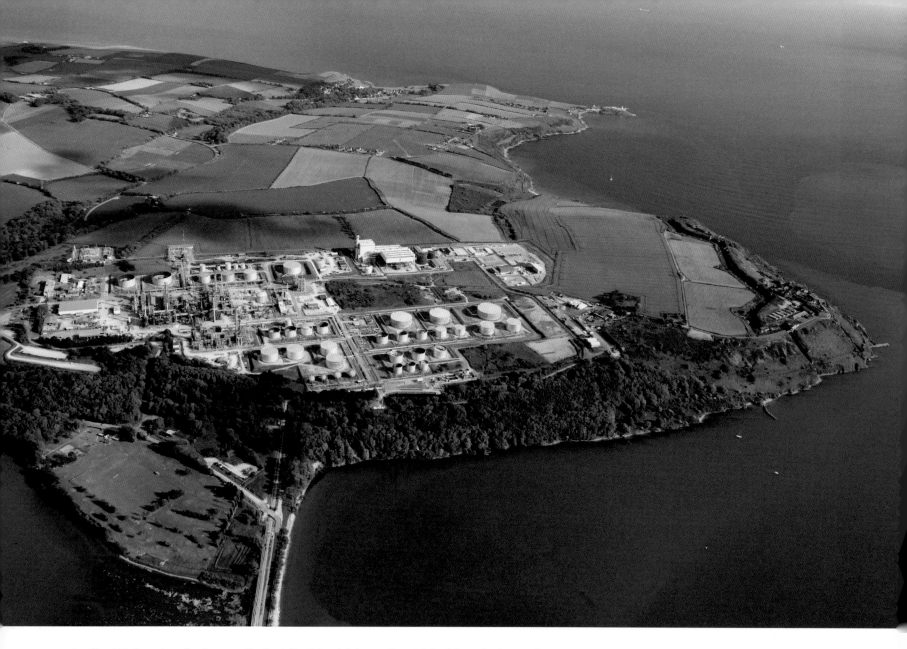

▲ The Whitegate oil refinery with Fort Carlisle visible on the right of the photograph.

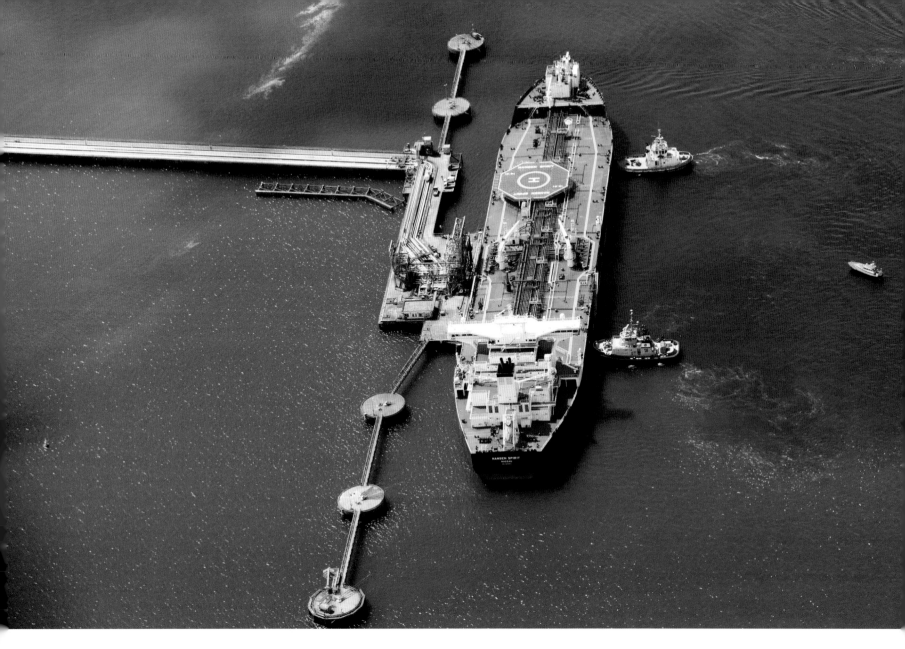

The oil tanker *Nansen Spirit,* a regular caller at Whitegate, is assisted into her berth by two tugboats.

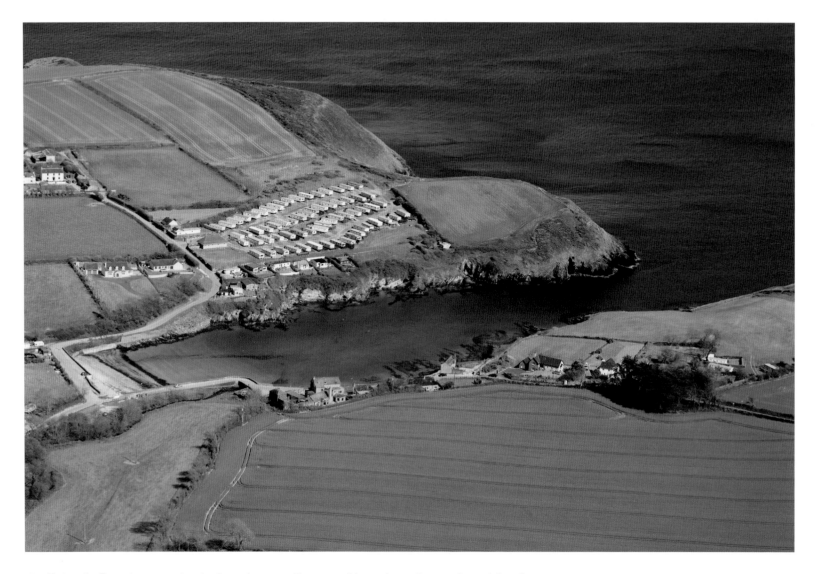

Robert's Cove is a scenic, sheltered cove with a small beach on the western side of Cork Harbour and popular with day trippers from Cork city.

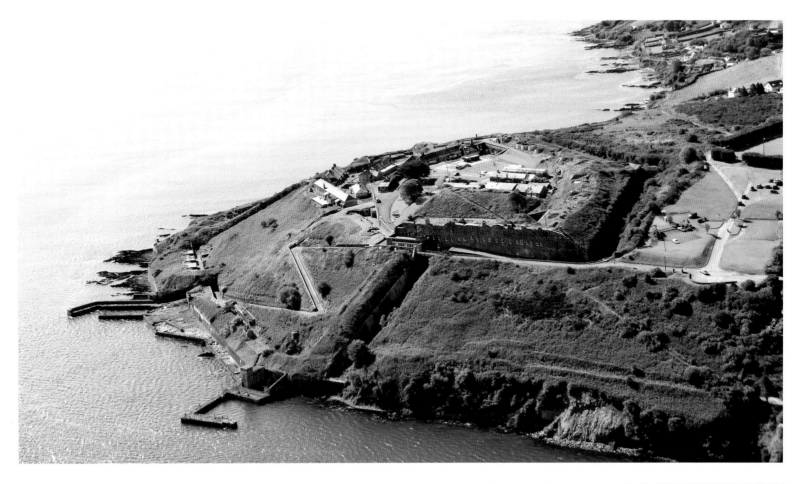

Camden Fort Meagher: a former coastal artillery fort located on a high hill in the inner harbour, the fort dates back to the 16th century. Extensive restoration work has taken place in recent years.

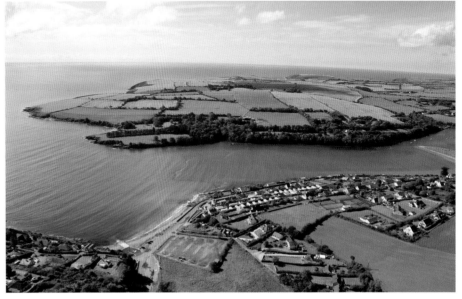

Fountainstown, a popular resort where many Cork people have holiday homes, has seen its permanent population increase in size due to its easy commute distance to Cork city. This view looks southwest towards Ringabella.

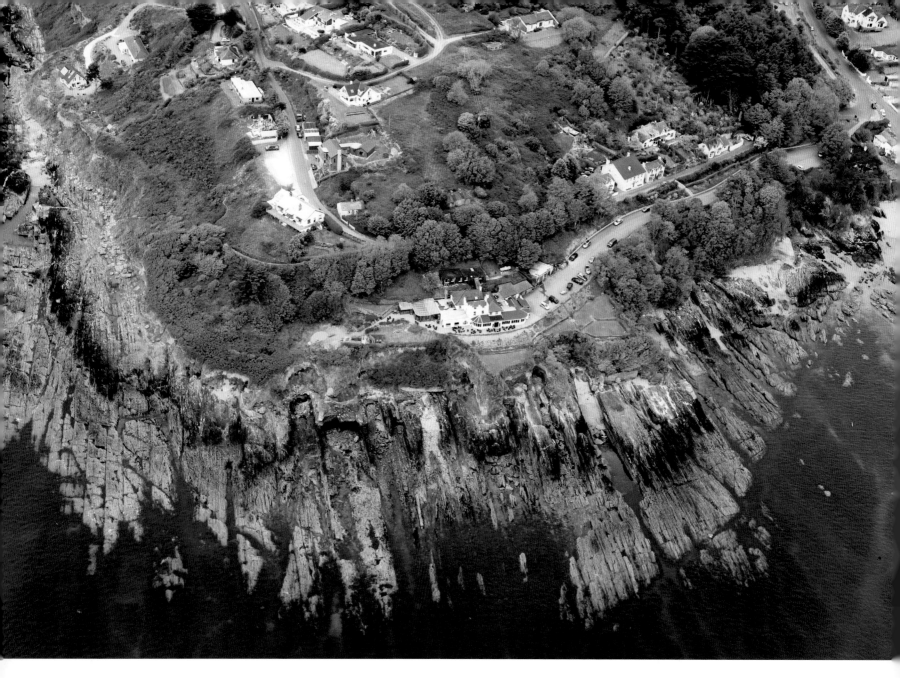

A spectacular outcrop of rock dominates the shoreline at Myrtleville. The popular bathing spot know as Pollgorm (from Irish meaning 'the blue pool') can be seen at the middle left.

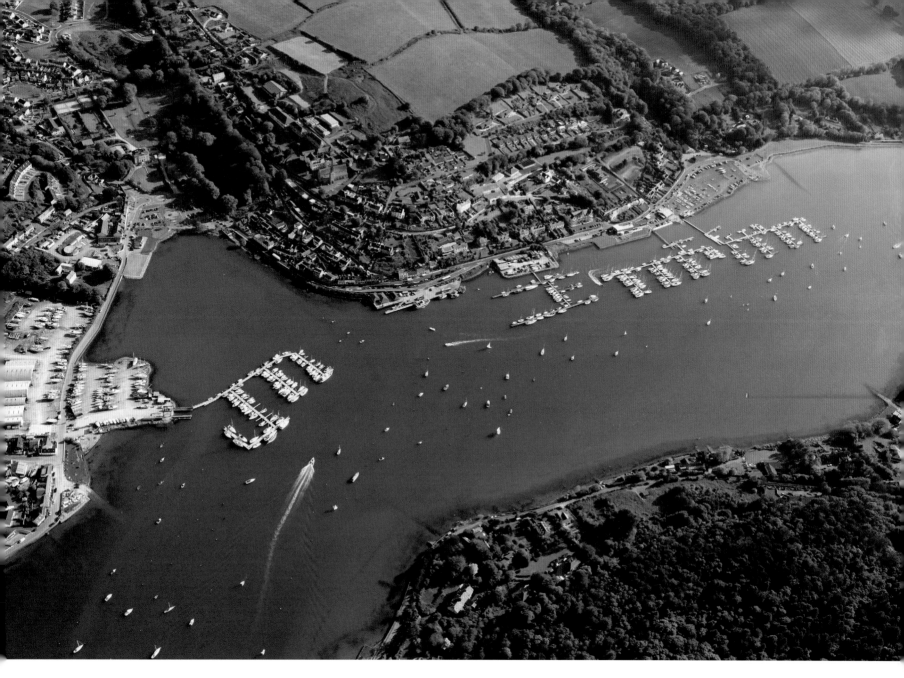

Crosshaven is a coastal fishing village whose population has grown steadily over the years. It is also home to the Royal Cork Yacht Club.

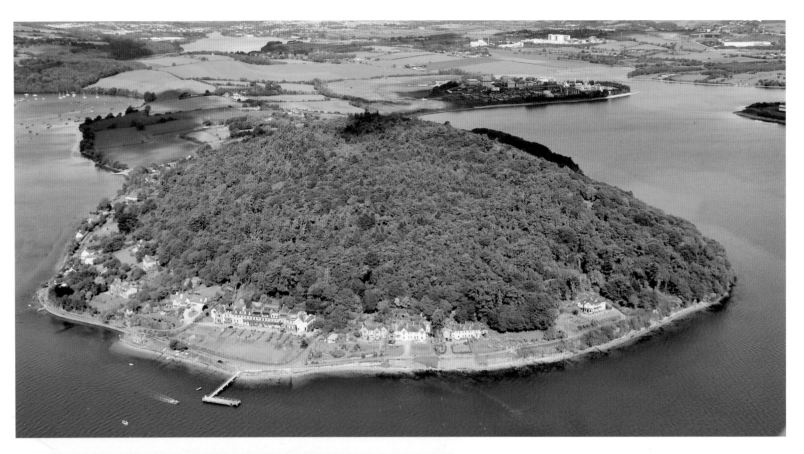

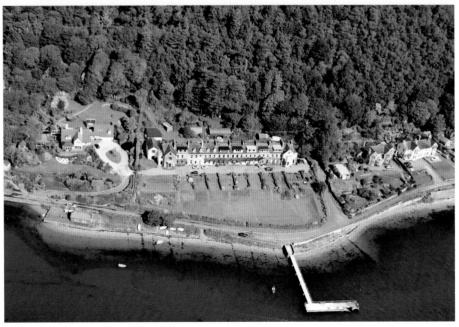

Currabinny, a wooded nature reserve directly opposite Crosshaven and situated where the Owenabue River flows into Cork Harbour.

The Terrace, Currabinny: with its pristine gardens and pier, this terrace was home to naval officers in the 1860s.

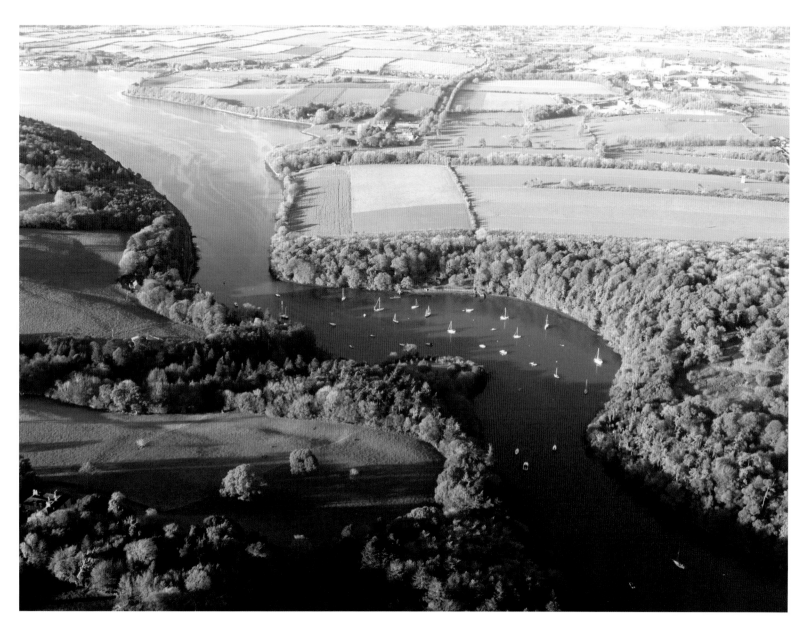

▲ Autumnal shades and moored yachts in Drake's Pool looking upriver towards Carrigaline. Legend has it that Sir Francis Drake hid his fleet here to escape from the Spanish Armada.

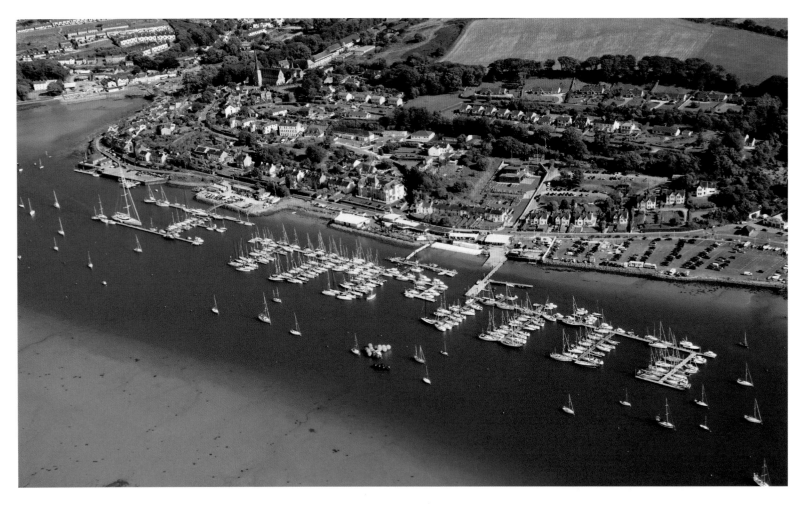

▲ Founded in 1720, the Royal Cork Yacht Club is the world's oldest yacht club
and hosts numerous national and international sailing events. Classes
range from dinghies to large cruisers and racing yachts.

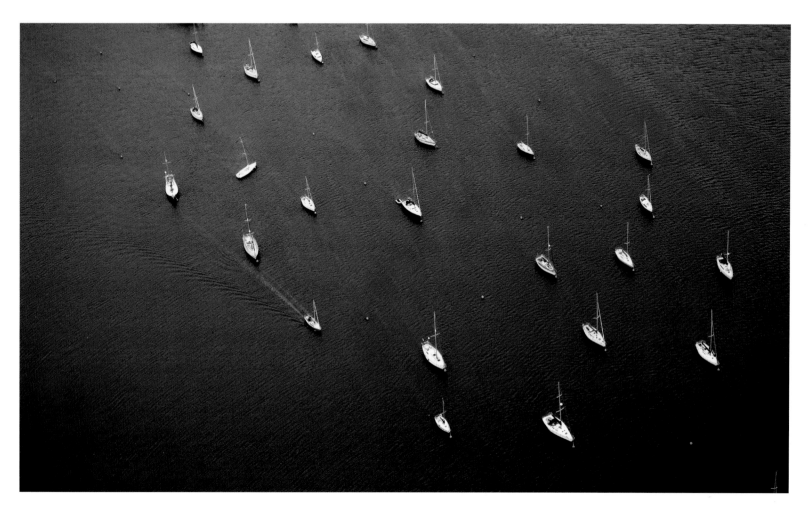

Yachts moored on the Owenabue River: an approaching squall darkens
the water off Currabinny on a late winter's evening.

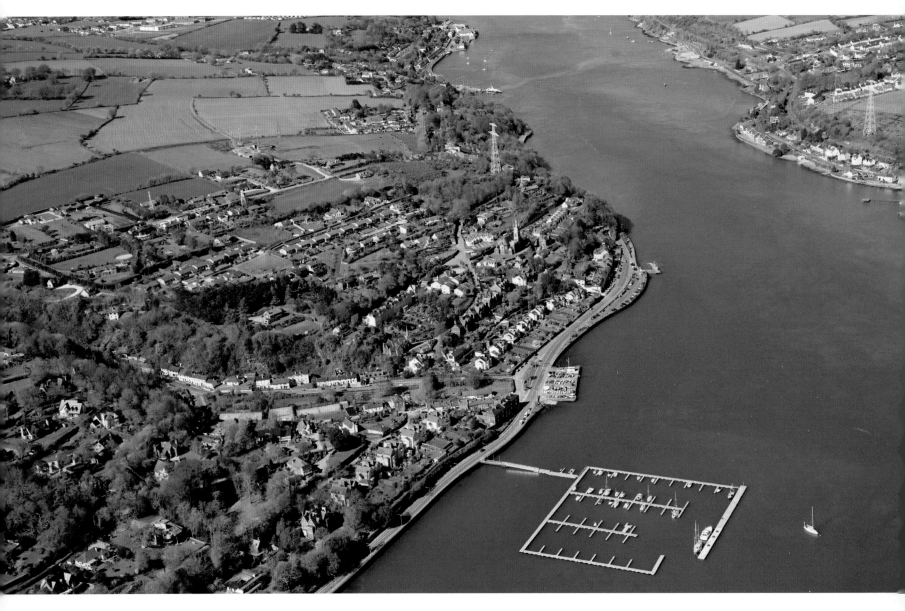

▲ The scenic coastal village of Monkstown is a short distance from Cork city and just upriver from Cork Harbour. Its facilities include a marina for local and visiting boats alike.

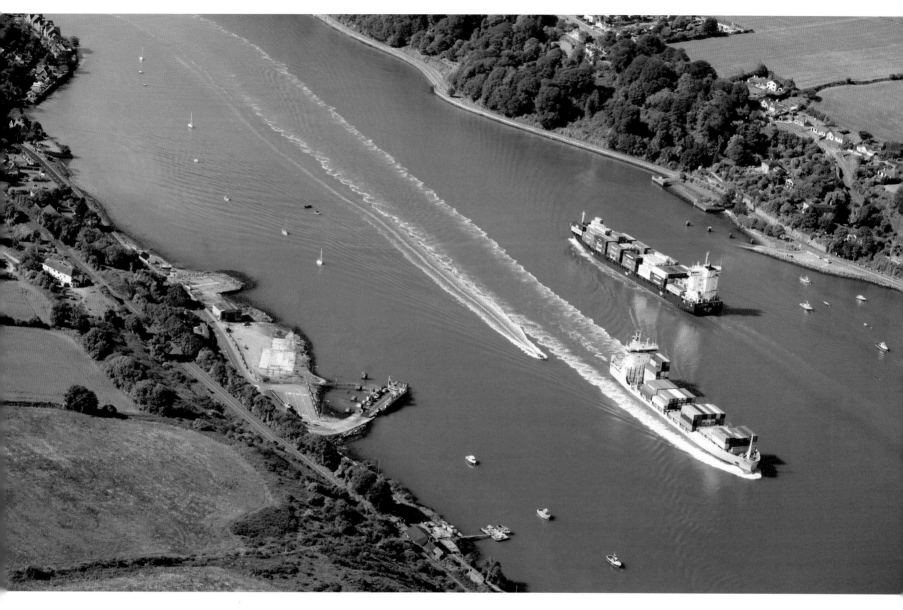

▲ Container ships pass each other in the channel at Monkstown. The cross-river ferry is visible on the left-hand side.

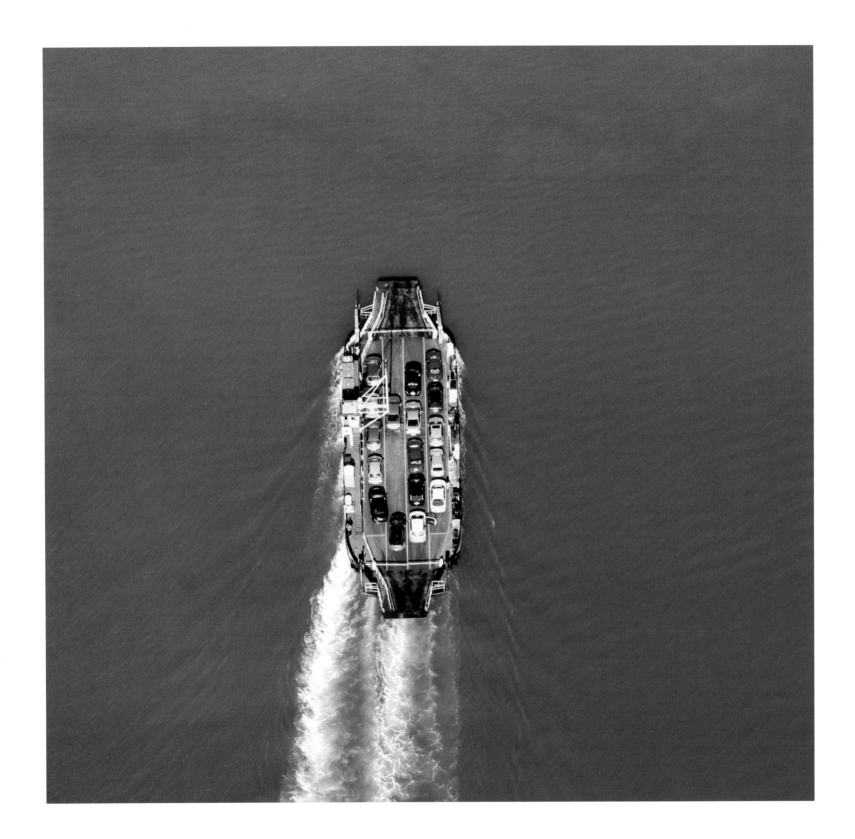

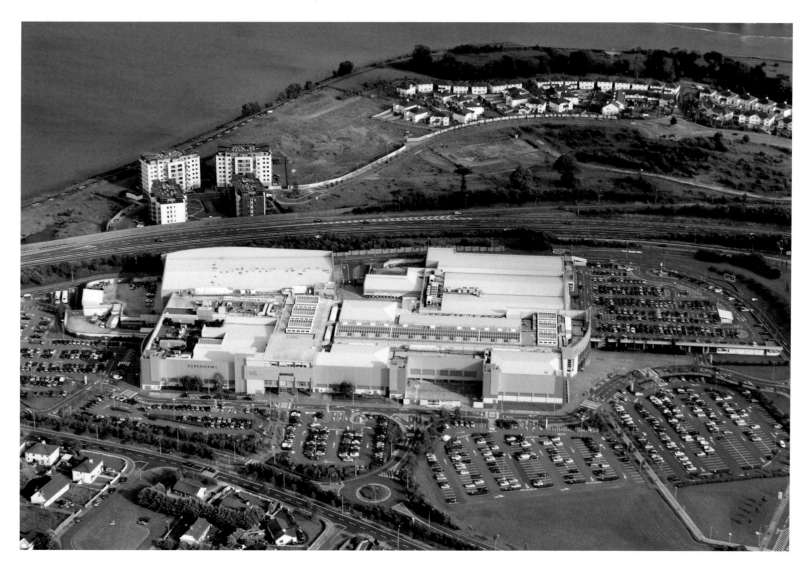

▲ Completed in 2006, Mahon Point is the fourth largest shopping centre in Ireland. Extending to over 23,000 square metres, it incorporates shops, restaurants and a multiscreen cinema.

◄ The Monkstown-to-Carrigaloe river ferry makes its regular crossing with a complement of cars on board.

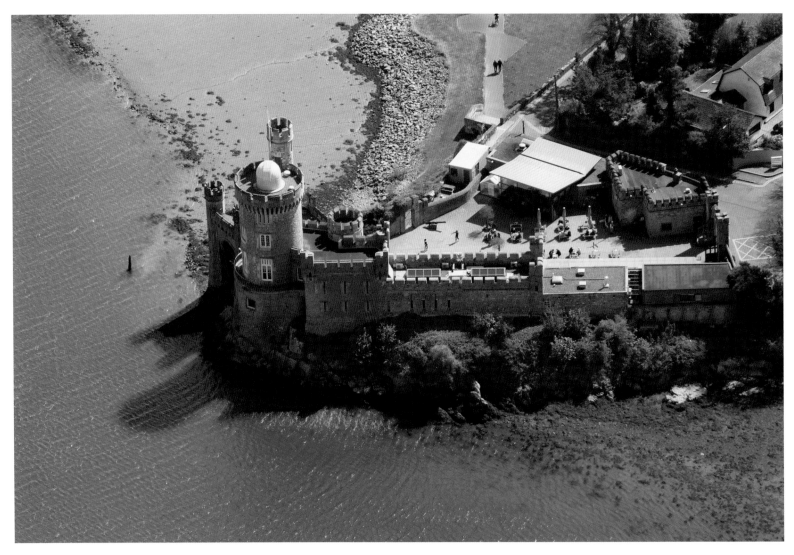

Blackrock castle on the banks of the River Lee dates from the 16th century and is one of Cork's best-known landmarks. It now houses an observatory, visitor centre and restaurant.

Sheep grazing near Ringaskiddy.

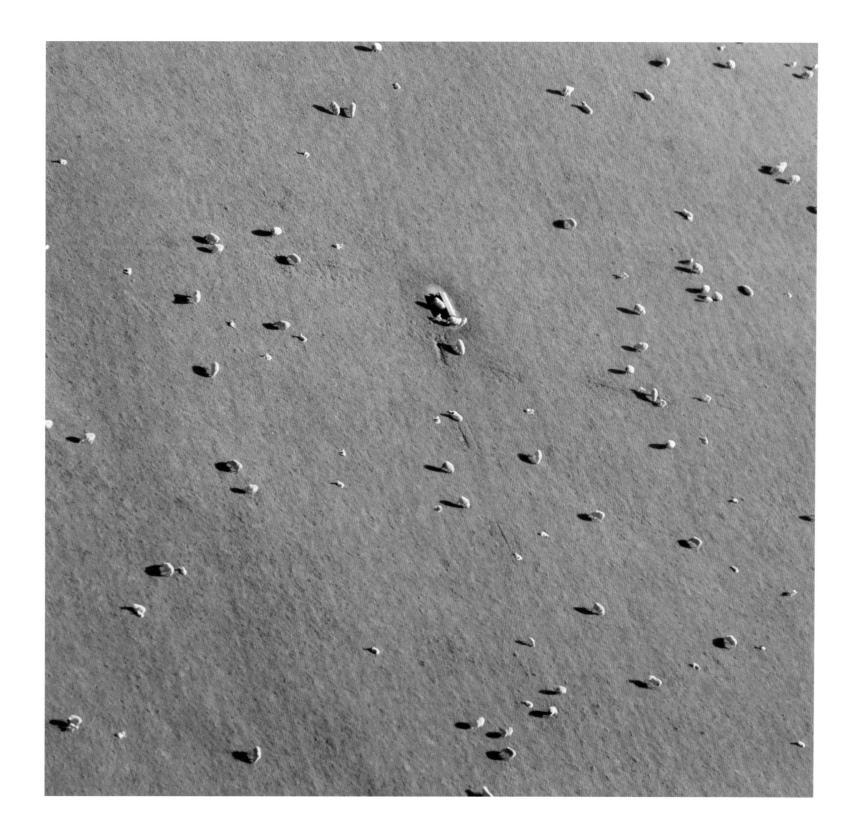

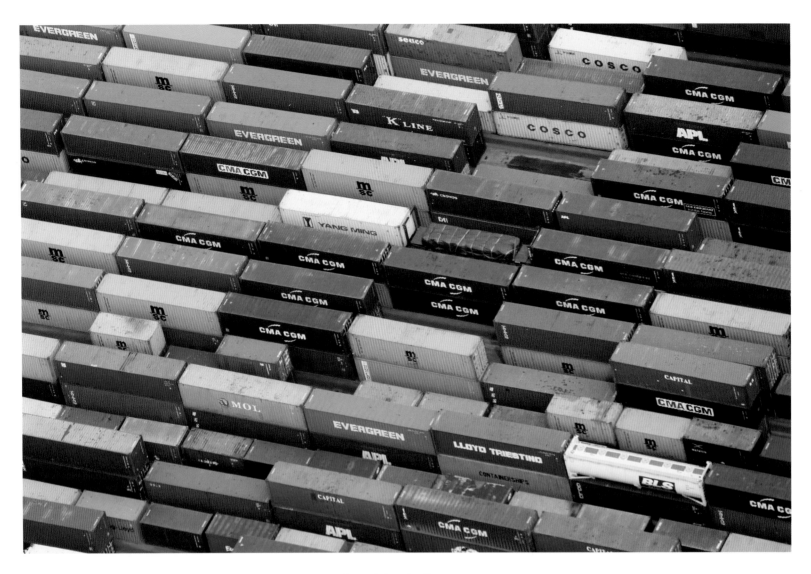

▲ Containers at Tivoli Dock. Each year large volumes of container traffic pass through the Port of Cork and are handled at this large terminal.

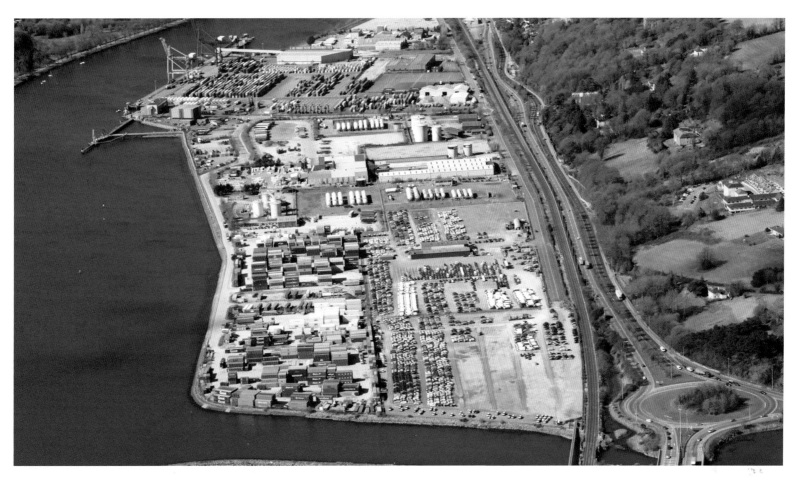

Tivoli Dock and Industrial Estate. This view looking towards the city gives a sense of the scale of the operations involved.

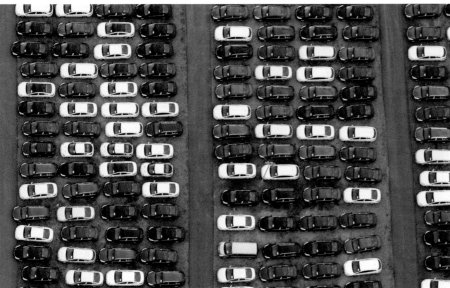

Newly unloaded vehicles sit at Tivoli Dock awaiting distribution to car dealerships throughout the country.

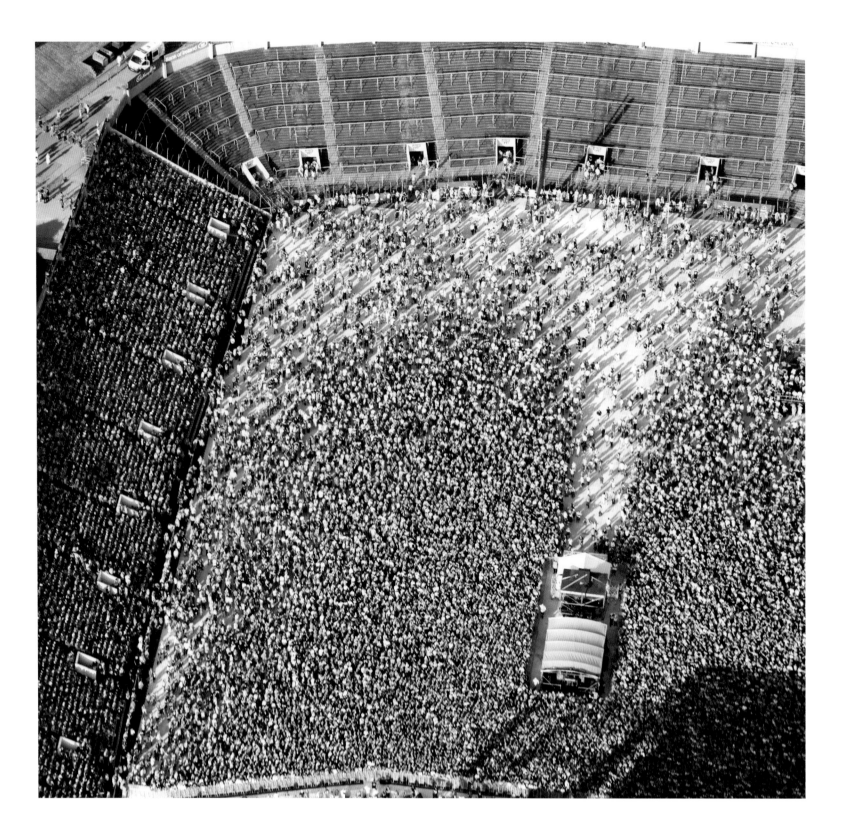

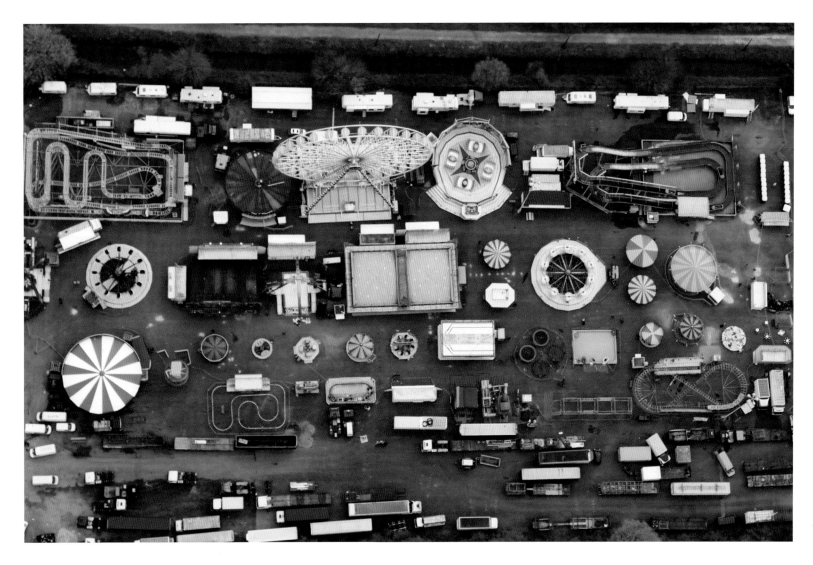

Funderland at the Marina: a bird's-eye view of the attractions at the travelling funfair which comes to Cork city on a regular basis.

A summer concert at, Páirc Uí Caoimh, Cork's premier sports arena, before it was closed in 2014 for redevelopment. Among those who have performed here are Michael Jackson, Bruce Springsteen, U2 and Oasis.

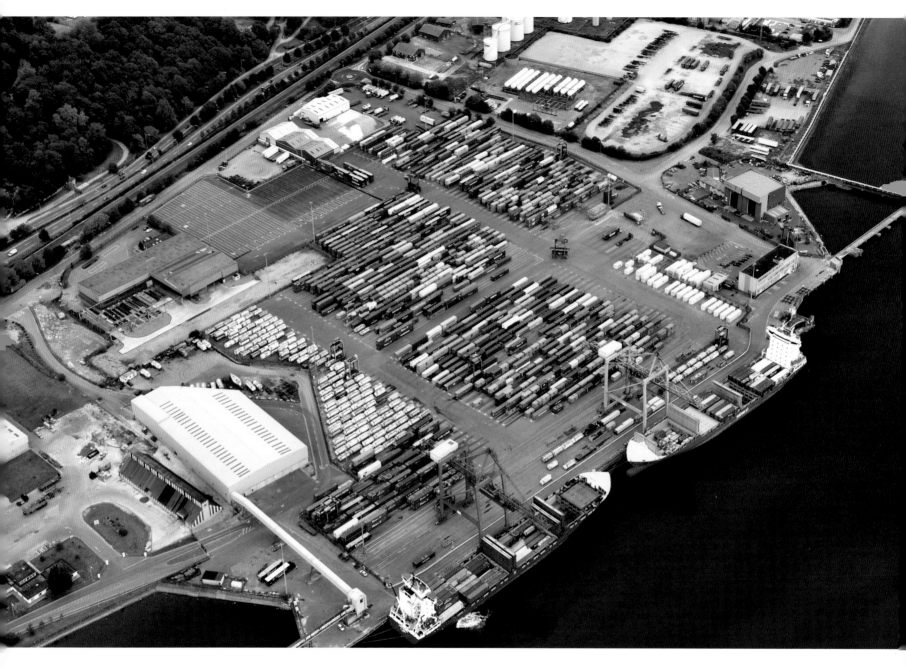

▲ Another perspective of Tivoli Dock and Industrial Estate.

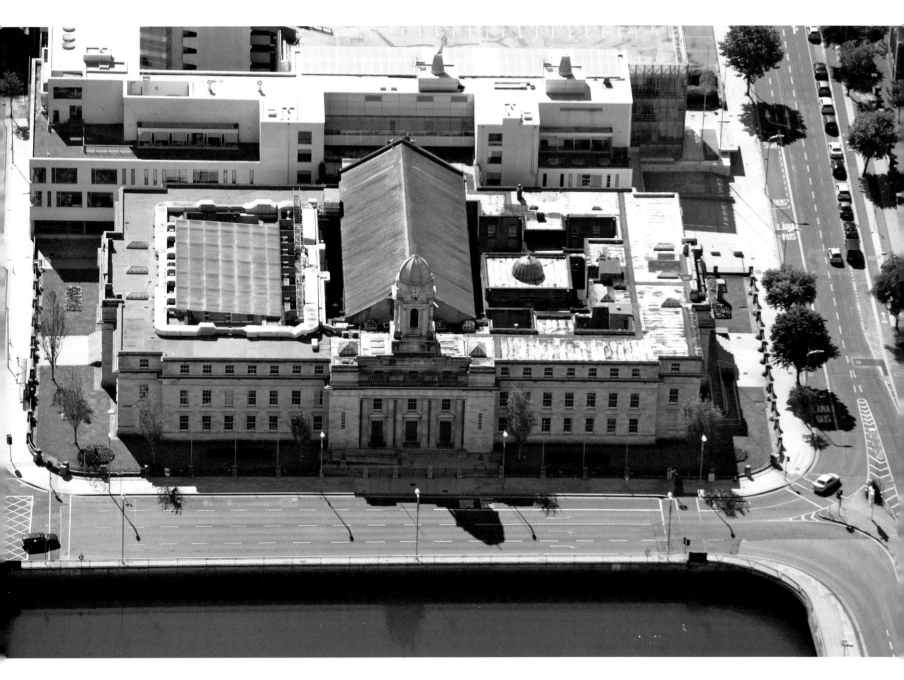

City Hall. This historic building houses Cork City Council, the local municipal authority; the new buildings to the rear are the Civic Offices.

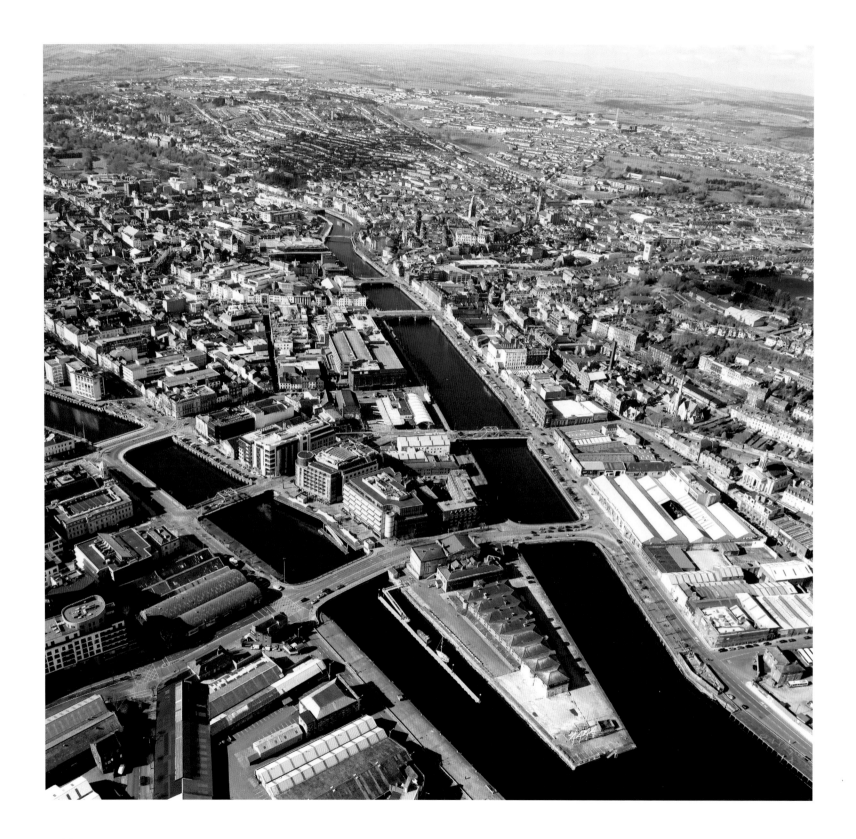

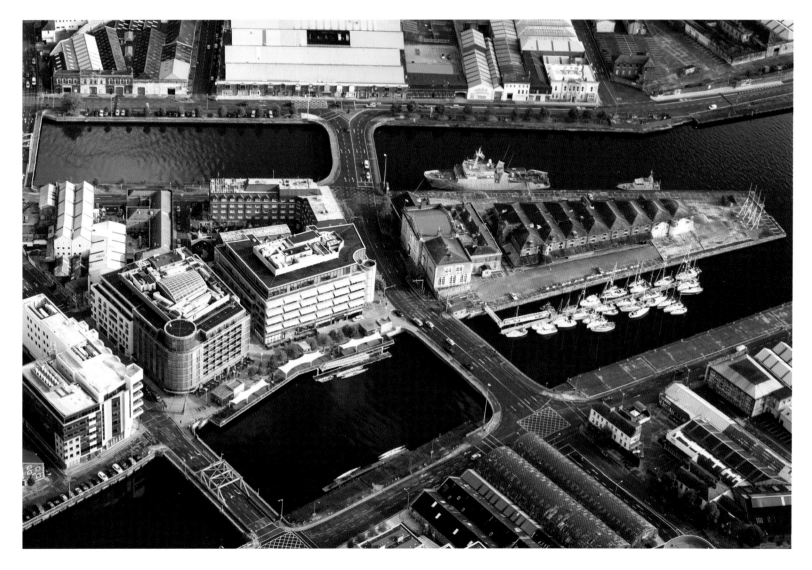

City Quarter with its offices, restaurants and boardwalk is a popular
spot with Corkonians and visitors. The Port of Cork Marina now provides
pleasure craft with berths in the heart of the city.

A view from where the River Lee divides into the North and South
Channels with the Custom House and City Quarter prominent in the
foreground. Cork takes its name from the Irish word *Corcach* meaning
'marsh' and the city originates from a monastic settlement founded by
Saint Finbarr in the sixth century

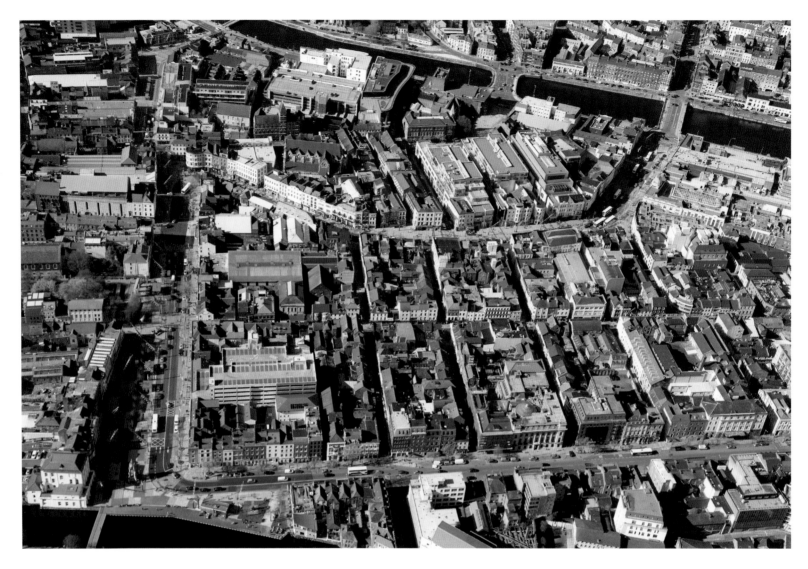

This view shows the western end of South Mall where it joins Grand Parade
– home of Cork's famous English Market.

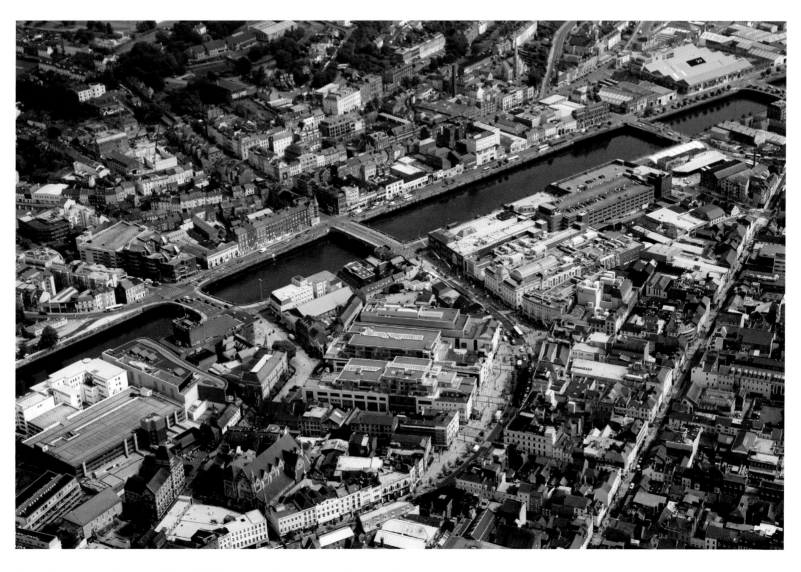

The elegant curve of Patrick Street, Cork's premier retail street.
Centre front is Opera Lane, a new retail development.

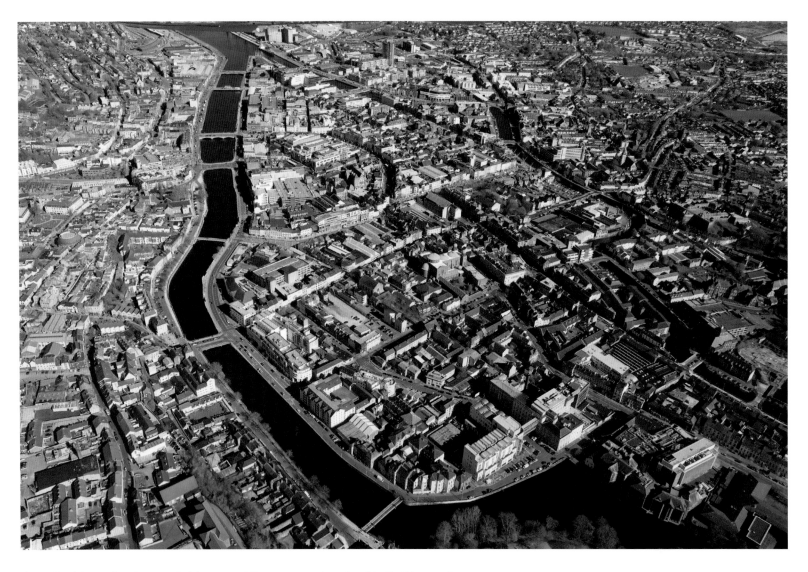

Cork is a city of many bridges and those spanning the North Channel are clearly visible in this image looking east from the city.

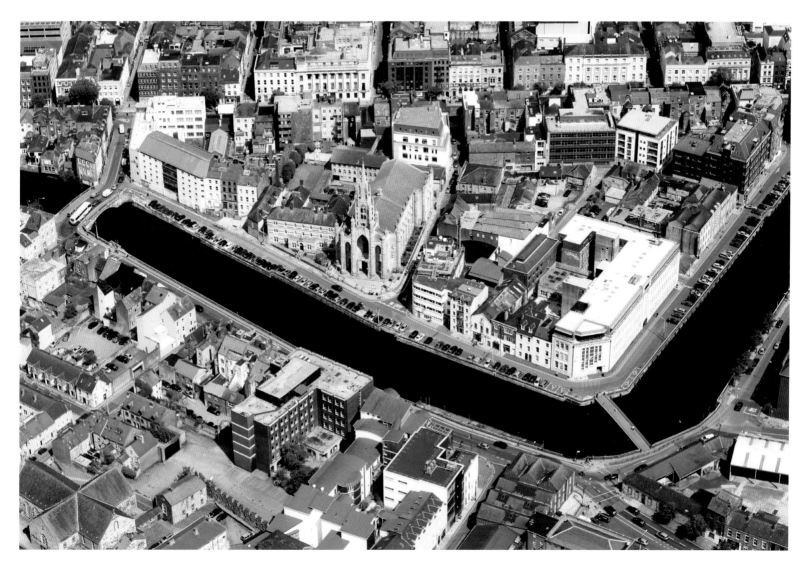

▲ Morrison's Island, with Holy Trinity Church in the centre and Cork College of Commerce to the right.

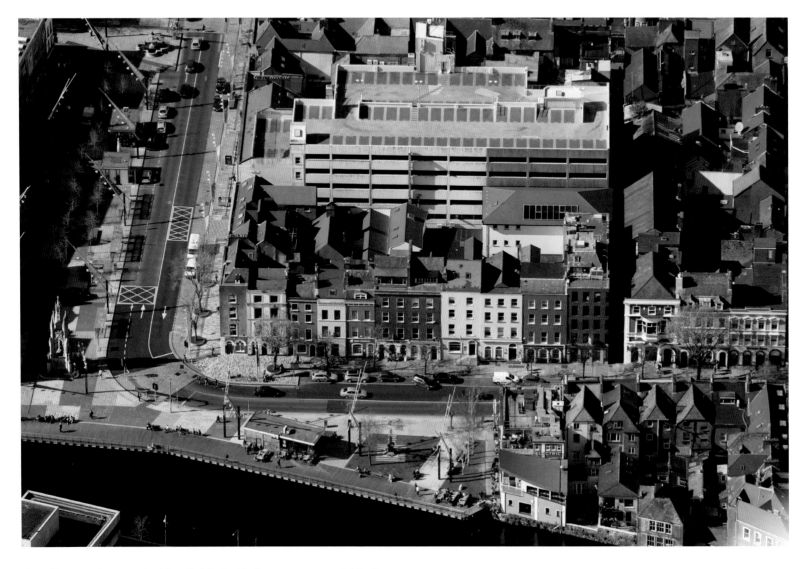

The western end of South Mall with the war memorial in the centre foreground.

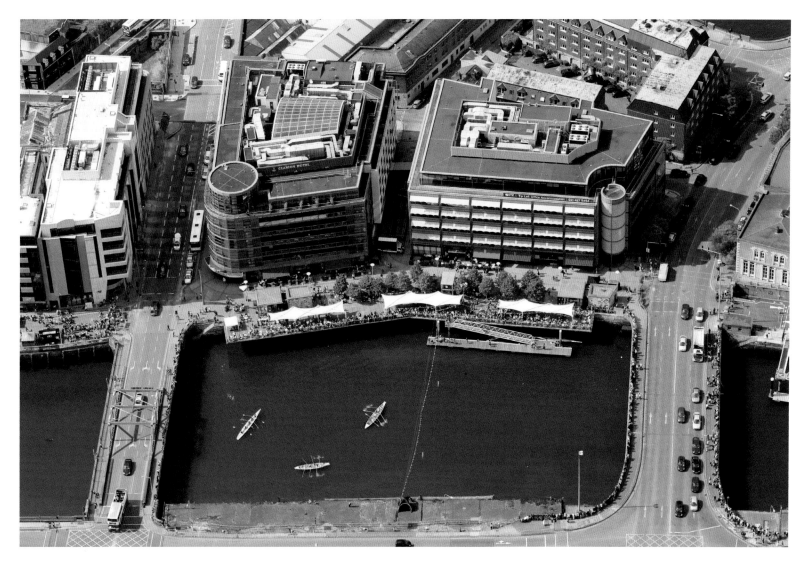

Crowds gather at the finish line of the annual Ocean to City rowing race. Each year the event attracts a large entry of all types of row boats from all over Europe.

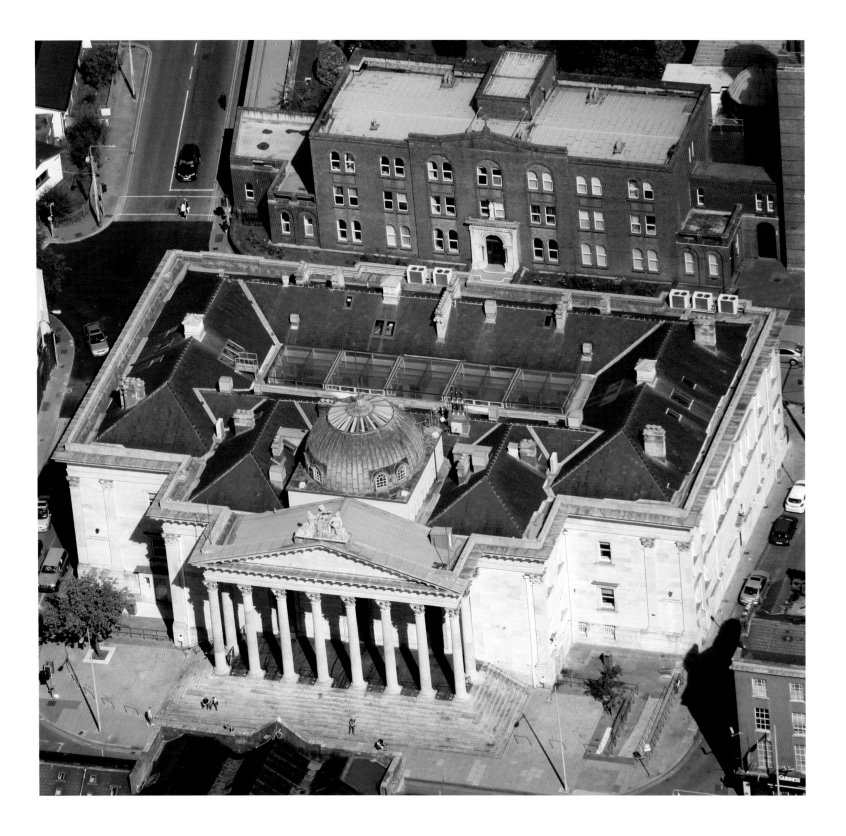

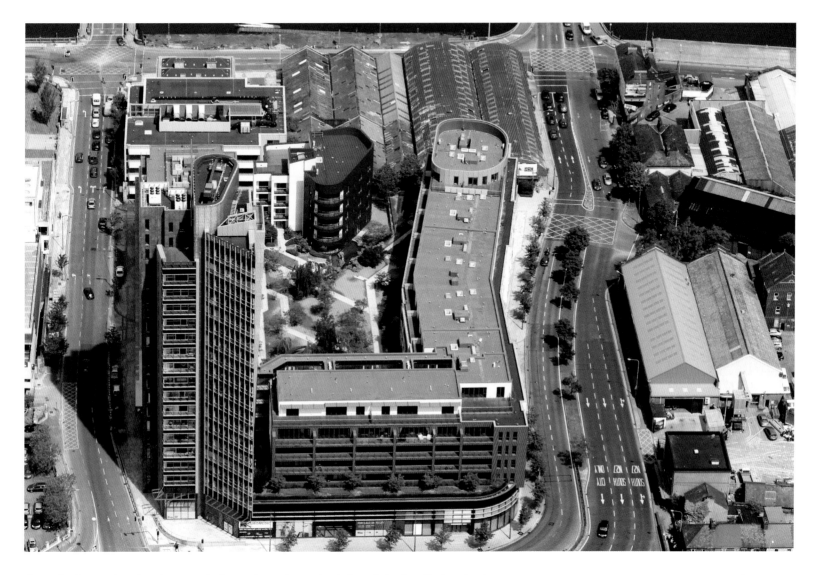

A city-centre development of apartments and retail outlets, the Elysian features a landmark 71-metre, 17-storey tower, the tallest building in Ireland.

Cork Courthouse was built in 1895. It is regarded as a superb example of neoclassical public architecture and one of the city's most important structures. The building was extensively refurbished and remodelled to coincide with Cork's selection as European City of Culture in 2005.

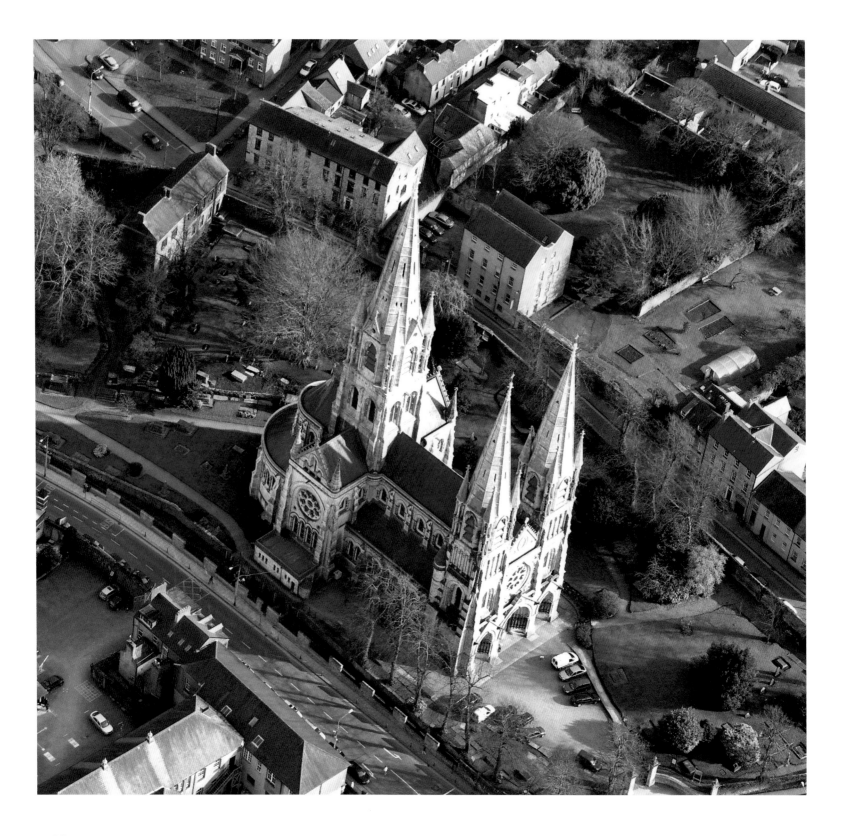

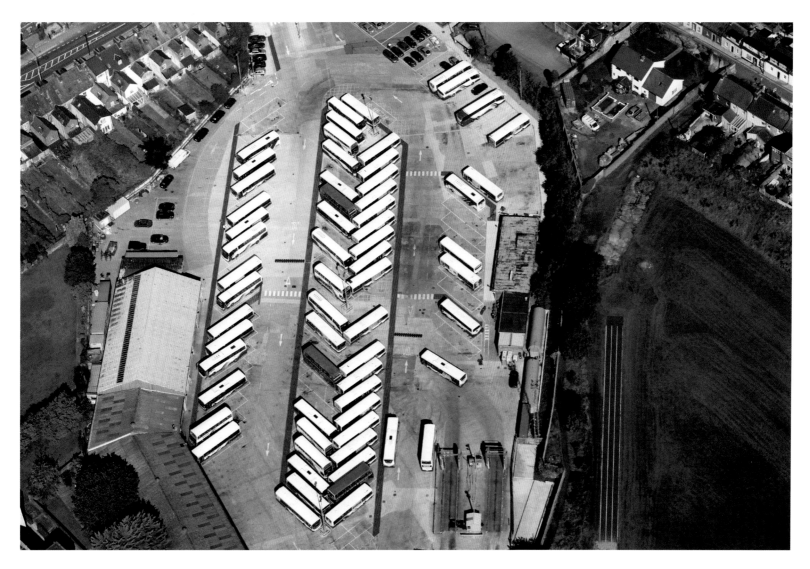

▲ Parked buses take on the appearance of toys in this view of
the Cork city's principal bus depot.

◀ Saint Fin Barre's Cathedral. This imposing Gothic-style cathedral
is built of Cork limestone and was completed in 1870. The
building is widely regarded as the finest example of its kind in
the western world.

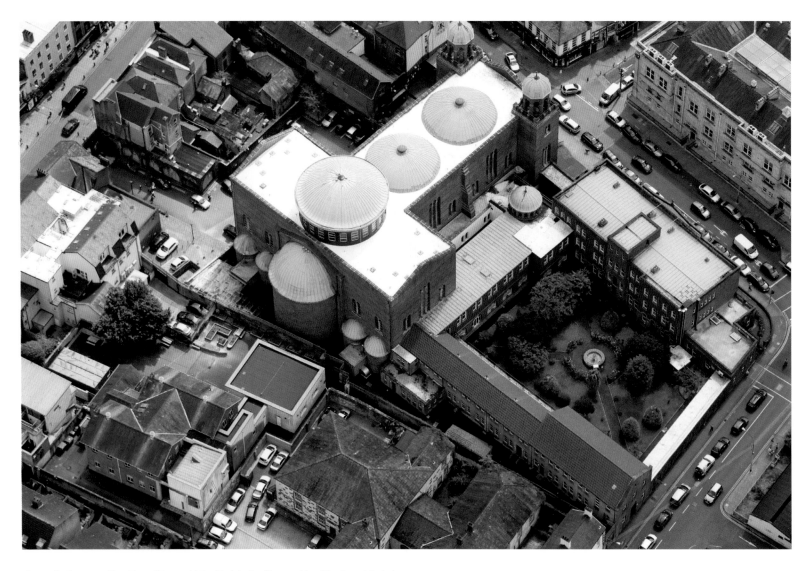

Between Grattan St and North Main St, and built of red brick in the Byzantine style, the Church of St Francis opened in 1953. The copper domes are a striking feature of the building and a small garden is visible in the centre of the structure.

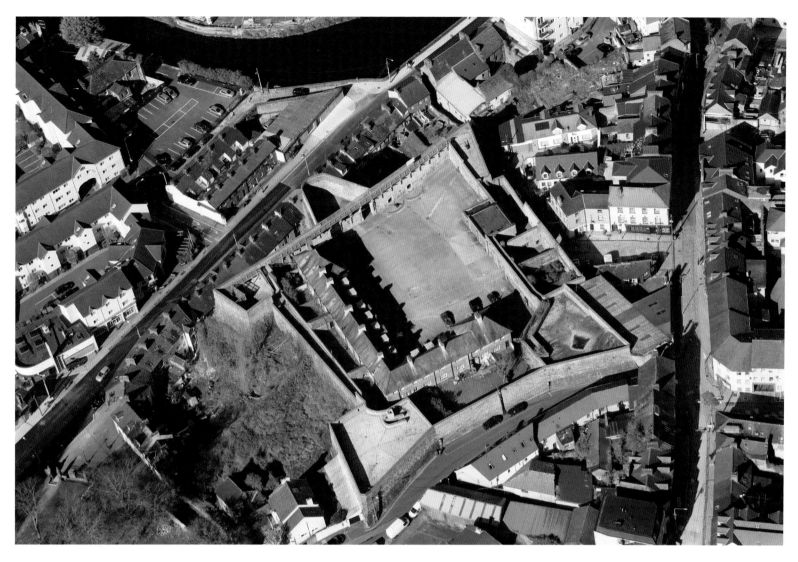

Elizabeth Fort, Barrack St. Built in 1690 this fine example
of a star fort continues to stand guard over the southern
approach to what was once the medieval walled city of Cork.

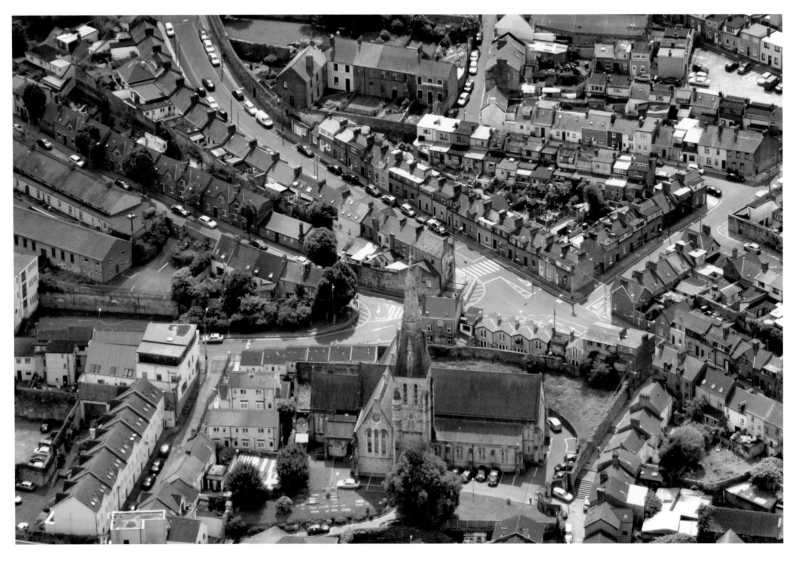

▲ Built in 1850 in the Gothic Revival style, St Nicholas' church was deconsecrated in recent times.

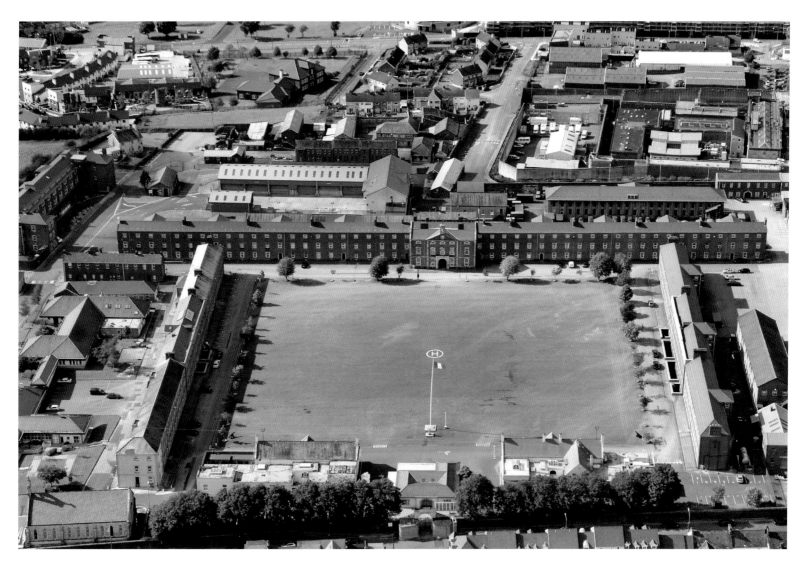

Garrison for the Southern Command of the Irish Defence Forces and visited by the late US President John F. Kennedy in 1963, Collins Barracks has the distinction of having the largest enclosed parade square in Europe.

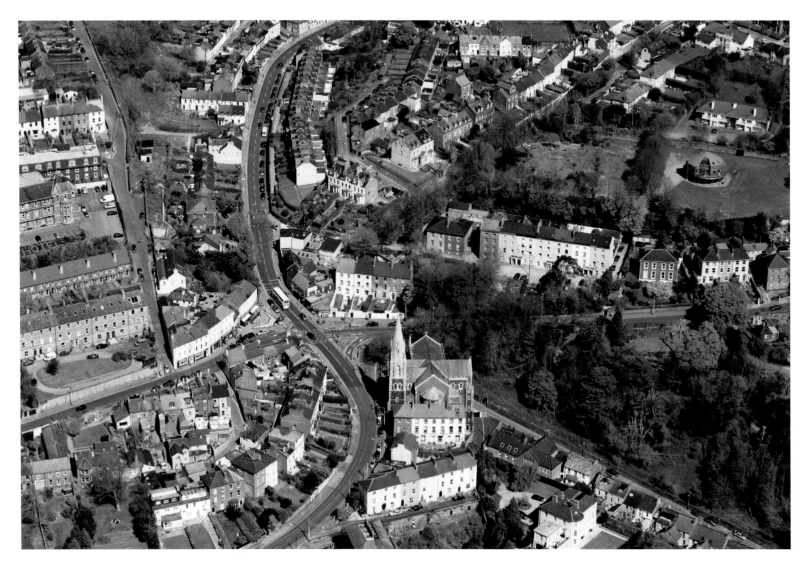

St Luke's Cross: an important crossroads since medieval times, a toll booth originally stood on the site. St Luke's was built in 1889 but has since been deconsecrated and now serves as a cultural centre.

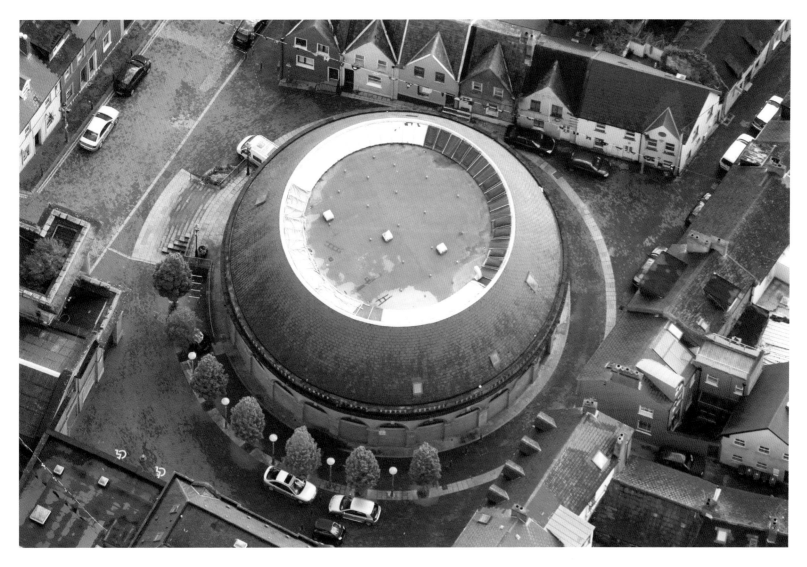

The Firkin Crane. This distinctively shaped circular building formed part of the original Butter Market in the mid-1850s. It is now home to contemporary dance in Cork.

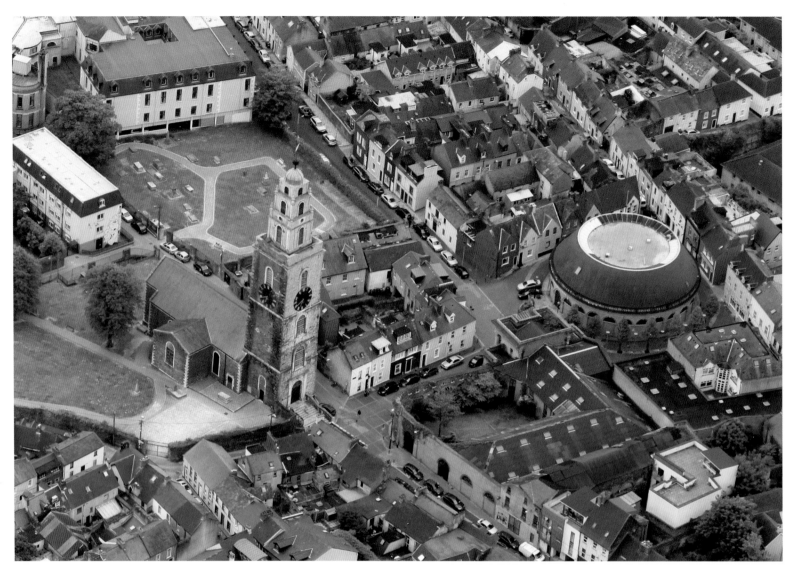

The Church of St Anne at Shandon and Firkin Crane.

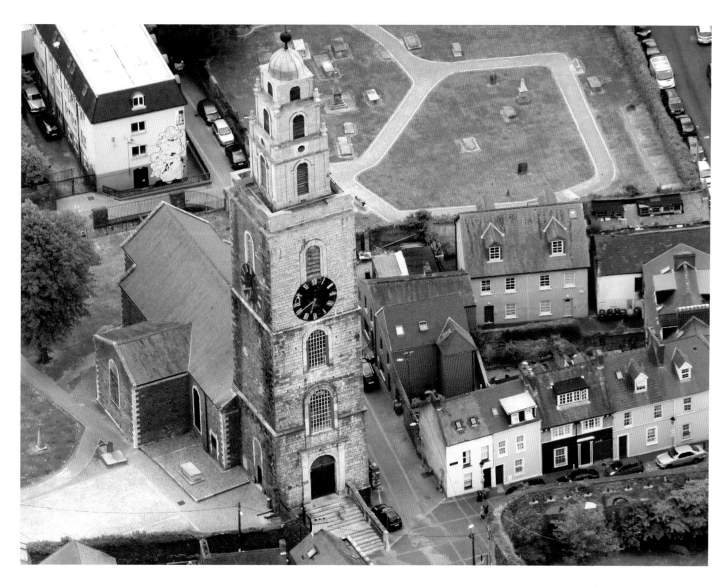

Built of red sandstone and limestone with its four-faced clock referred to locally as 'The Four-Faced Liar', Shandon Church – St Anne's – is without doubt Cork's best-known landmark, visible from most areas of the city.

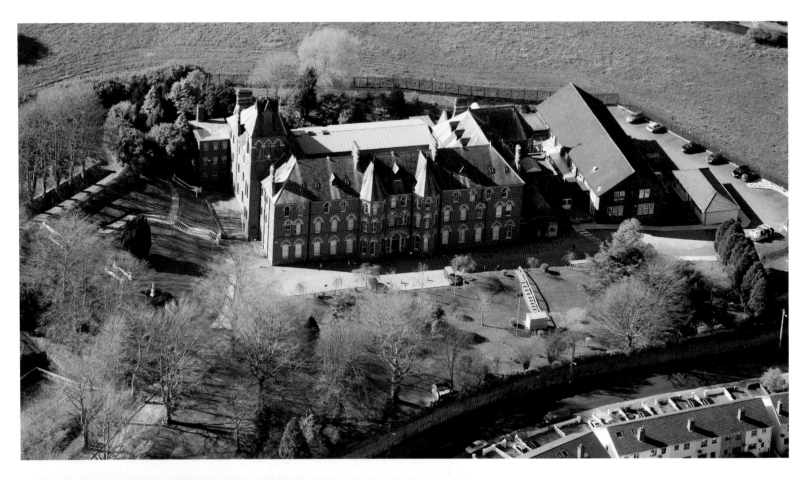

St Finbarr's Diocesan Seminary was established at Farranferris in 1887. Over the years it provided day and boarding school facilities. With a decline in vocations and falling enrolments, the school closed in 1997.

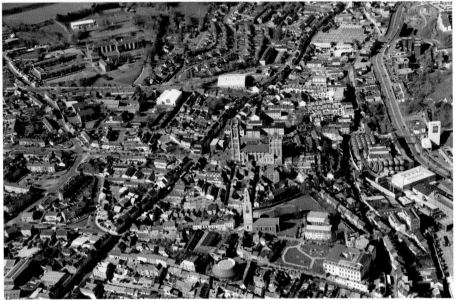

Cork's north side: looking north-west towards Blackpool and the route to Limerick.

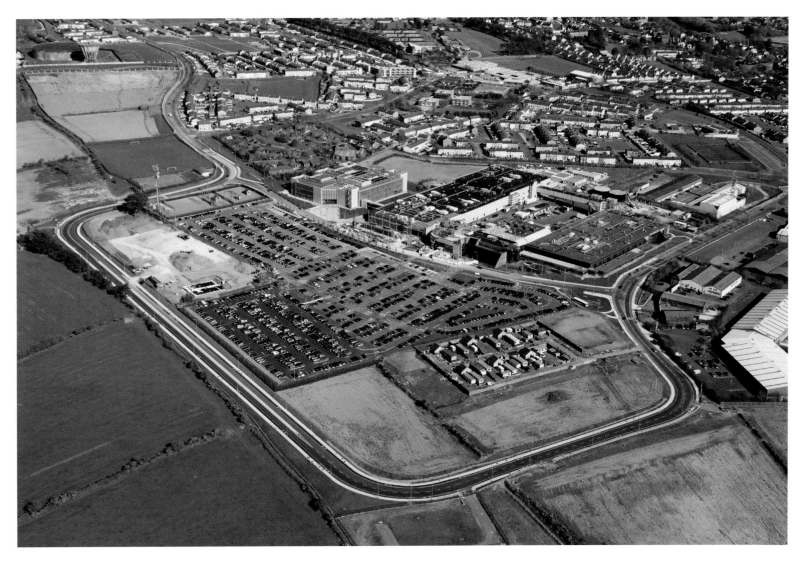

The Apple facility at Hollyhill, which opened in 1980, is the company's only facility outside the United States. Apple is a major contributor to the local economy and employs over 4,000 people in Cork.

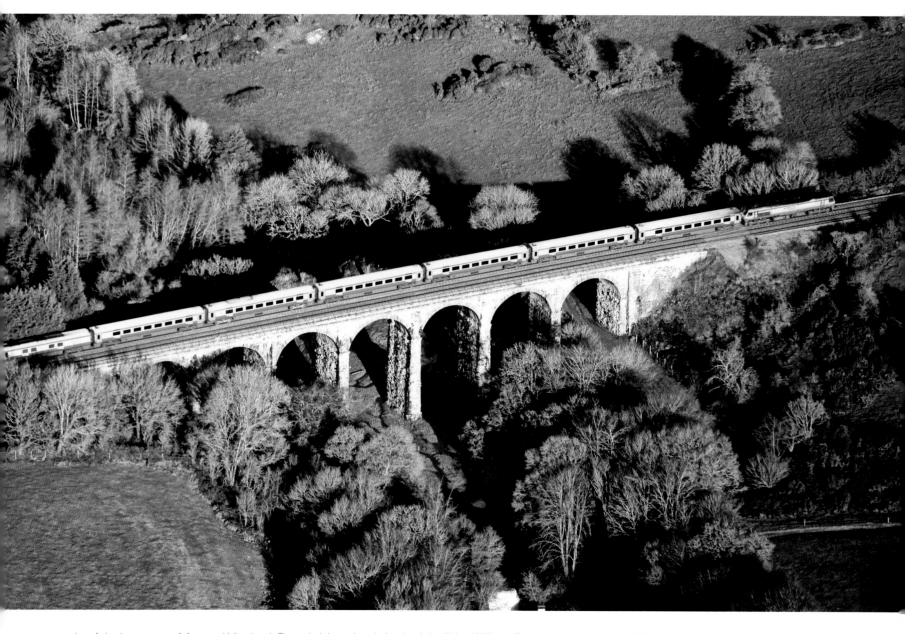

A train crosses Monard Viaduct. The eight-arched viaduct, built by William Dargan and opened in 1849, spans the Blarney River.

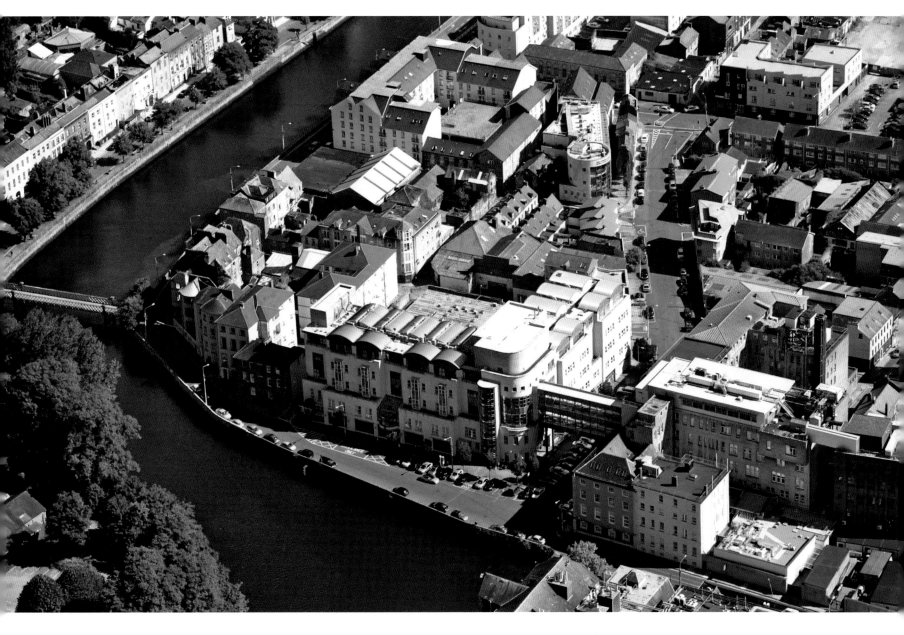

The Mercy Hospital was originally Cork's Mansion House. Built in the 18th century many of the features are still evident in the hospital today.

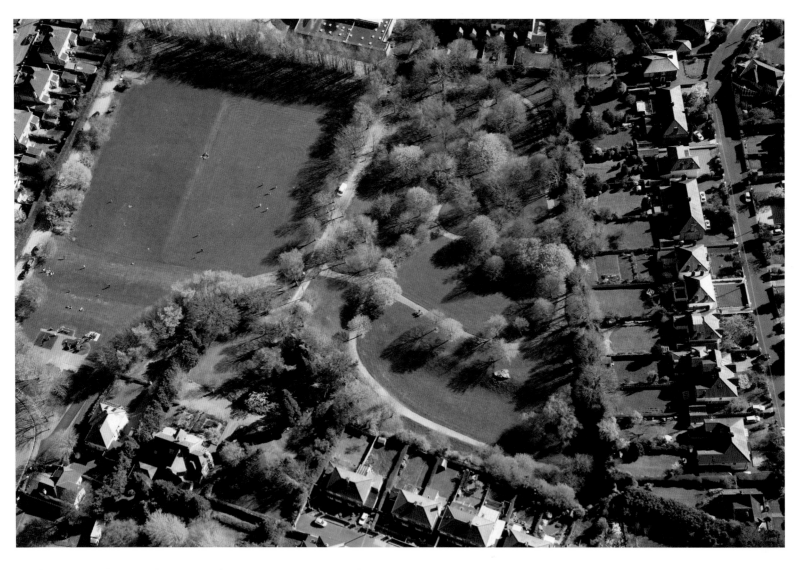

▲ Ballinlough Park: on the edge of the city, a quiet oasis of trees and parkland.

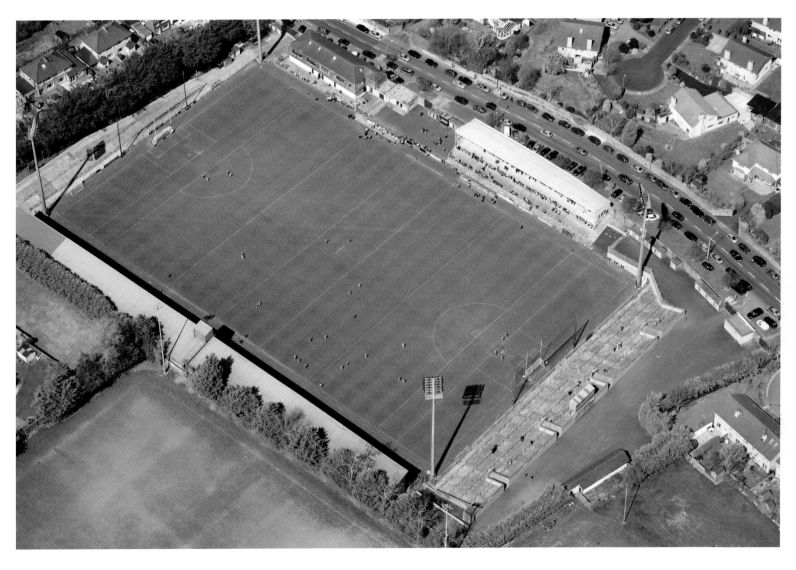

Formerly Flower Lodge soccer pitch, Páirc Uí Rinn was purchased by the GAA in 1993 and extensively modernised. It is named after legendary Cork hurler Christy Ring.

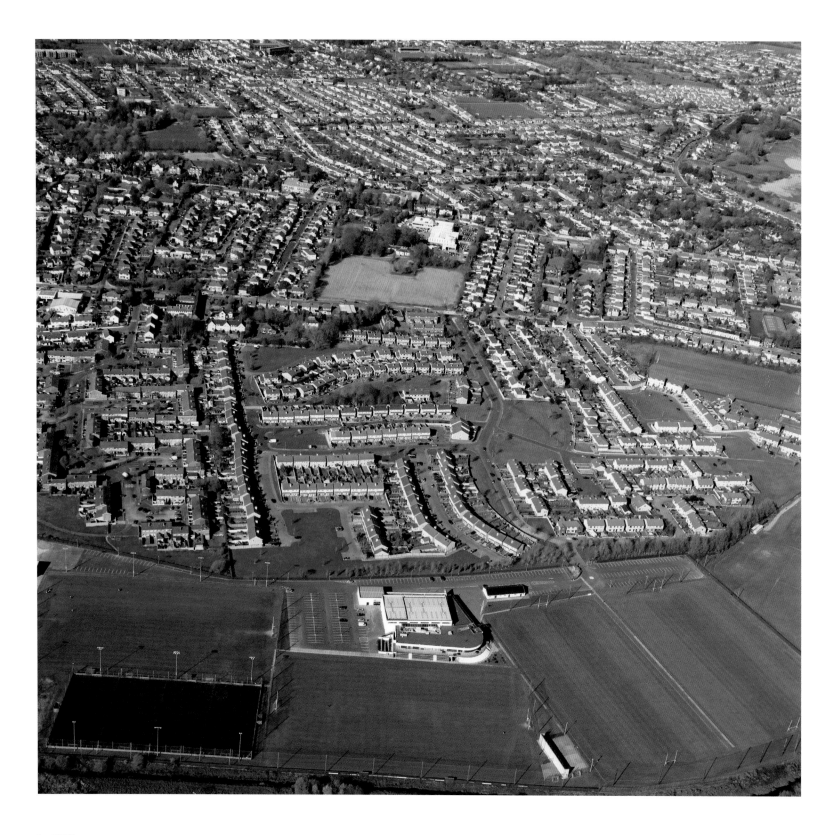

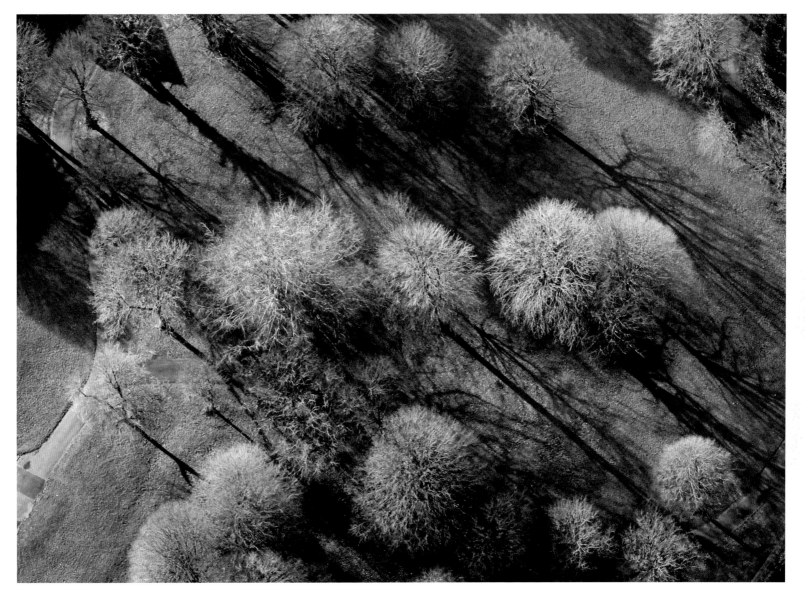

▲ Austere shadows contrast with the soft halo of early shoots on these trees in Blackrock on a February afternoon.

◄ Douglas on the south side of Cork city is a large thriving suburb. Nemo Rangers Hurling & Football club (foreground) has one of largest and most modern facilities in Ireland.

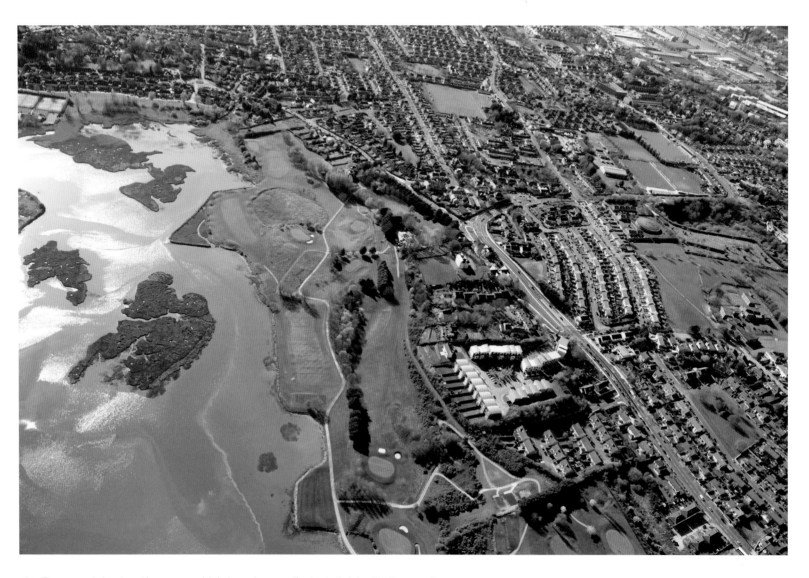

The municipal golf course at Mahon is a golfer's delight with its creative use of the estuary, trees, slopes and hollows.

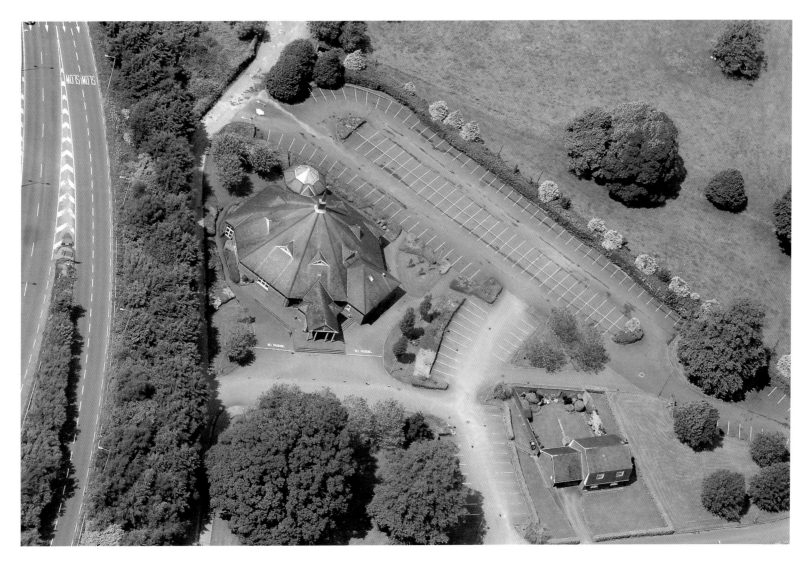

Situated just off the South Link Road, the redbrick St Patrick's Church is of modern design and incorporates a distinctive umbrella-like roof.

Garryduff Sports Club has its origins in the late ▽
19th century and is now one of the largest
multi-sports clubs in Ireland.

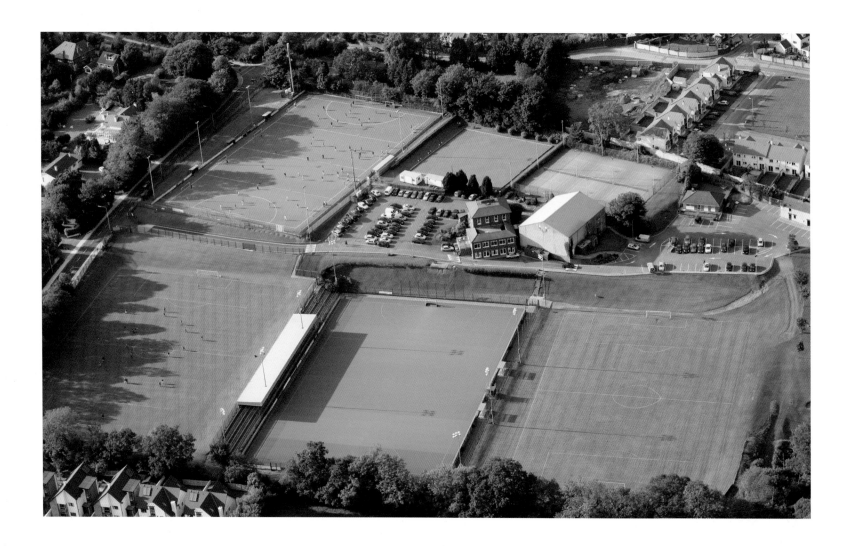

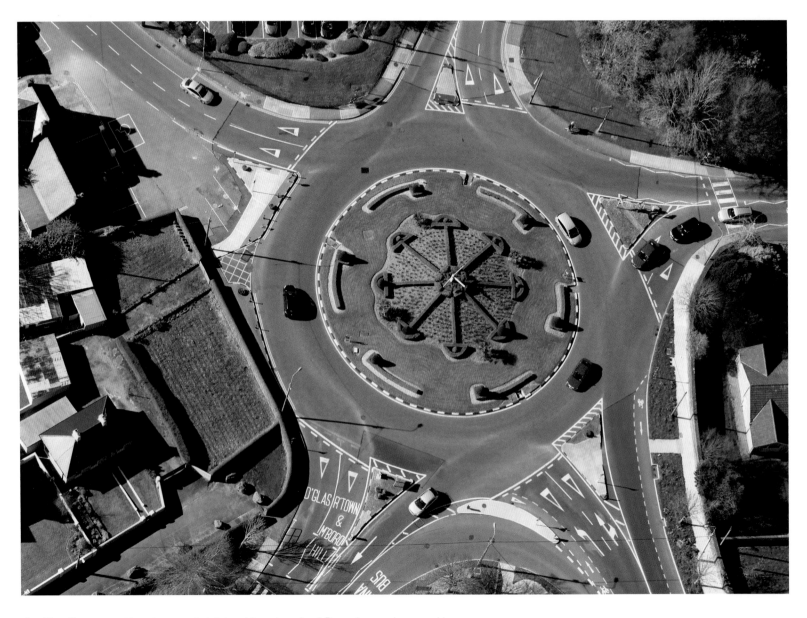

The Fingerpost is a long-established landmark at Douglas, enhanced by a colourful floral arrangement designed and maintained by local residents.

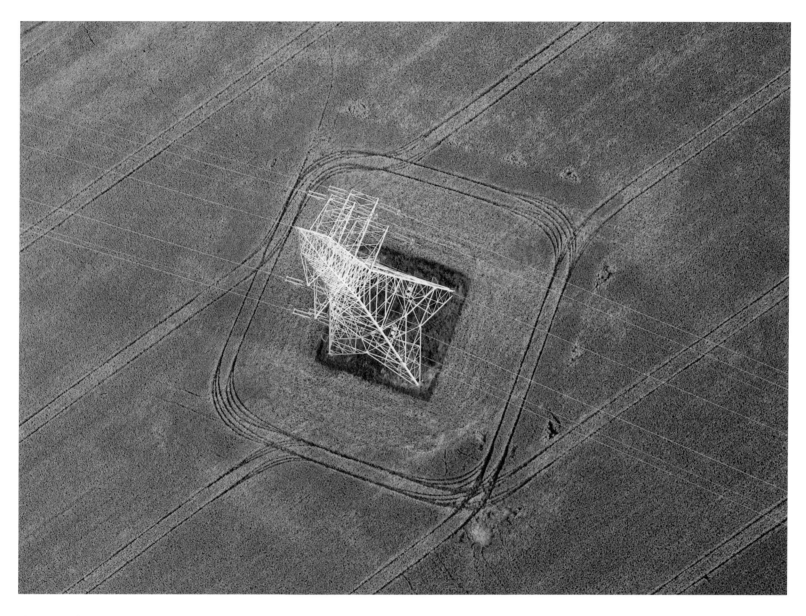

Near Carrigaline, a pylon towers over a field of barley. Pylons are evident all across the countryside and carry hundreds of miles of electric cables across vast stretches of farmland.

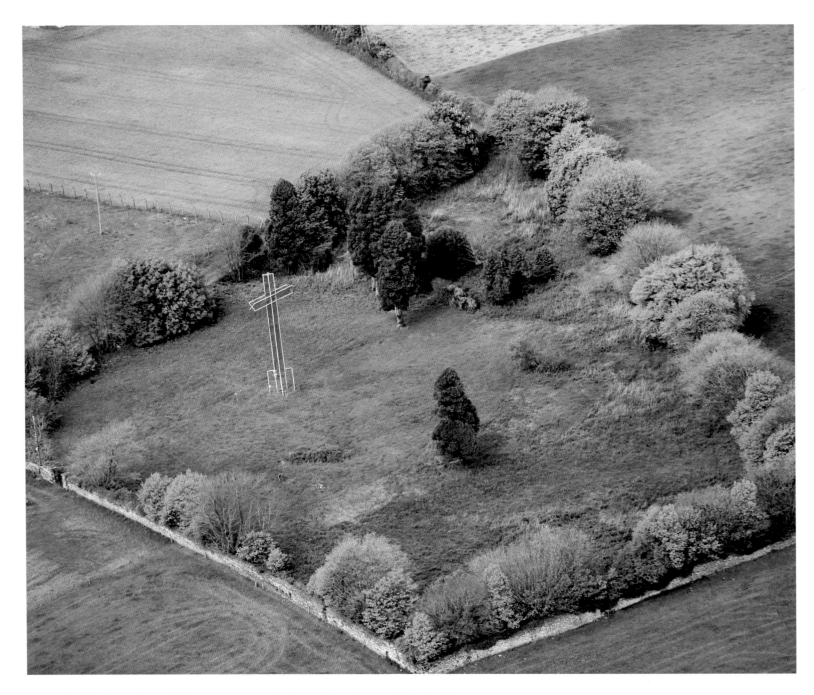

All Saints Cemetery at Moneygourney, between Douglas and Carrigaline, where many victims of the Great Famine were buried in unmarked graves. It closed in 1947 and in the early 1950s a Corkman called Olaf Sorensen erected a high metal cross to honour those interred there.

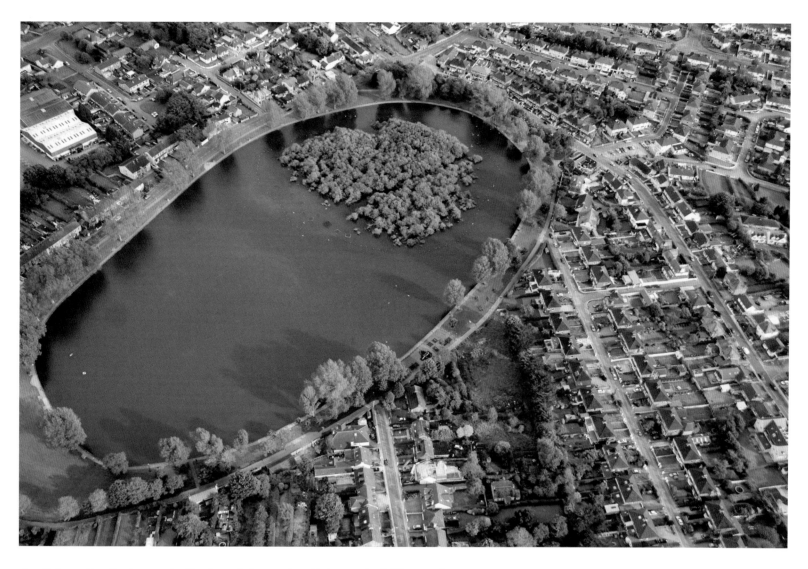

Beloved by Cork people, The Lough is a natural lake and wildlife sanctuary, home to many varieties of wildfowl. It is a favourite haunt for walkers.

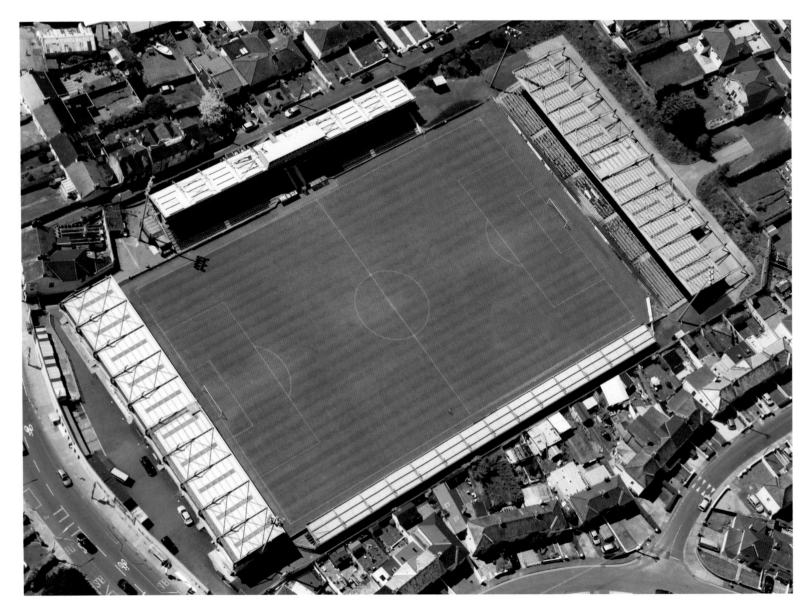

Turner's Cross Stadium, the home of soccer in Cork. Rugby and cricket were originally played here. In 1940 the Football Association of Ireland took over the grounds. Many famous international players, including George Best, have made appearances here over the years.

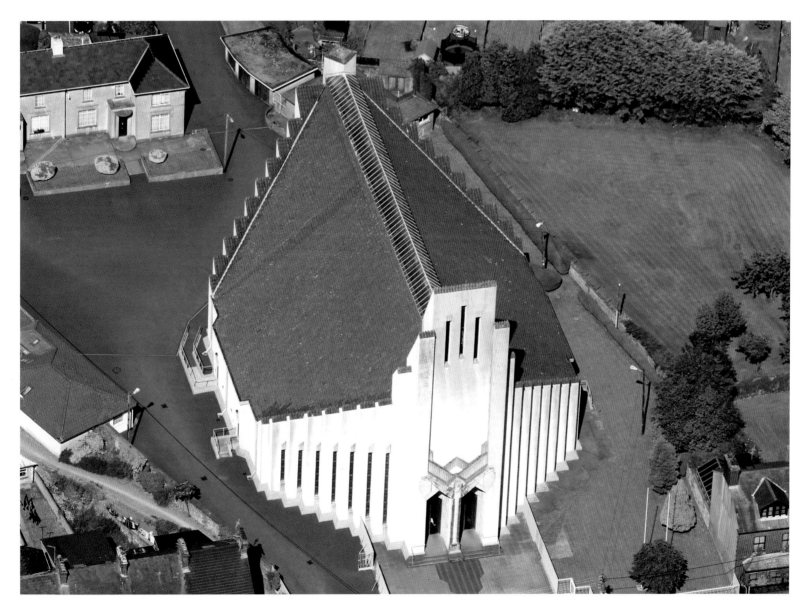

Completed in 1931 and designed by Chicago architect Barry Byrne, the Church of Christ the King at Turner's Cross was a radical departure from traditional ecclesiastical architecture. It is the largest suspended-ceiling church in Europe and the first to be built of concrete.

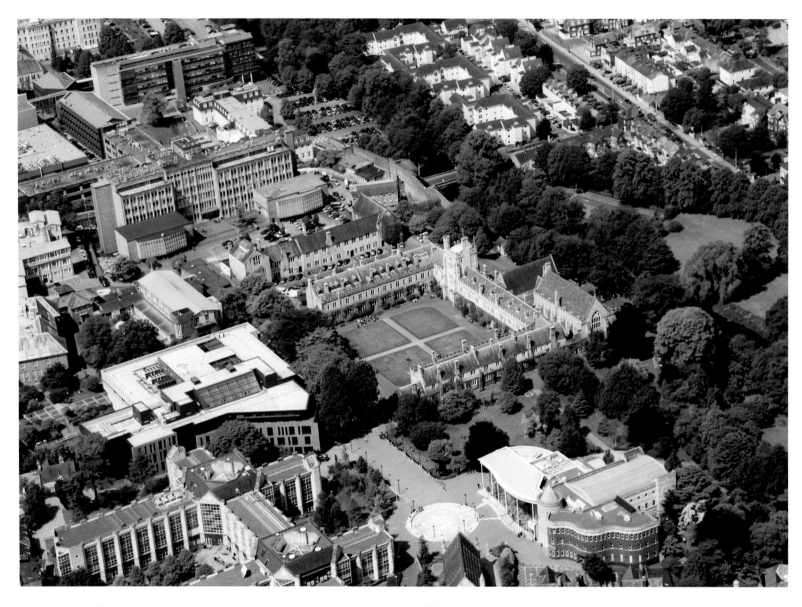

Queen's College, Cork – now University College Cork – opened in 1849 and today has over 15,000 students spread over a large campus area. George Boole, who developed algebraic logic, was the College's first professor of mathematics.

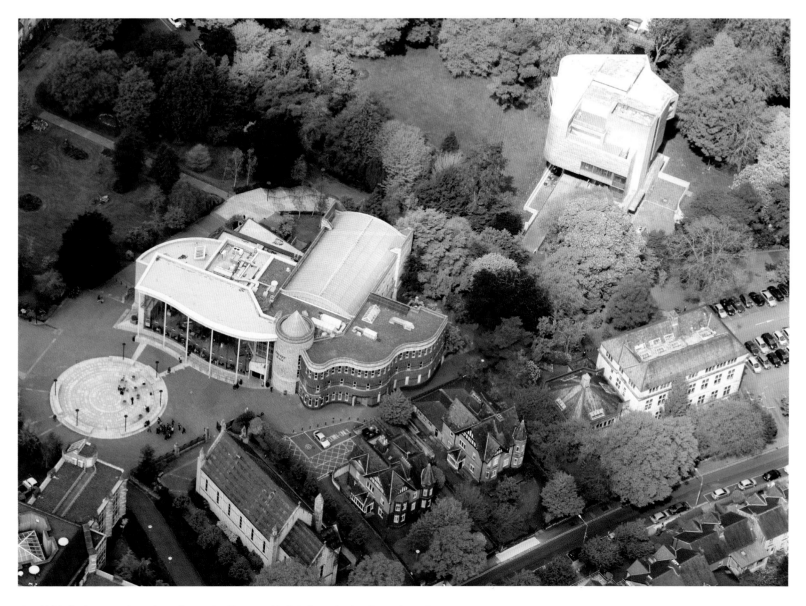

With its impressive glass facade, Devere Hall is the student centre of University College Cork. The adjacent Lewis Glucksman Gallery is an award-winning art gallery in the College grounds.

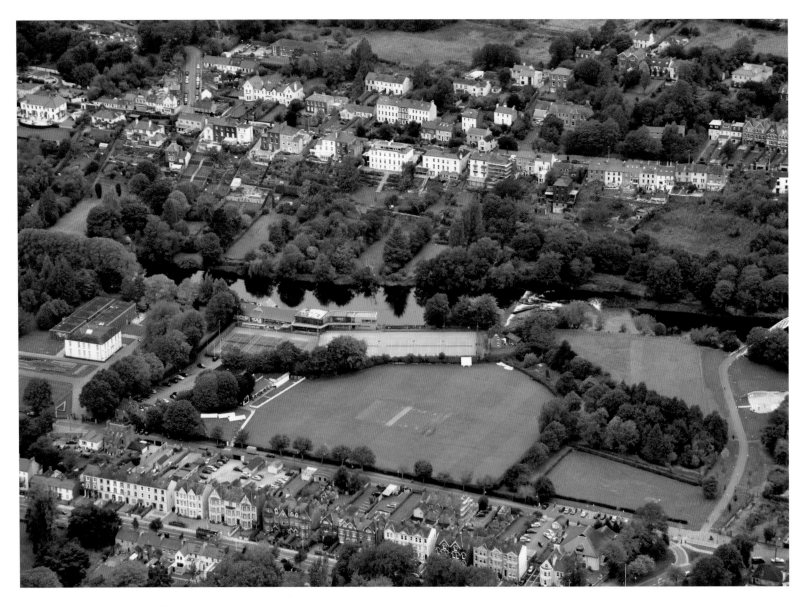

On the banks of the River Lee, the Mardyke has been home to Cork County Cricket Club since its foundation in 1874. The grounds have hosted several important international matches.

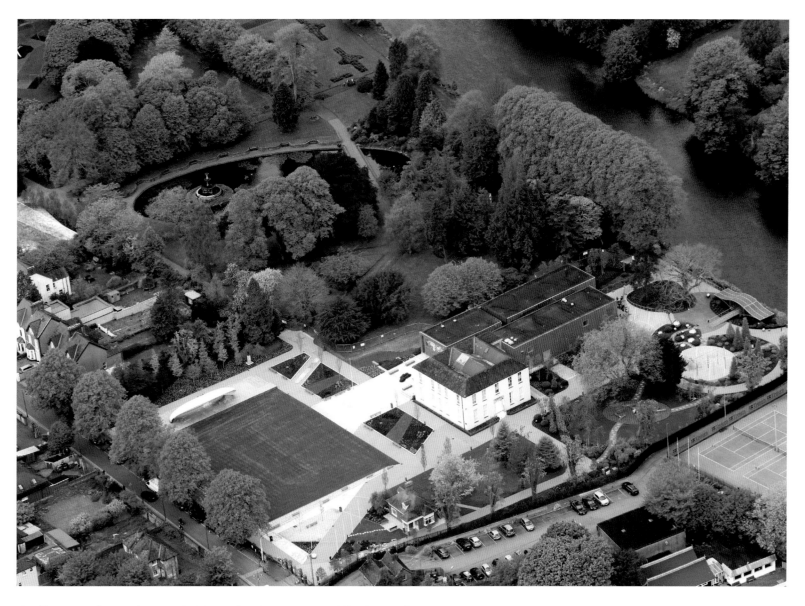

For years Corkonians and visitors alike have enjoyed the tranquil atmosphere of Fitzgerald Park on the banks of the River Lee, close to the city centre. It has been upgraded in stunning fashion and now features a public performance area and an award-winning Chelsea Flower Show garden, Diarmuid Gavin's Sky Garden.

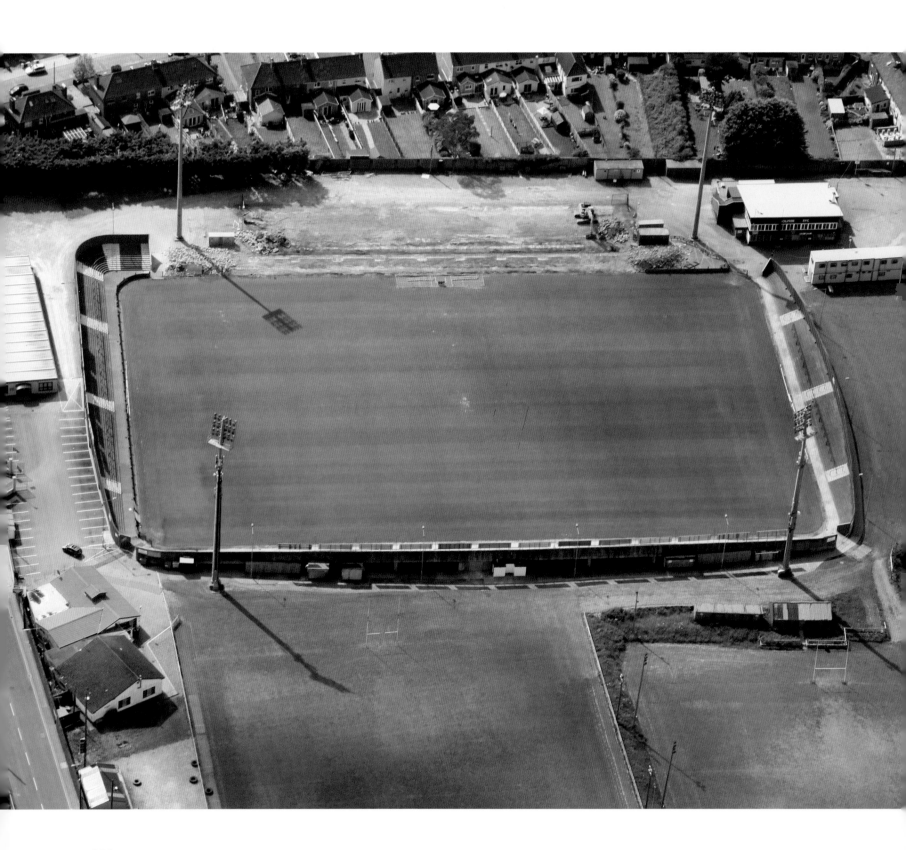

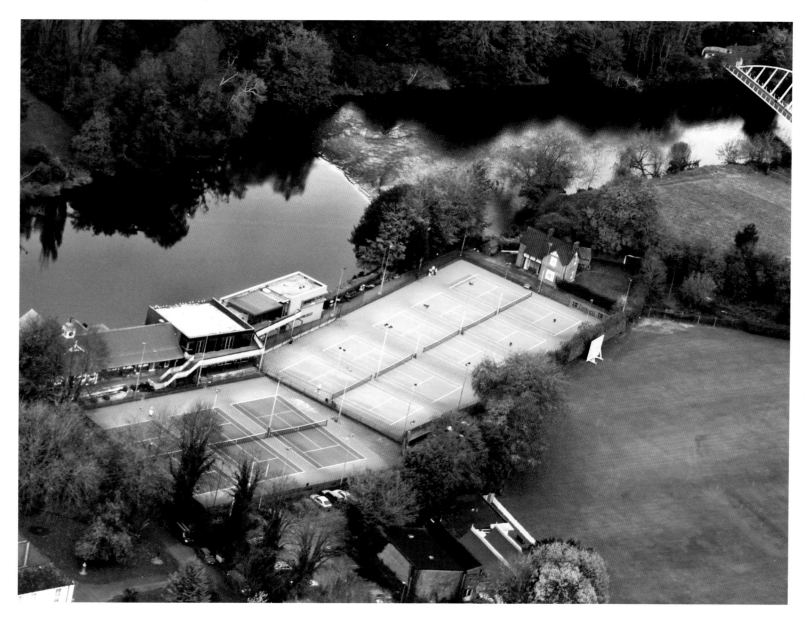

Sundays Well Boating and Tennis Club is one of Cork's oldest sporting clubs. Founded in 1899, it enjoys a tranquil riverside setting.

Irish Independent Park (formerly Musgrave Park), is home to Munster Rugby in Cork and also Dolphin & Sundays Well Clubs.

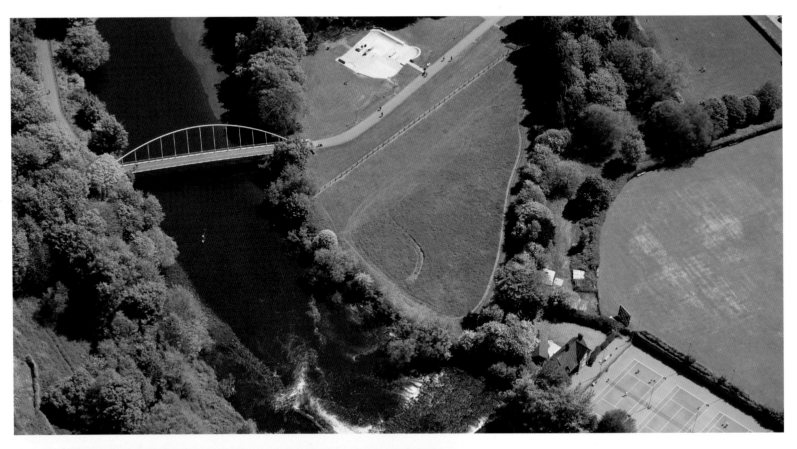

The Mardyke has been enhanced in recent times by the addition of a pedestrian bridge and walkway.

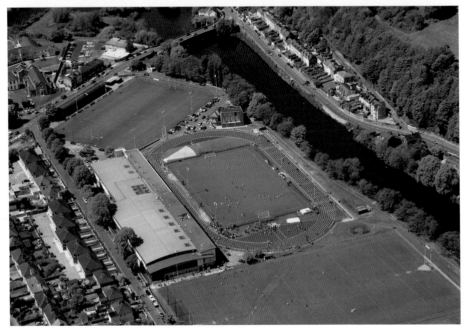

The University College Cork athletics track at the Mardyke. This state-of-the-art facility hosts a variety of athletic event throughout the season.

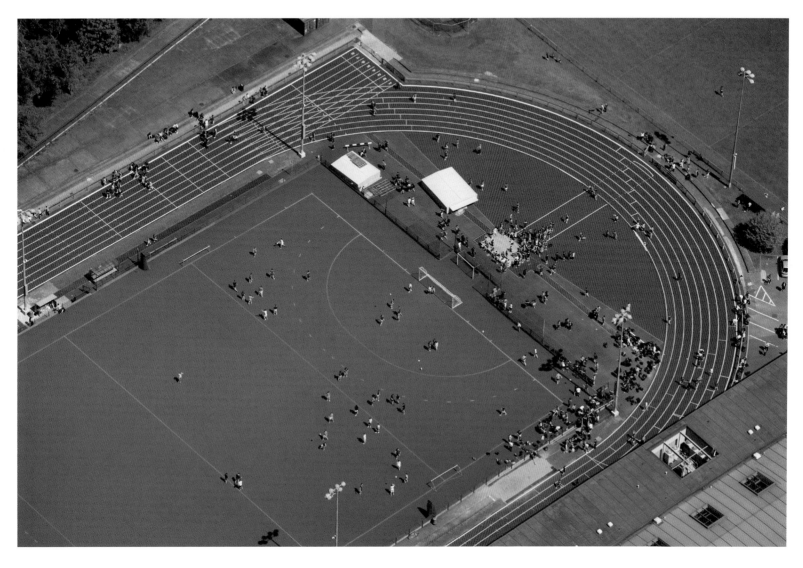

Athletes competing in a summer meeting at the Mardyke arena.

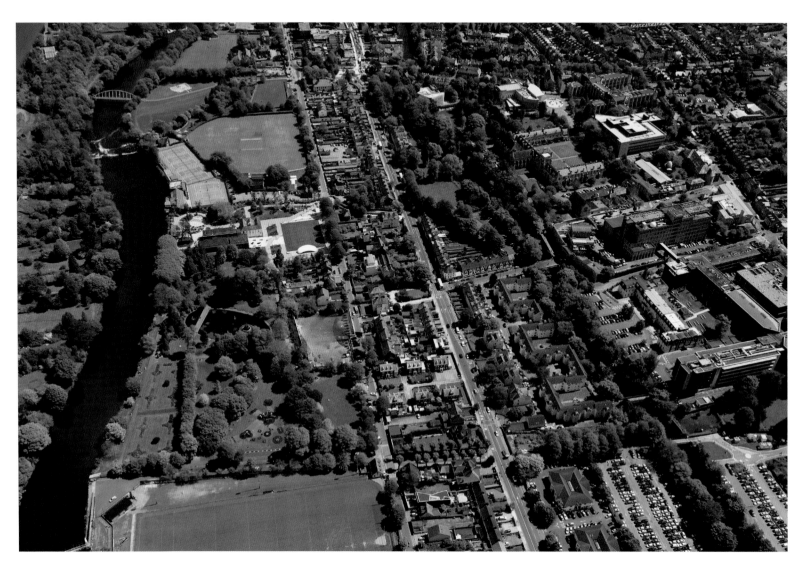

The Mardyke. A dyke topped by a promenade was built here in 1719 by the then City Clerk Edward Webber. The area became fashionable and the promenade was dubbed 'Meer Dyke Walk' after the Meer Dyke in Amsterdam.

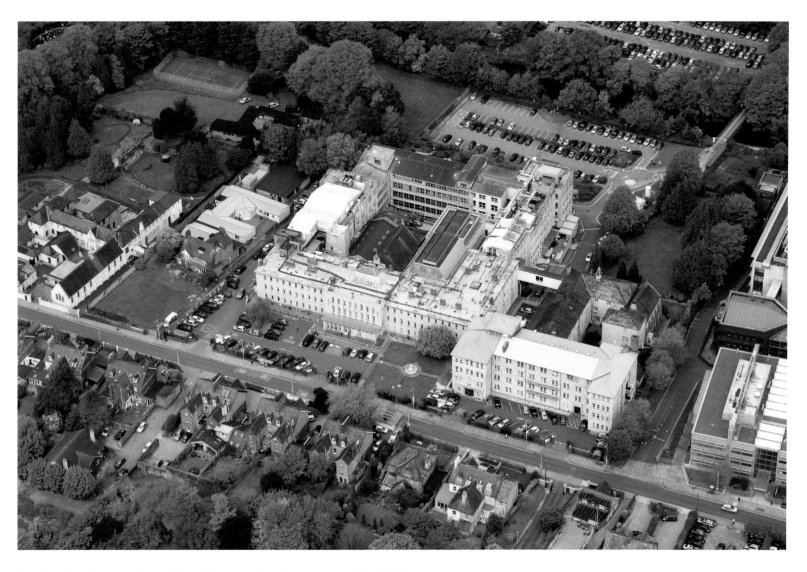

The Bon Secours Hospital on College Road was opened in 1915 and is owned by the Bon Secours Sisters.

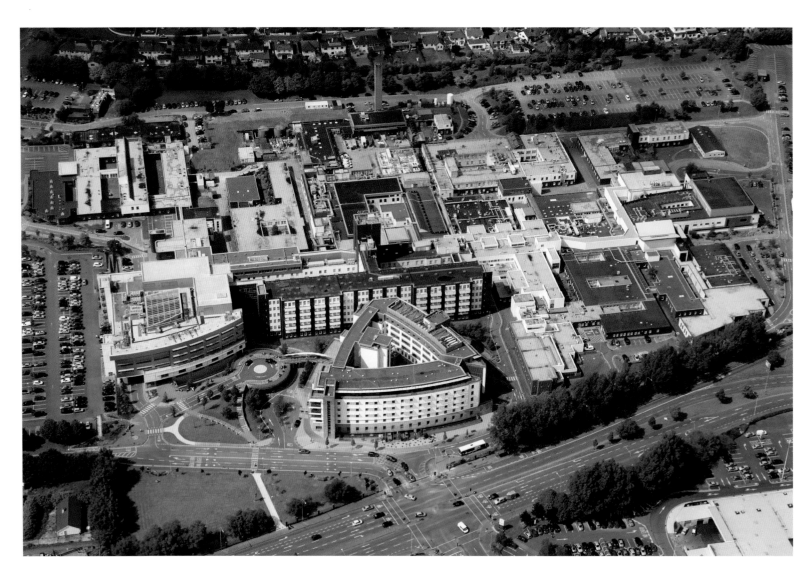

Cork University Hospital opened in 1978 and is now the country's largest university teaching hospital and primarily serves the counties of Cork and Kerry, which have a combined total population of over 630,000.

Brookfield Medical and Health Sciences Campus is part of University College Cork and home of the Faculty of Medicine. It is built around the old Brookfield House (the cream-coloured building in the centre of the structure).

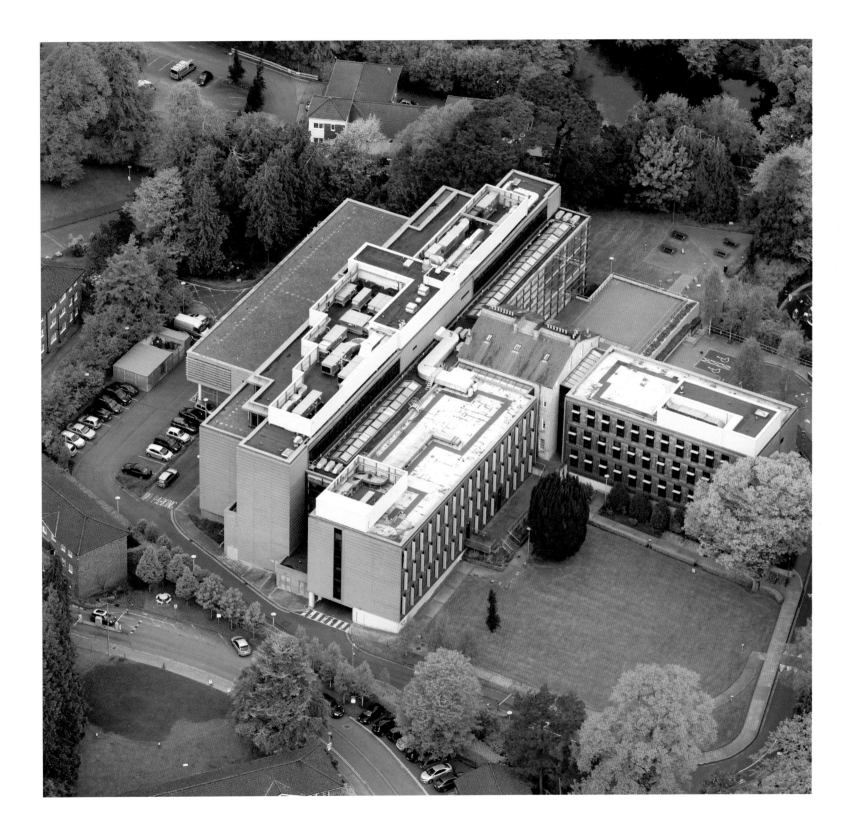

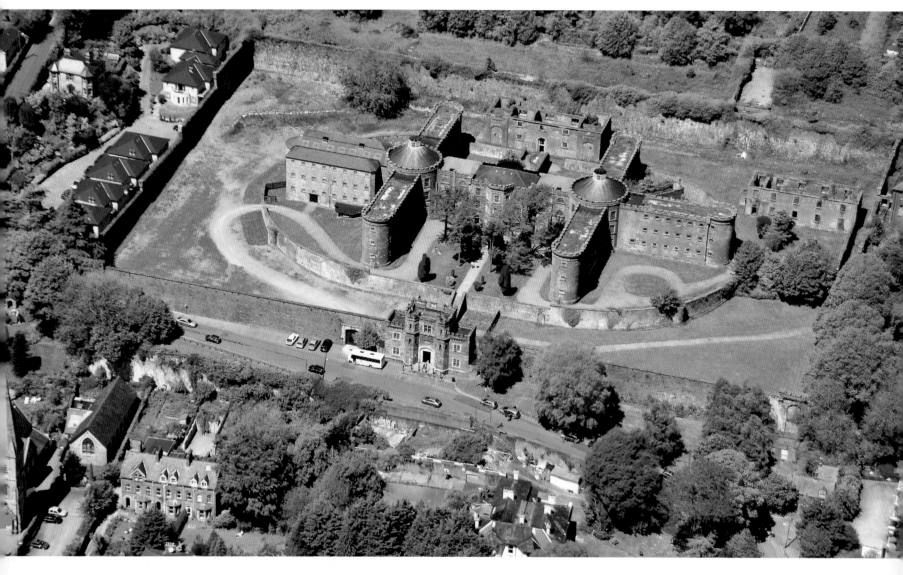

Surrounded by high sandstone walls and standing on a hilly
site overlooking Sundays Well, Cork City Gaol opened in 1824
and closed in 1923. It is now an important heritage centre
and radio museum.

Cork Institute of Technology (CIT) is located on a large campus
in the western suburbs of the city. CIT opened its doors in 1973
and now has 17,000 full- and part- time students.

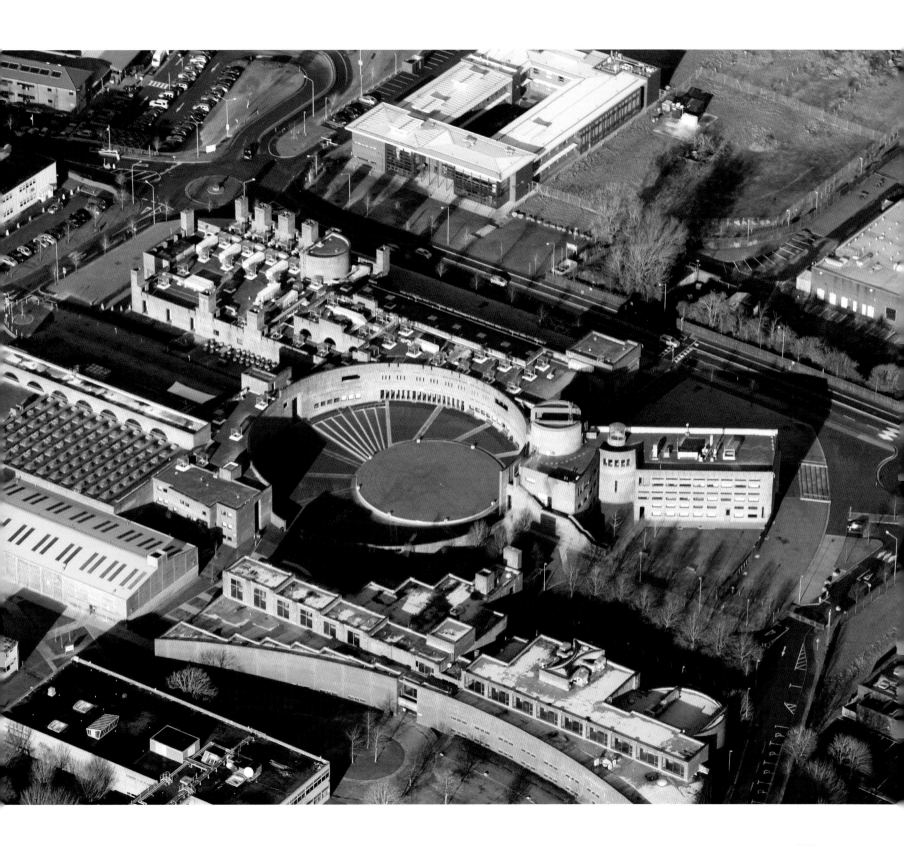

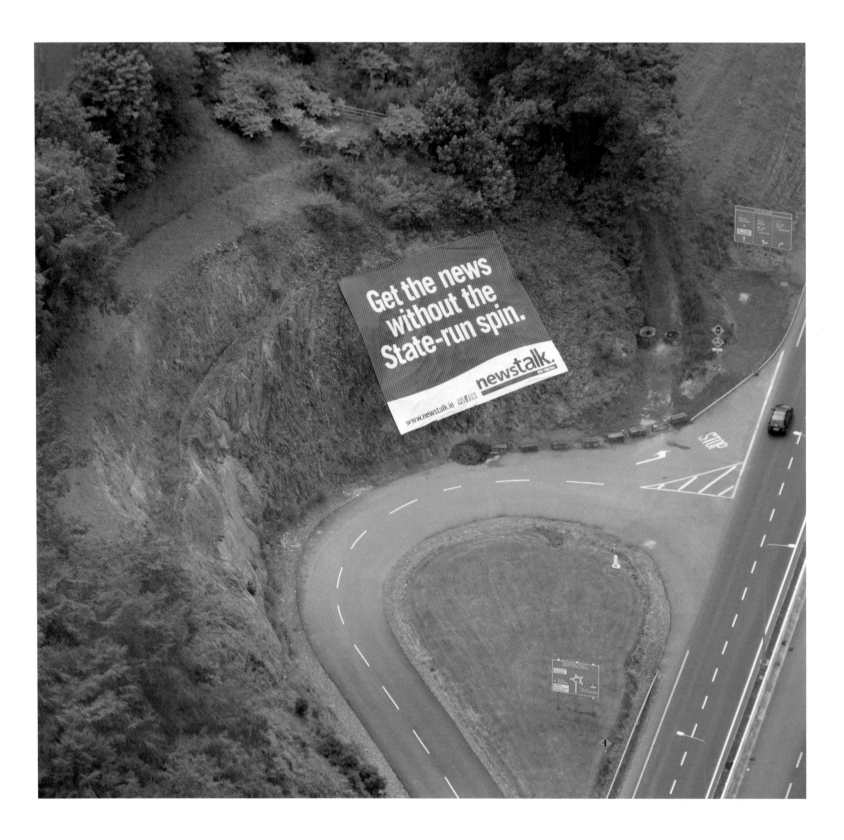

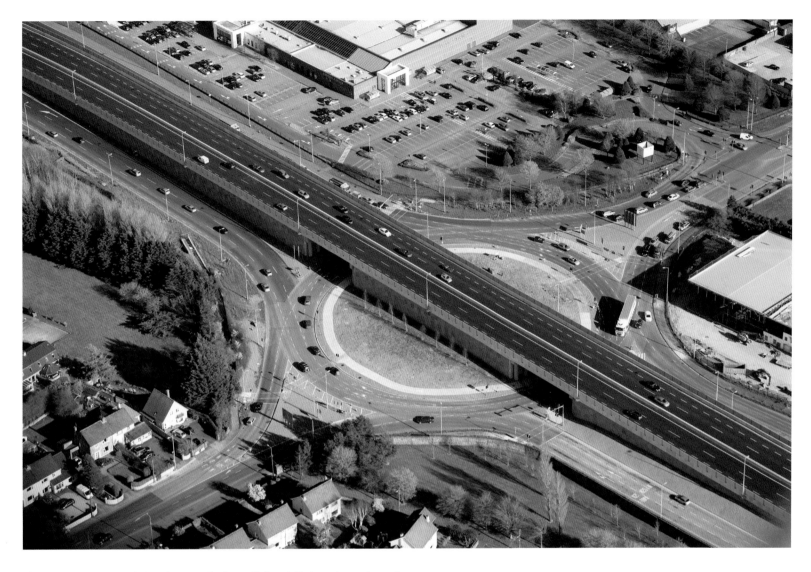

An important interchange in the city's orbital route system, the Bandon Road Roundabout carries large volumes of traffic and is linked directly to the Jack Lynch Tunnel.

Innovative advertising on the South Link Road.

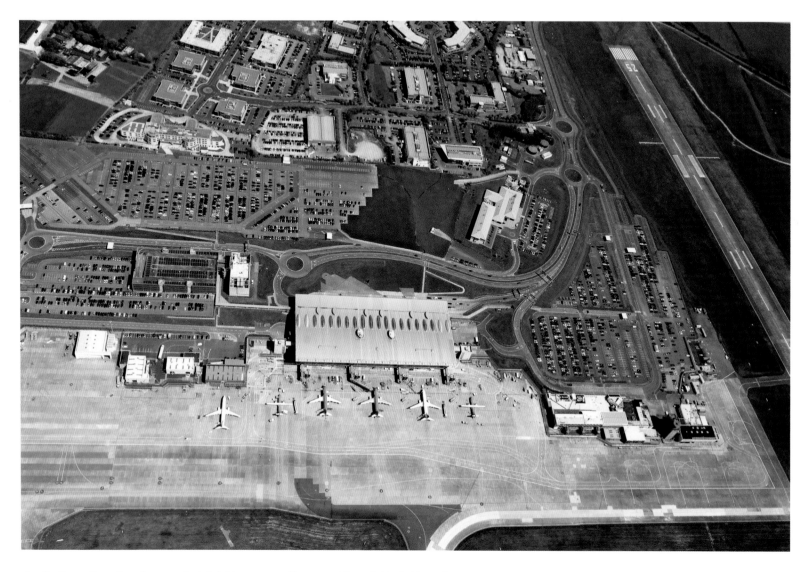

Built on the site of a small airfield known as 'Farmers Cross', Cork Airport became operational in 1961 and a large business park was developed in recent years. The new terminal was opened in 2006. Cork is the busiest airport in Ireland outside Dublin and has more than 50 destinations to Britain and the European mainland.

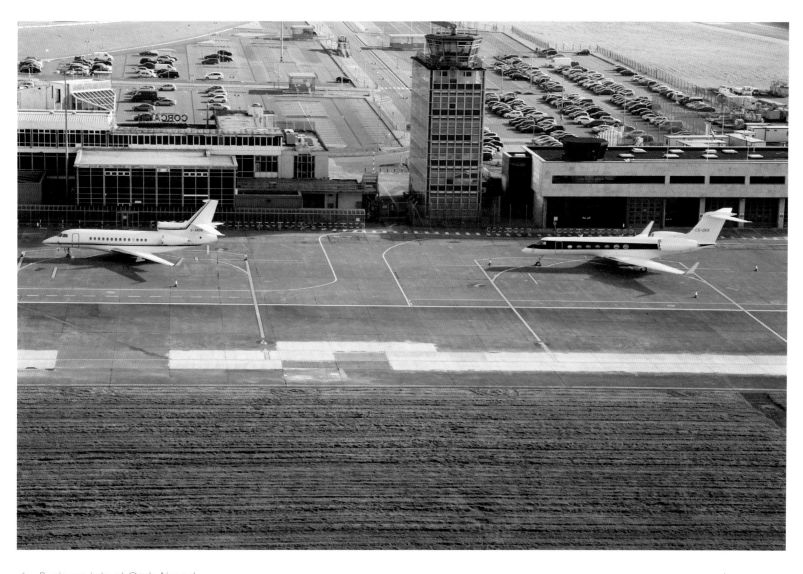

▲ Business jets at Cork Airport.

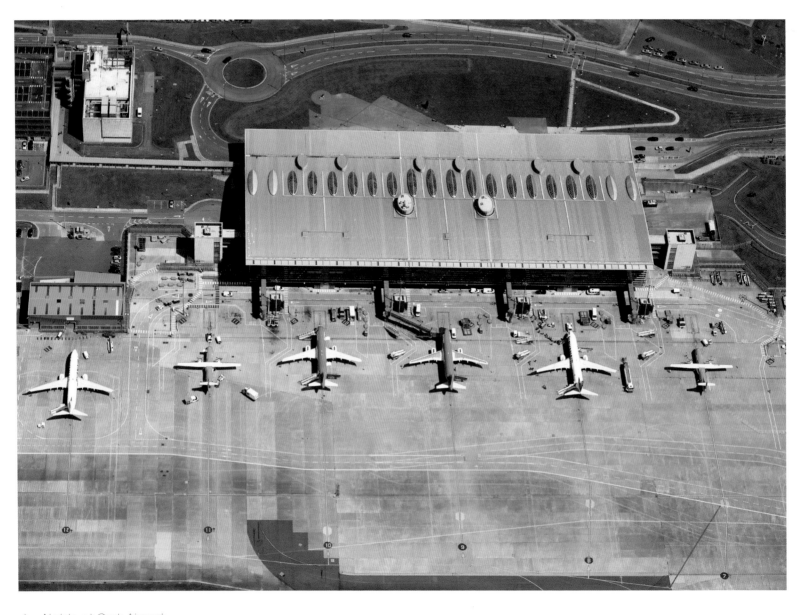

Airside at Cork Airport.

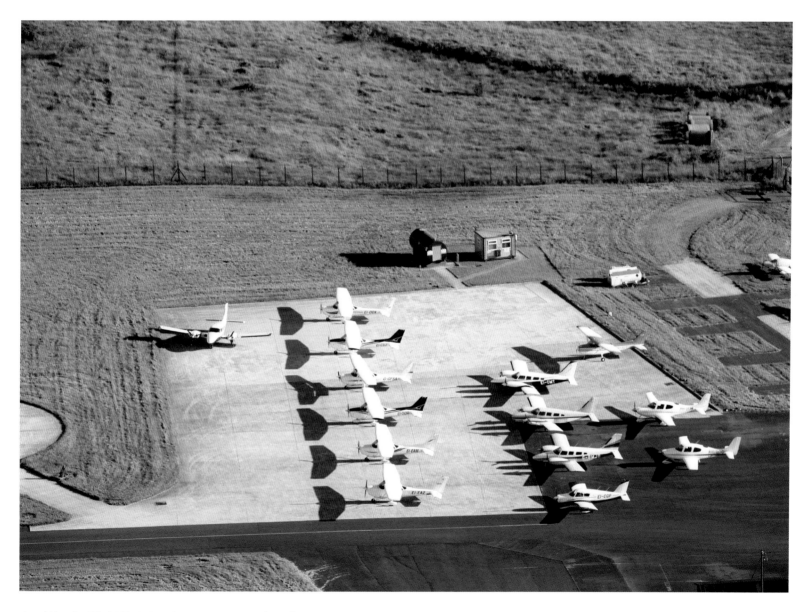

Atlantic Flight Training Academy aircraft at Cork Airport. The Academy trains commercial pilots for some of the world's leading airlines as well as providing other aviation services.

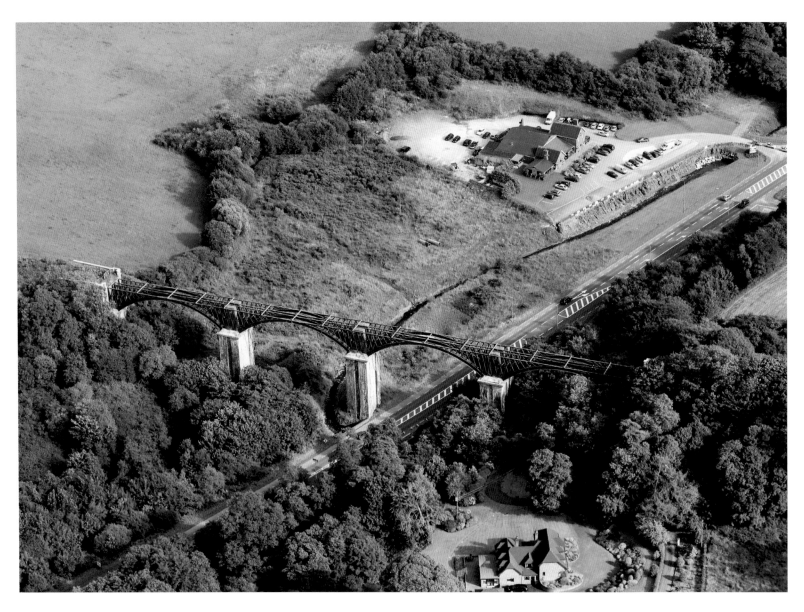

▲ Opened in 1850, the 28-metre-high Chetwynd Viaduct carried a railway line over the main Cork–Bandon Road and was designed by Charles Nixon, a former pupil of Isambard Kingdom Brunel. It closed in 1961.

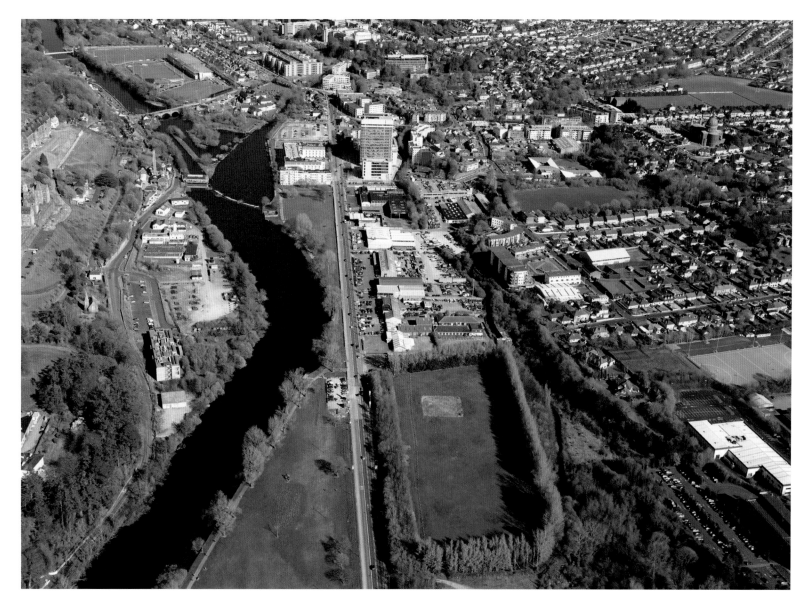

Known as the 'Straight Road', this section of road linking the edge of the city with Carrigrohane is 4.5km long and was laid down in 1931. The road has been used for speed trials involving both motorcycles and cars.

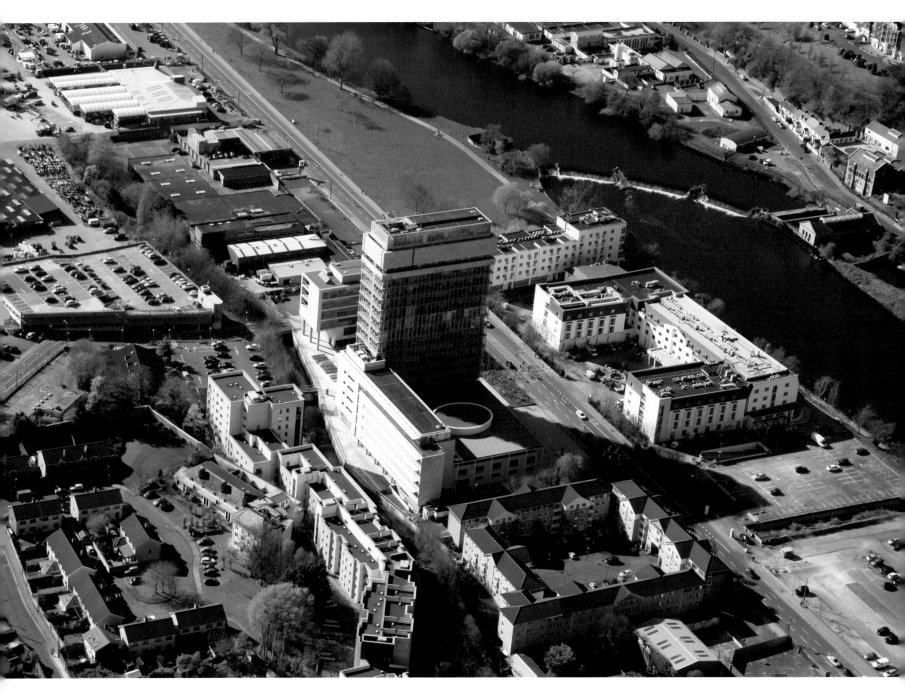

▲ The County Hall is a 17-storey office block which houses the administrative offices of Cork County Council. At 64 metres in height, it is the second tallest building in Ireland.

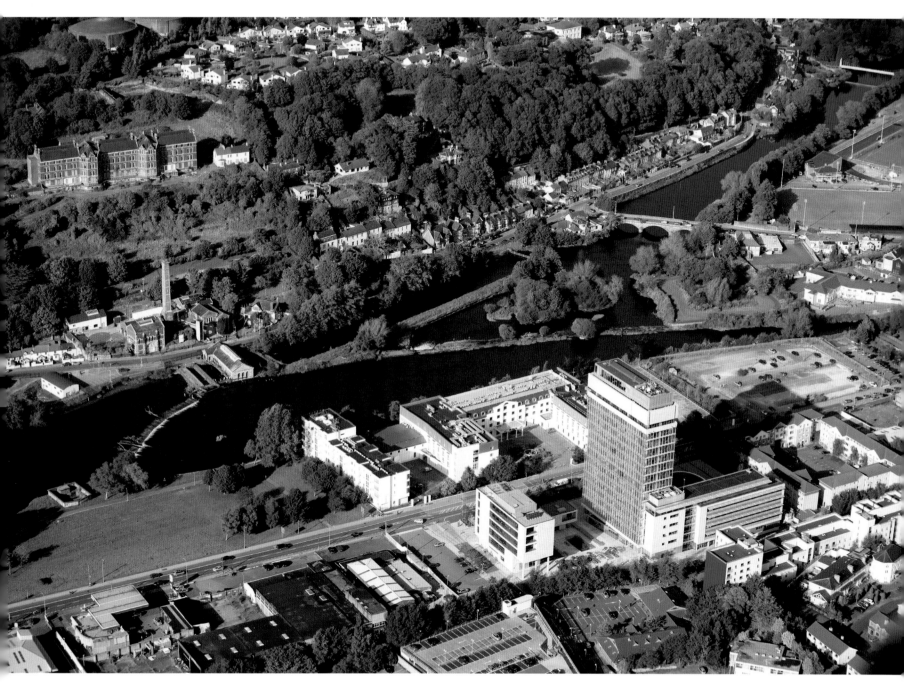

The Lee Fields are one of Cork's favourite recreational areas, bounded by the River Lee to the north and the Carrigrohane Straight Road to the south.

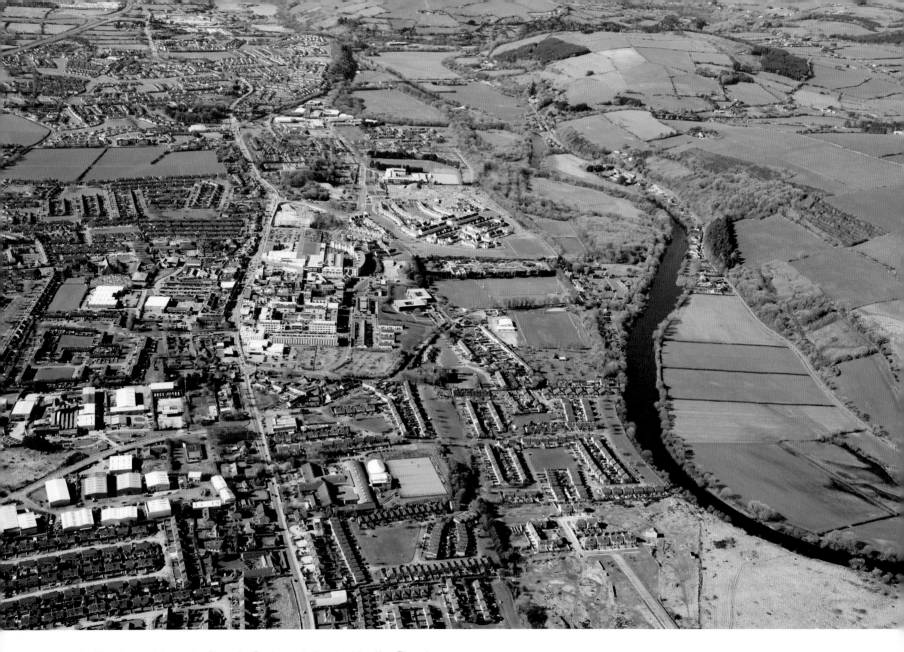

The largest town in County Cork and situated by the River Lee, Ballincollig has expanded dramatically in recent years with the redevelopment of the town centre.

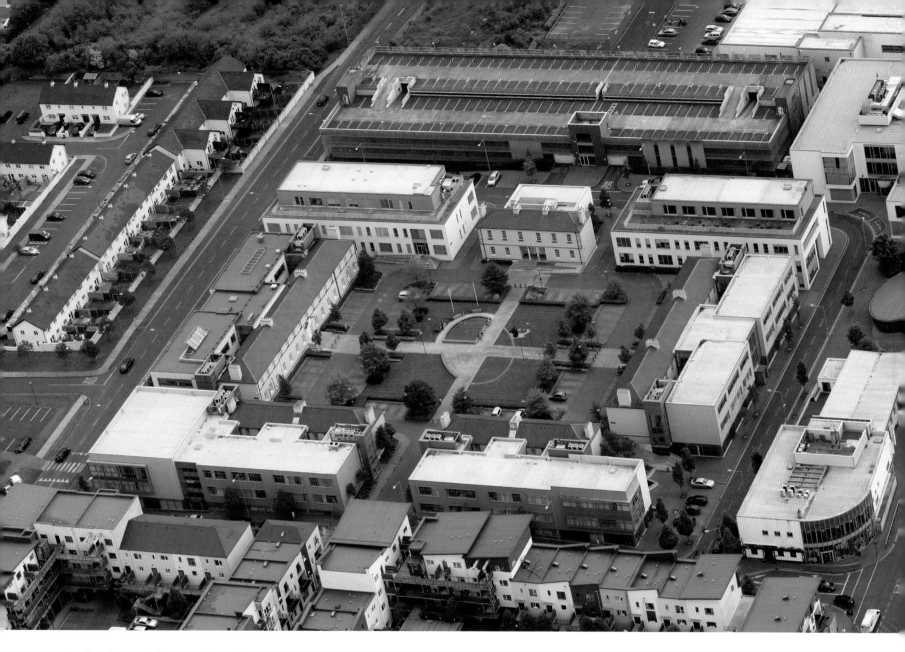

The Barrack Square of the former Murphy Barracks has now been redeveloped as an office campus. The former buildings are preserved and have been complemented by the addition of modern buildings.

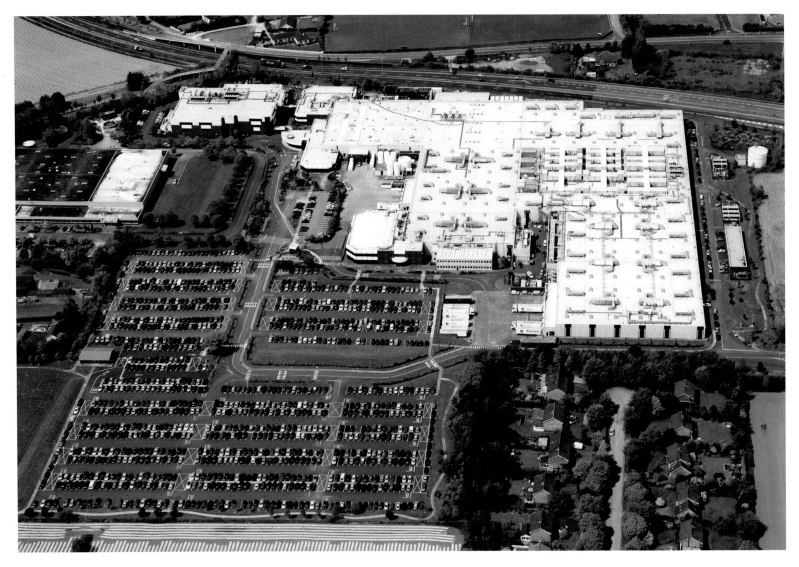

EMC established a plant in Cork in 1988 and is the company's largest facility outside North America. Over 2,500 people work in Cork, making the company one of the city's major employers.

Kilcrea Abbey (also known as Kilcrea Friary) dates back to 1465 and a graveyard is situated within the ruins. Restoration works on the building were undertaken in recent times by the Office of Public Works.

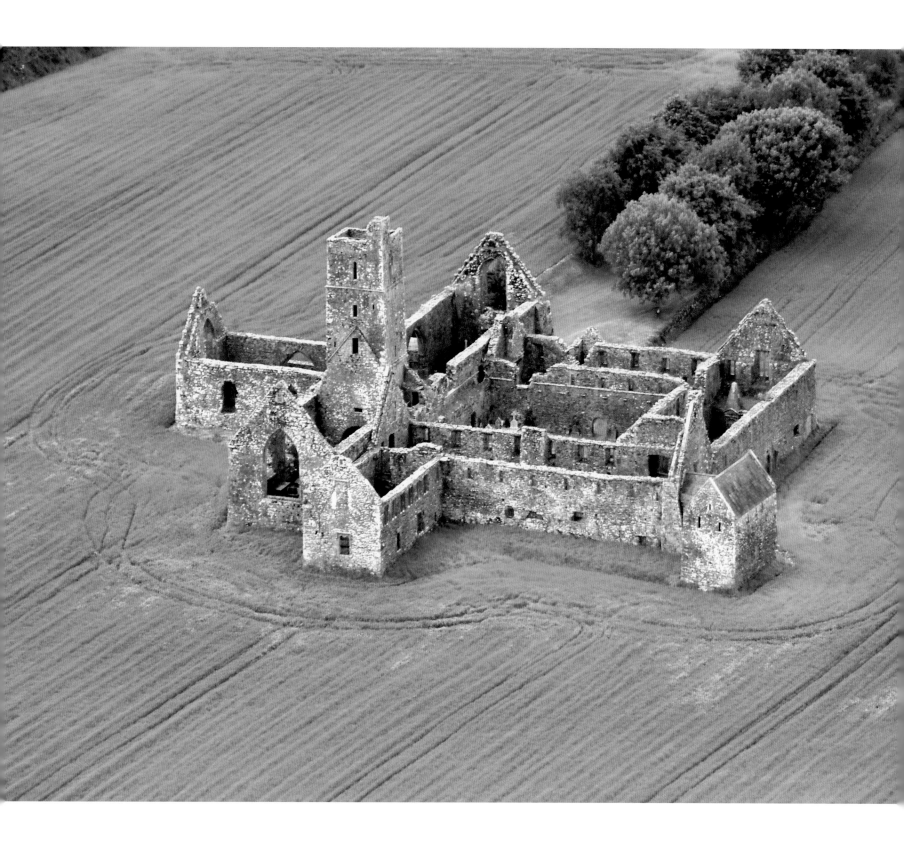

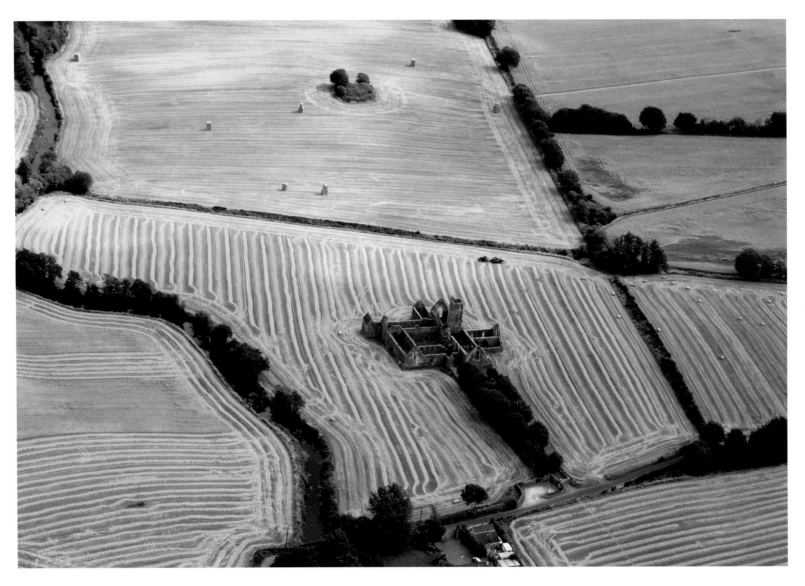

Barley being harvested on the lands surrounding the historic Kilcrea Abbey. ▲

After the harvest, bales of straw await collection. ▶

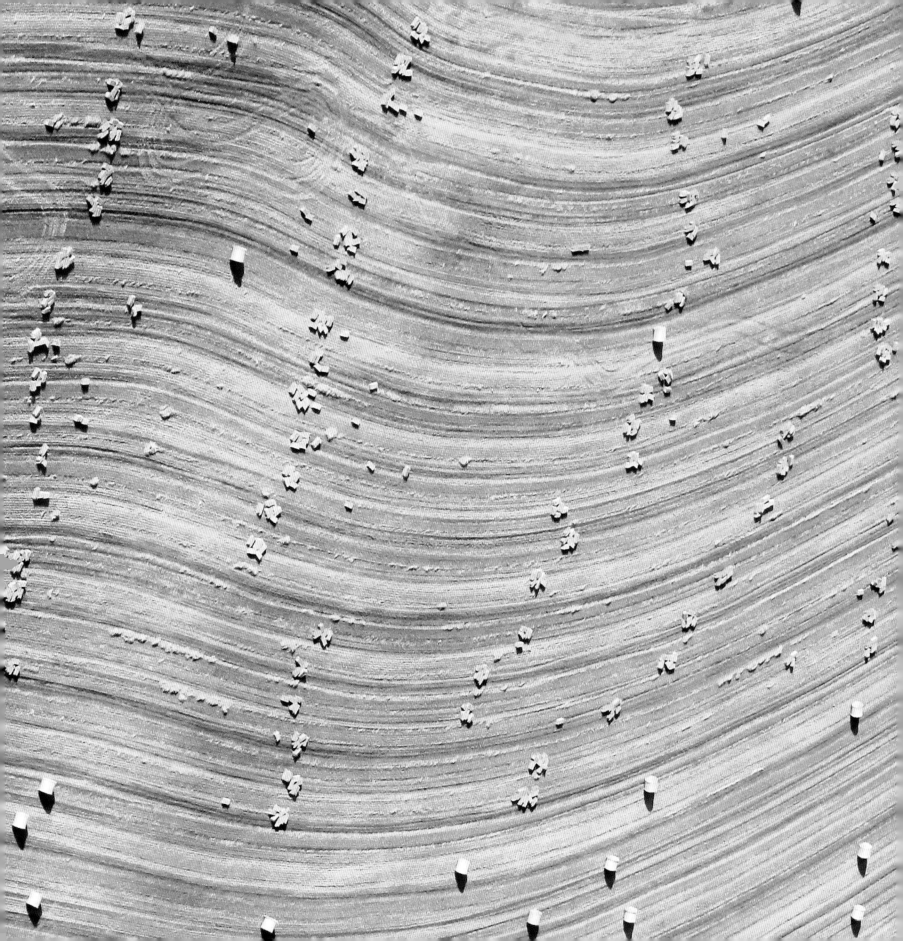

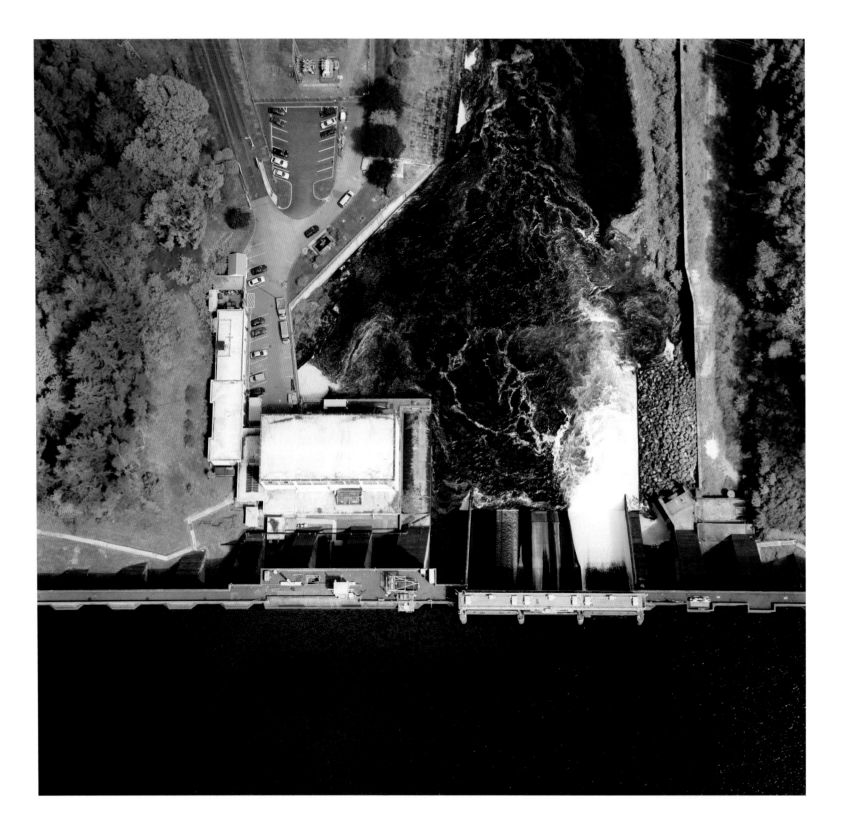

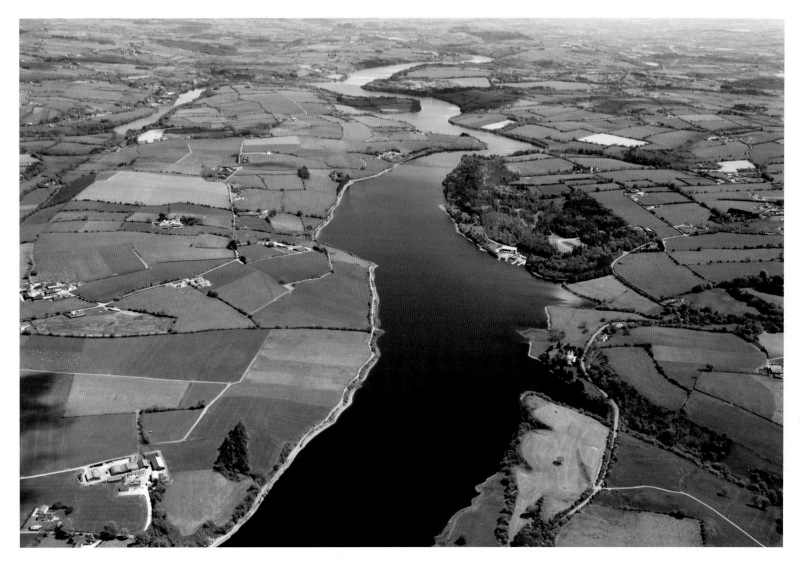

The River Lee at Farran Wood. Many recreational activities take place on the River Lee, including sailing, swimming, rowing and kayaking. The river is also a favourite of coarse anglers who fish the waters for salmon and trout.

The hydroelectric dam at Inniscarra is over 40 metres high and almost 230 metres across. It was built in the 1950s and a large reservoir created.

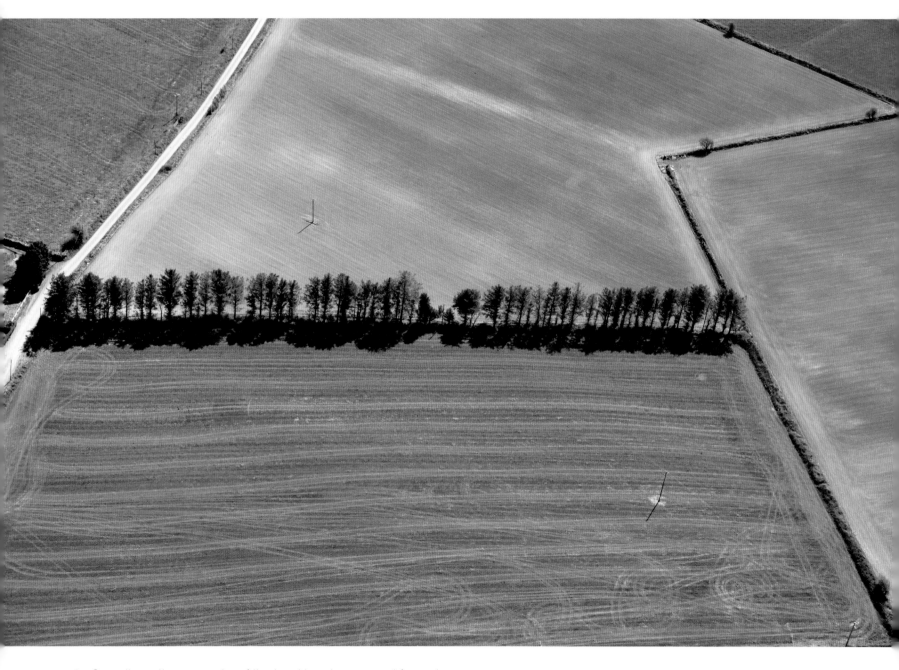

Sometimes the symmetry of the land is only apparent from above,
like with this row of trees in a field near Farran.

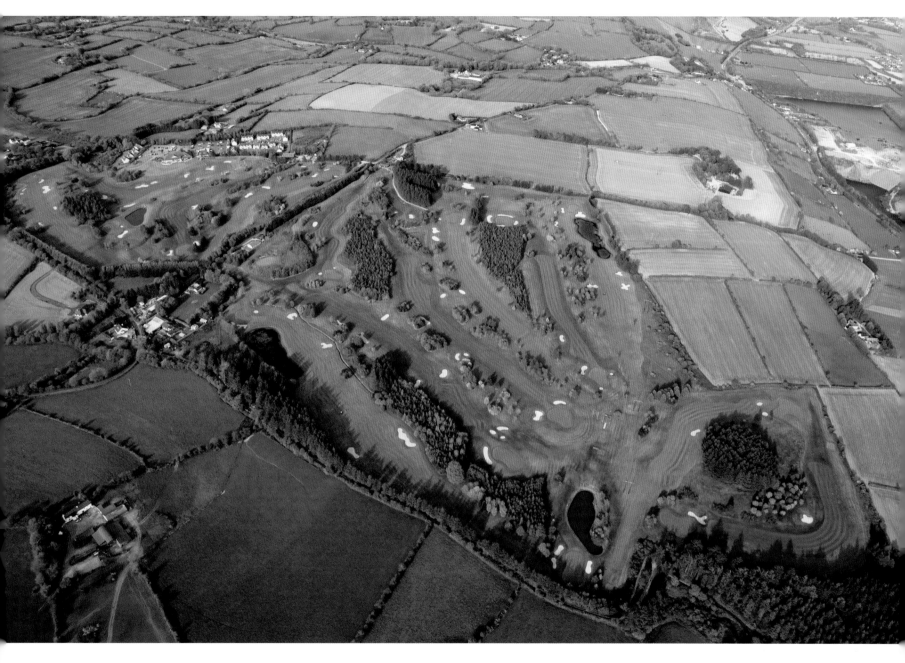

The picturesque setting of Lee Valley Golf Club in the heart of the River Lee valley, west of Cork city.

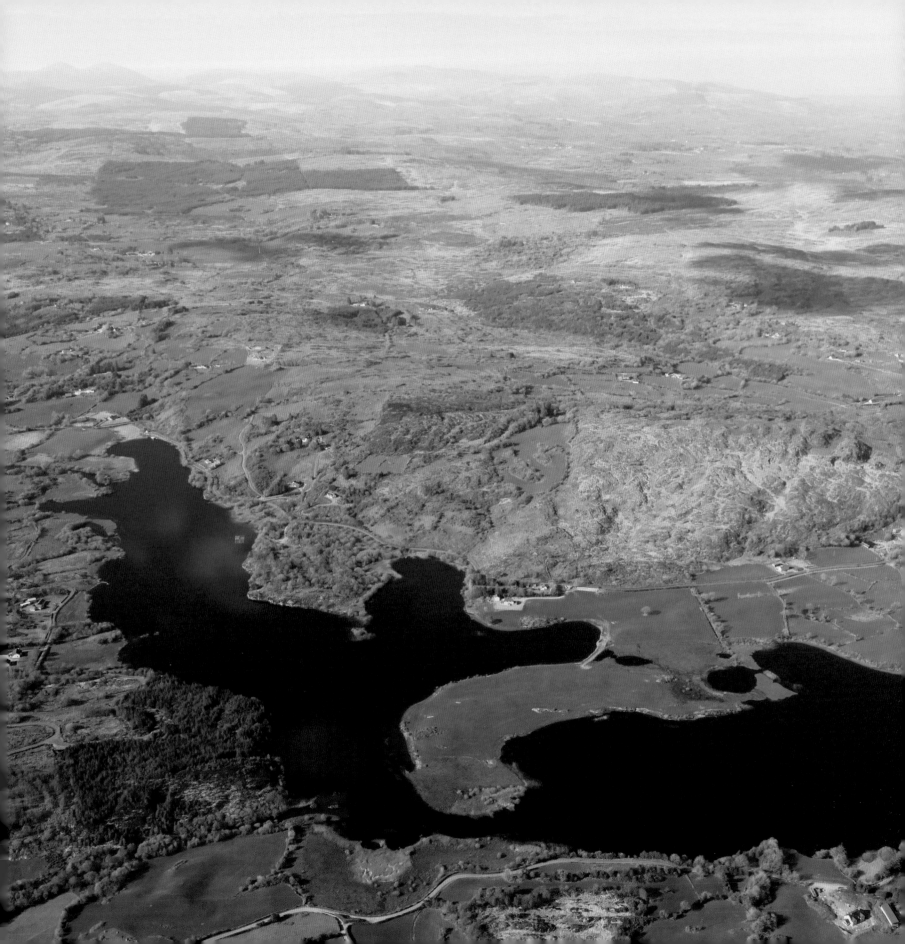

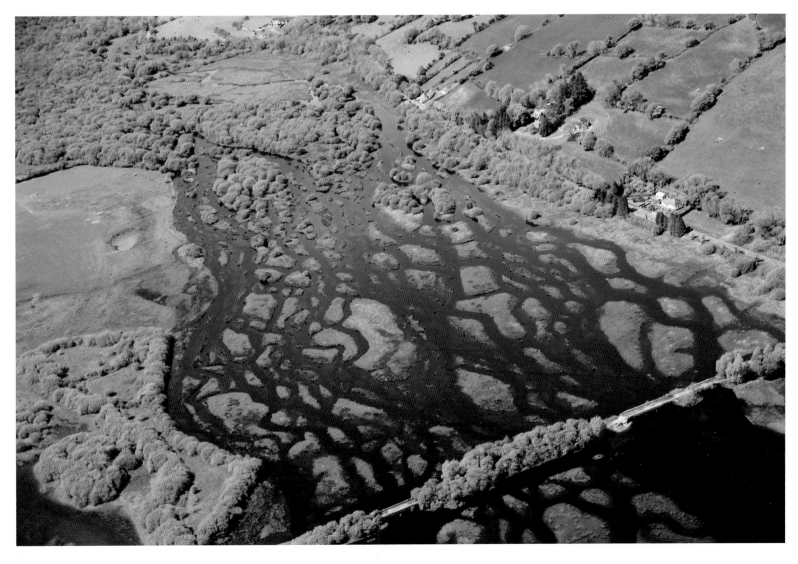

A unique place of streams, narrow channels and small islands, the Gearagh is the remains of a former alluvial forest. It is a wildlife sanctuary and home to many species of bird and animals.

The Inchigeelagh Lakes stretch in a 10-kilometre chain and are considered one of the premier pike fisheries in the country.

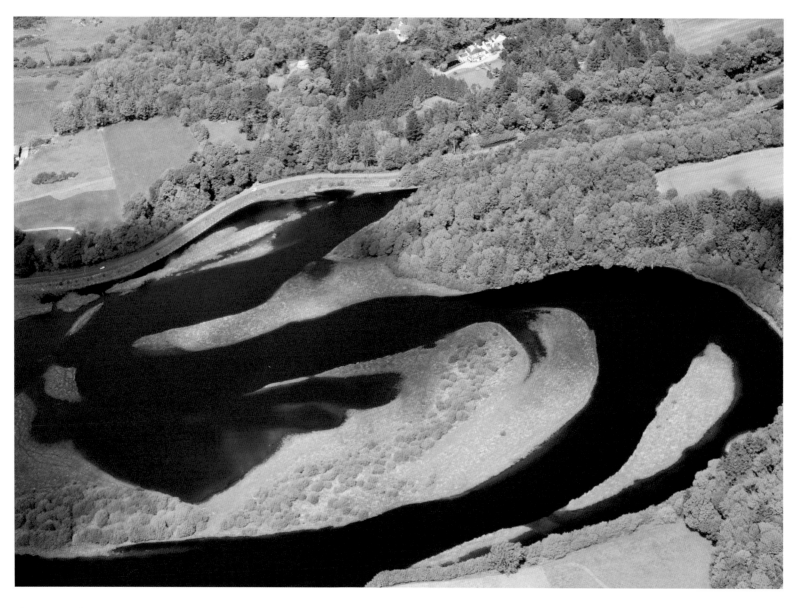

▲ Lough Allua is valued by coarse anglers for the quality of its fish:
pike, bream and rudd.

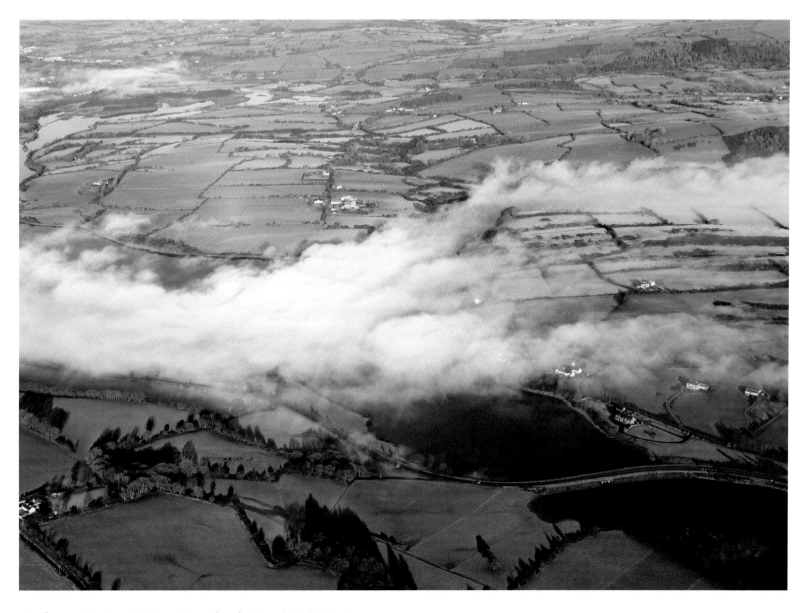

On a winter's morning a layer fog forms a blanket over the River Lee near Lissarda.

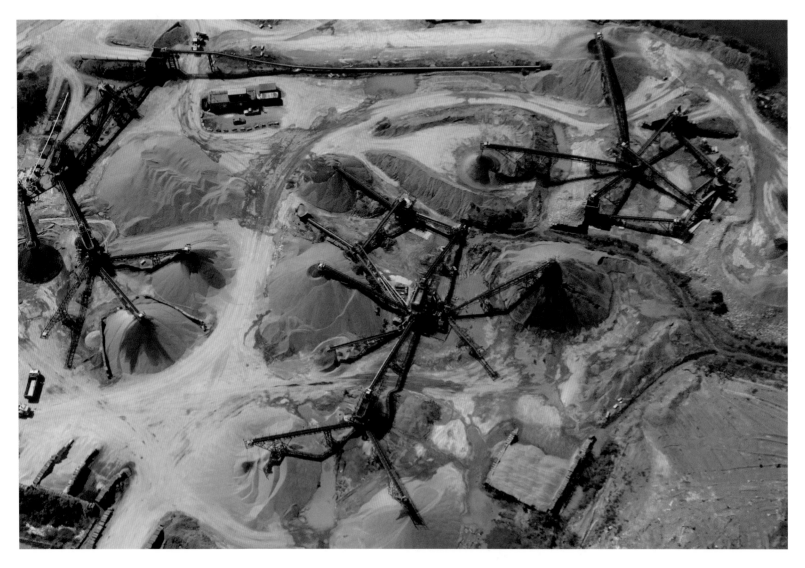

The lunar-like landscape of this sand pit near Macroom, with its elongated grading machines, resembles a scene directly out of a science-fiction film.

Located on the Cork/Kerry border, the sandstone peaks of the Shehy Mountains took their present form during the ice age when glaciers carved out many deep valleys in the area.

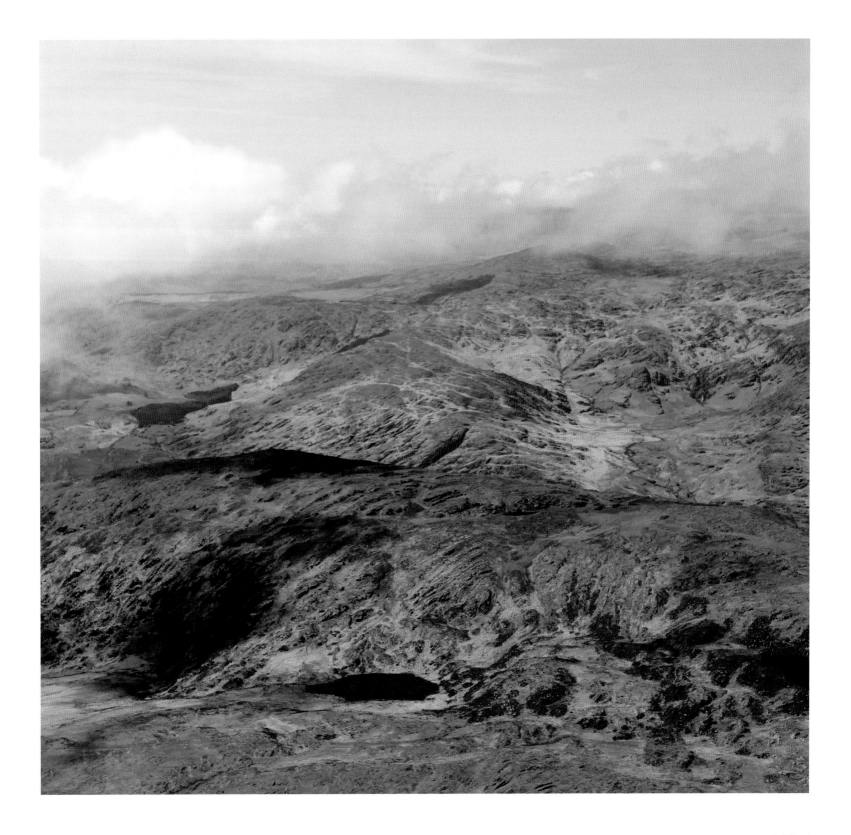

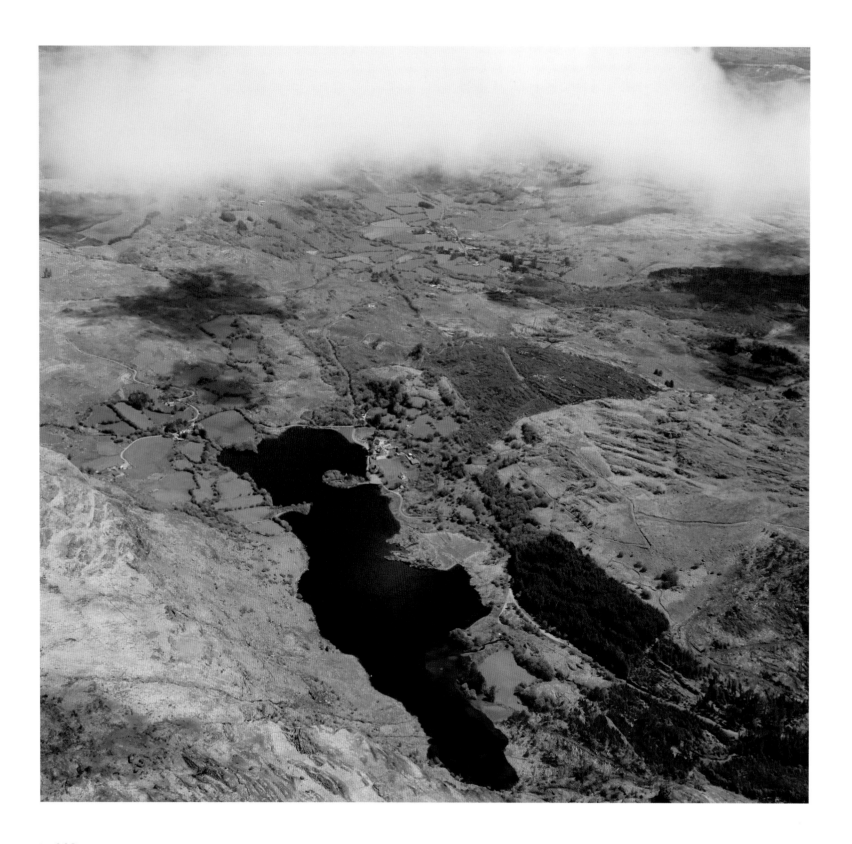

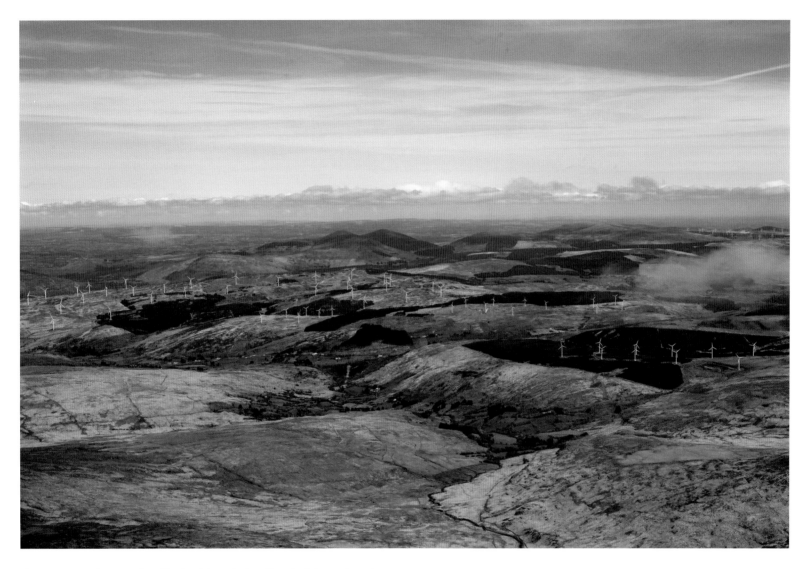

▲　A wind farm in the Shehy Mountains. The turbines stand like sentries on these high hills in north Cork.

◀　Surrounded by high hills, Gougane Barra is the source of the River Lee and an area of great natural beauty. St Finbarr founded a monastery here in the sixth century. In the centre of the lake is a small oratory and the remains of monastic cells.

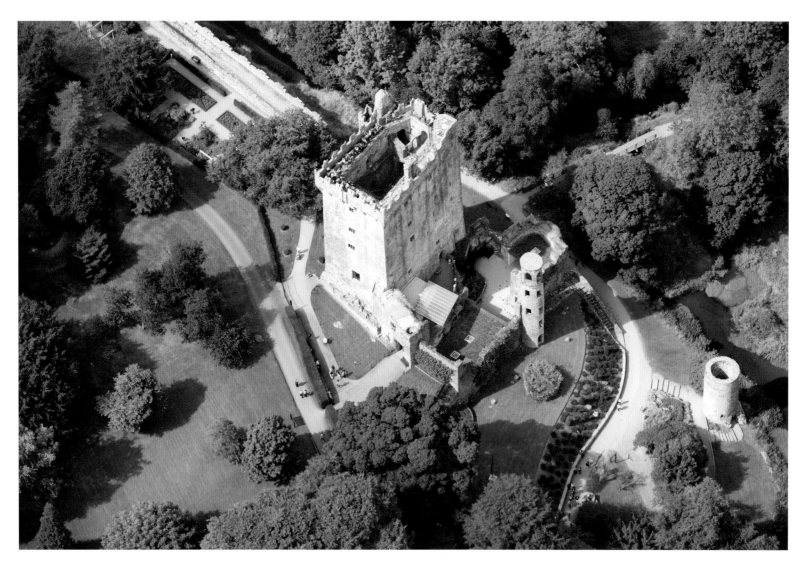

Blarney Castle, which dates back to 1446, was built by
Dermot McCarthy, King of Munster, and is now an important
visitor centre. At the top of the castle is the Blarney Stone
and thousand of visitors come each year to kiss the stone,
which is said to bestow the gift of eloquence.

Blarney House. Set in the grounds of Blarney Castle and
overlooking the lake, this fine house was built in 1874 in
the Scottish Baronial style. It has been restored to its former
grandeur in recent times.

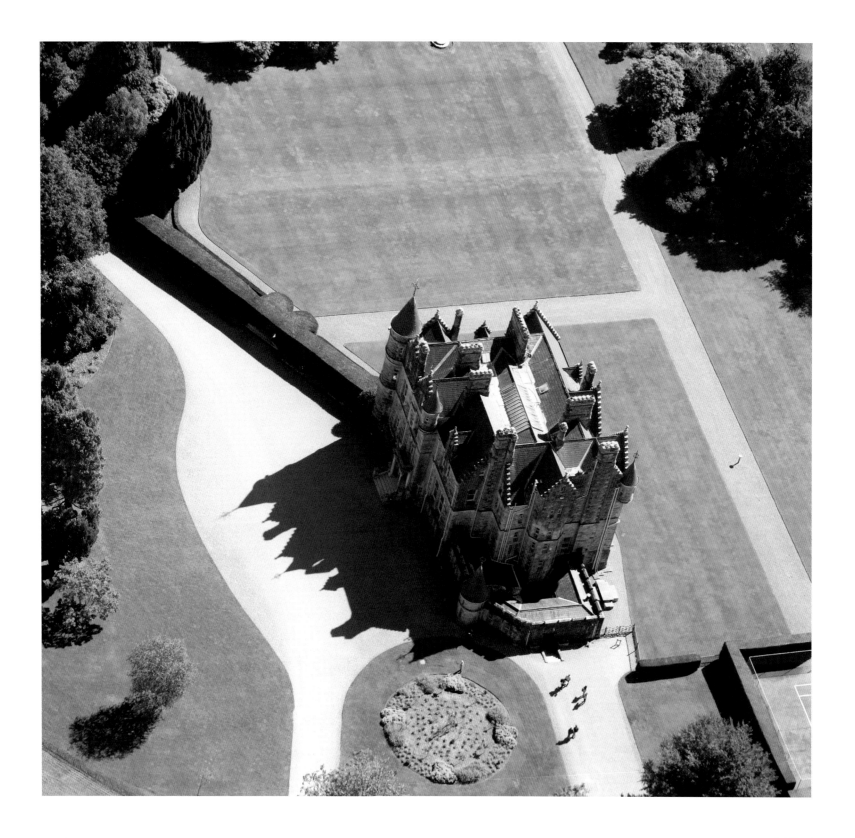

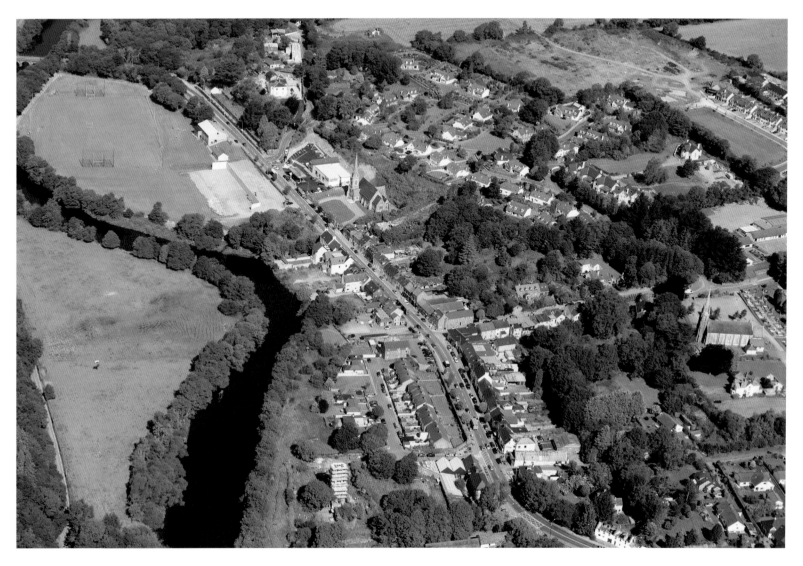

Built on the River Bandon, Innishannon is a large village situated on the main road west of Cork city.

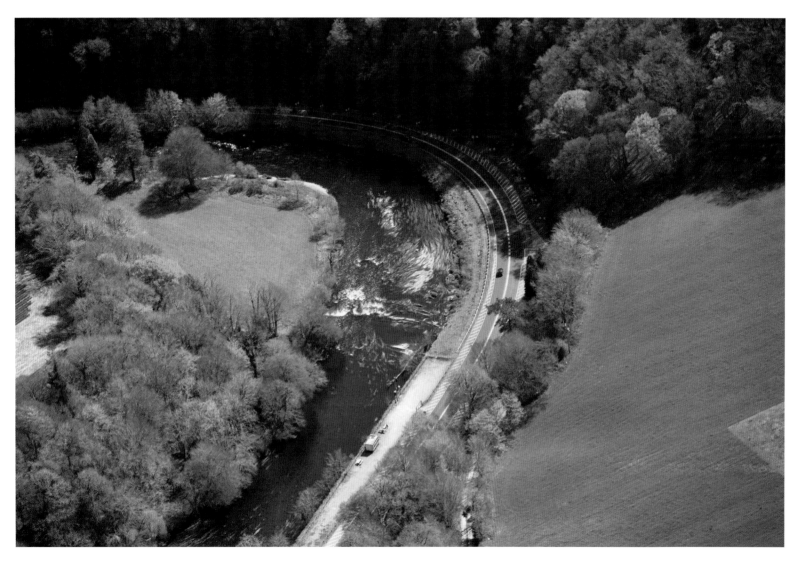

This curve in the River Bandon is a well-known fishing spot and the acute bend in the road beside it is known as 'Nun's Corner'.

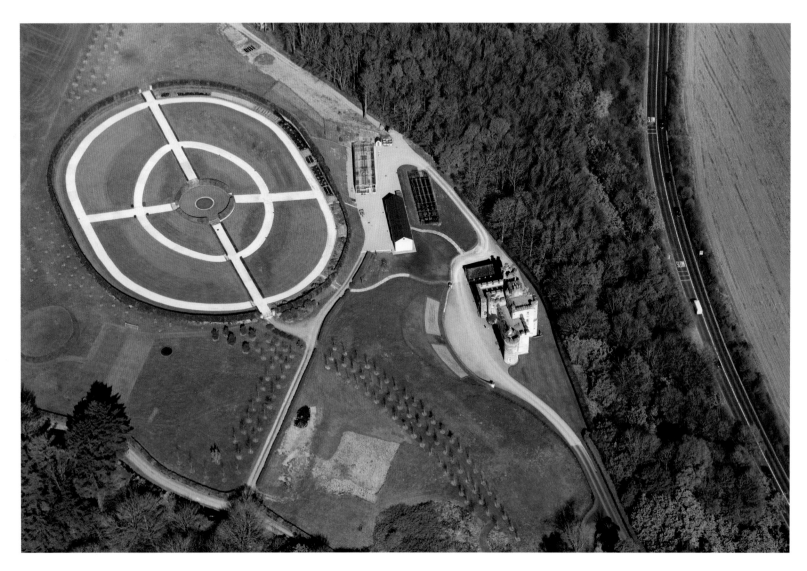

Situated high above the Cork–Bandon Road, Cor Castle with its stunning ornate gardens, is a Regency-style house built in the early 1800s. The property is a private residence.

The picturesque village of Kilmacsimon on the banks of the River Bandon.

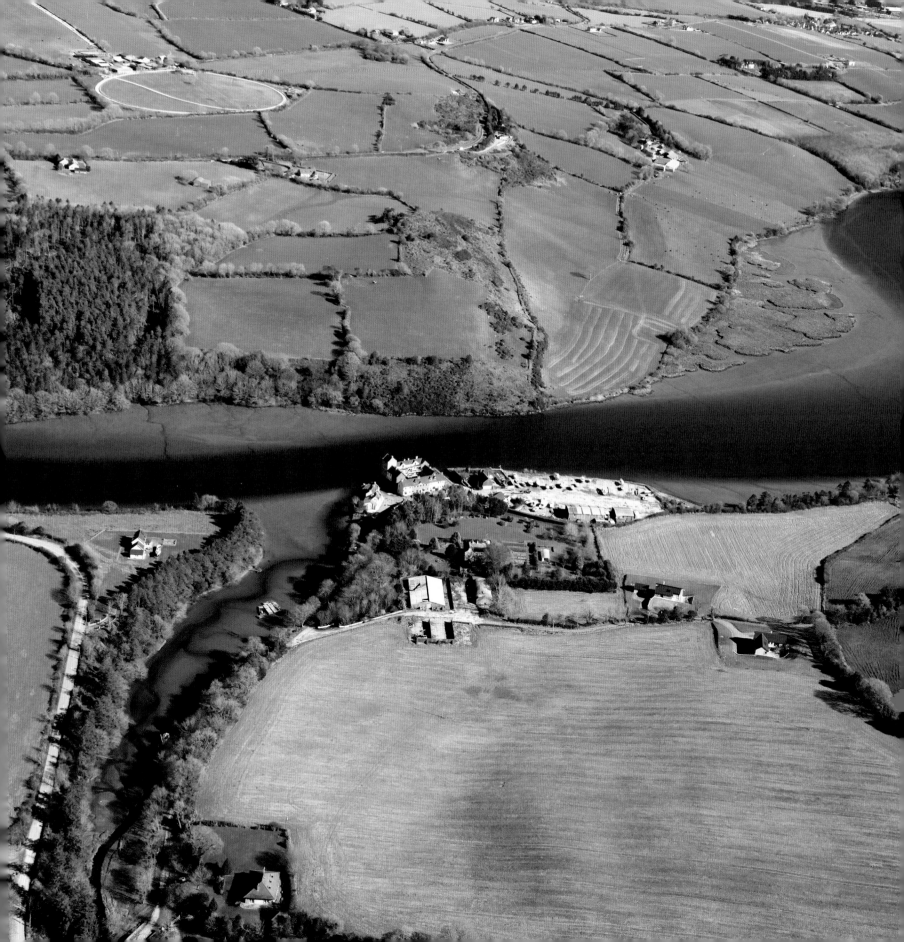

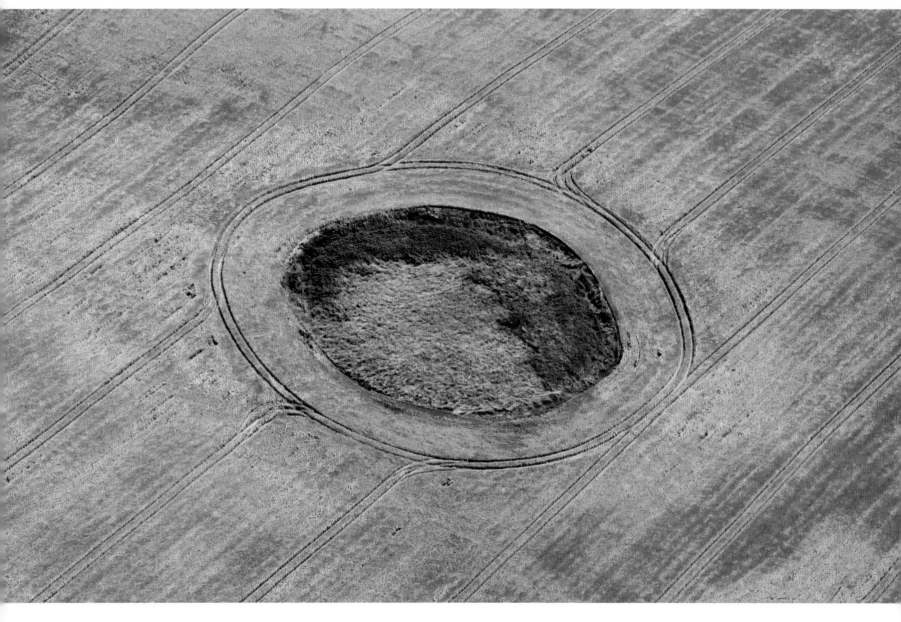

A nearly circular patch of land stands in the middle of a field of ripening barley near Bandon. Probably the remains of an ancient ring fort (or 'rath' from the Irish), there are many similar examples scattered throughout County Cork. Most landowners will leave such sites undisturbed.

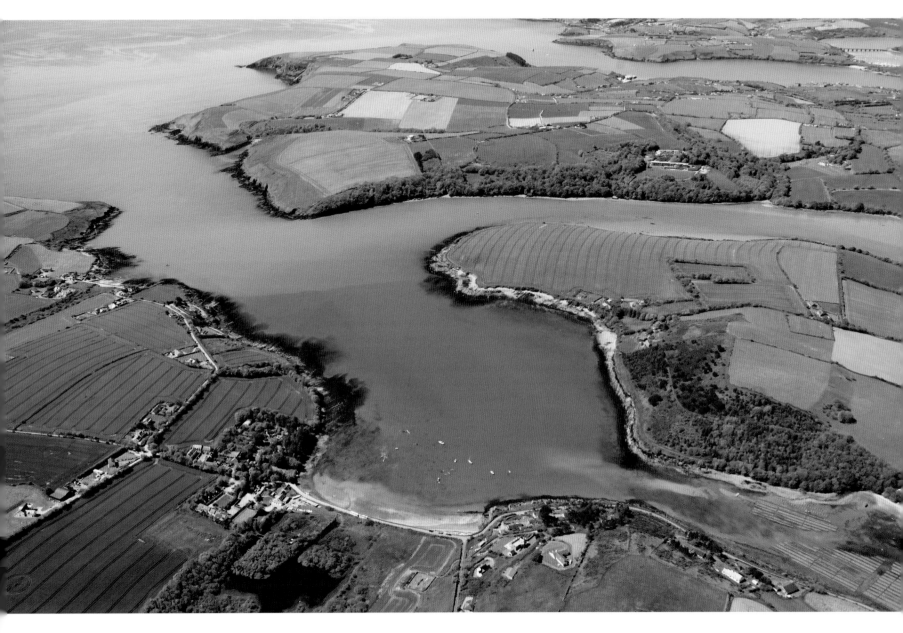

Oysterhaven is a picturesque sea inlet to the west of Cork Harbour. During the siege of nearby Kinsale in the 1600s, the besieging English forces brought supplies by ship into Oysterhaven. It is now a popular sailing and watersports centre.

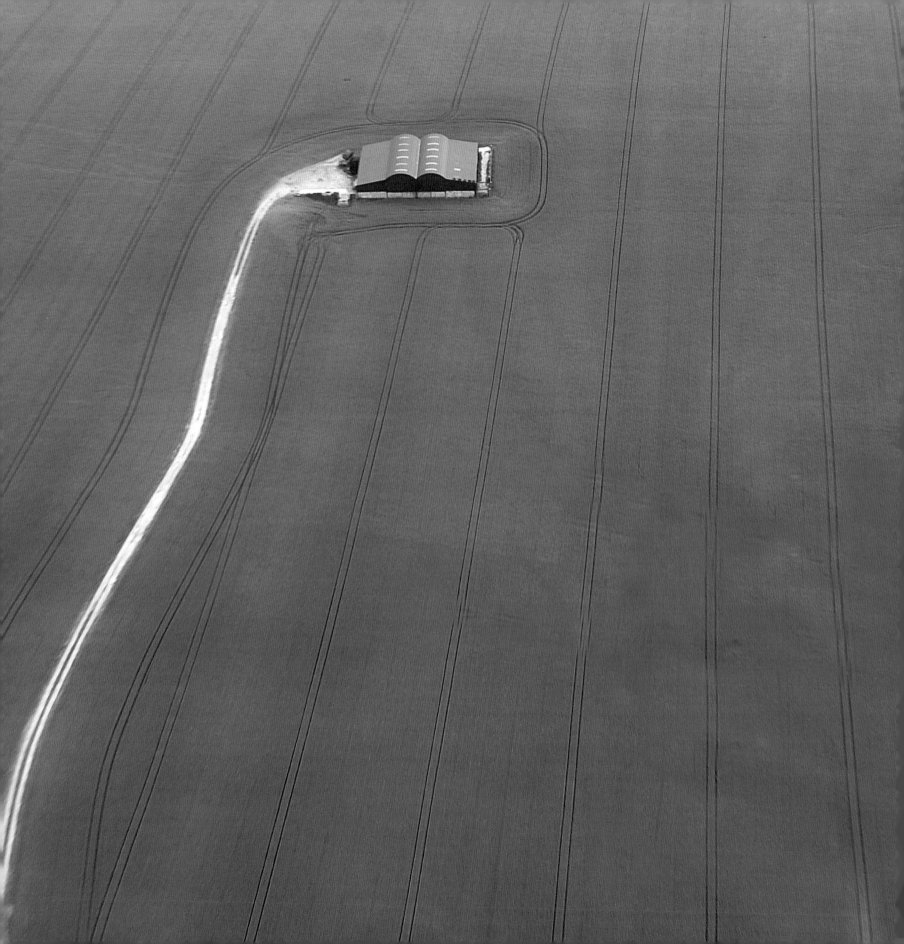

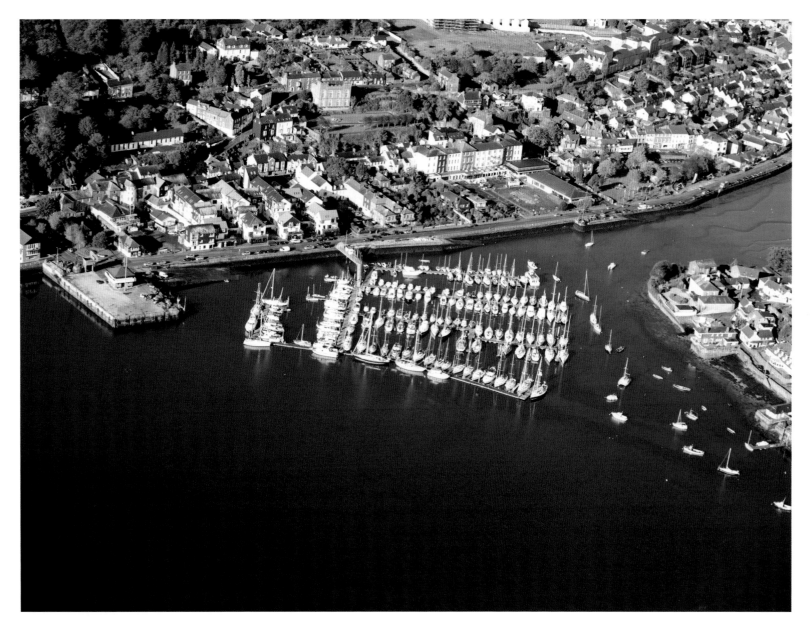

Originally a medieval fishing port, Kinsale is a popular tourist destination.
It is also a well-known sailing and sea angling centre with a large marina.
The town is noted for its restaurants.

A track runs through a working farm at Oysterhaven.

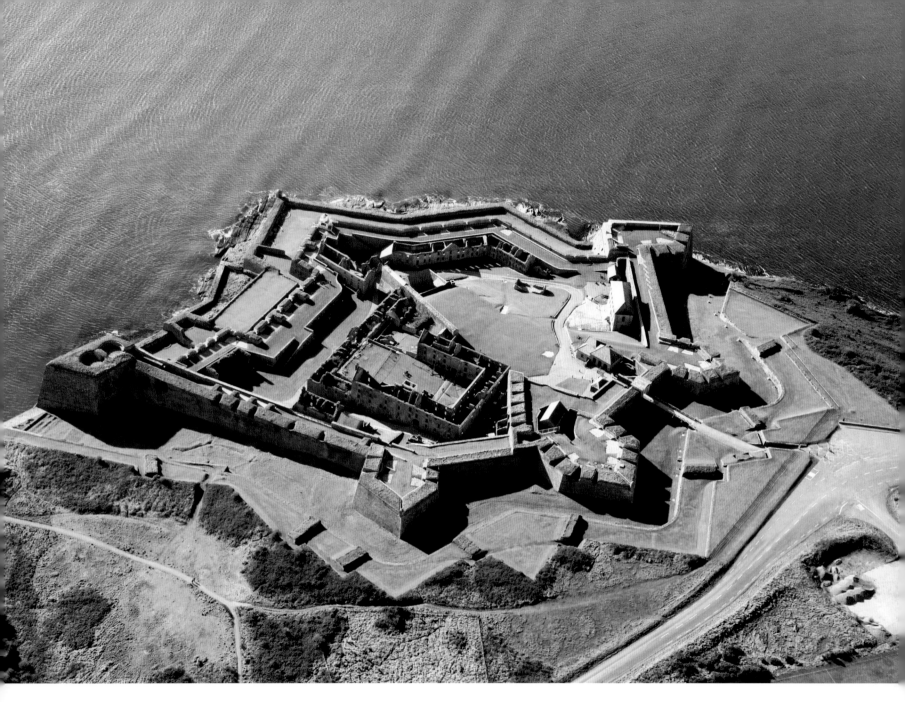

Charles Fort is a classic star fort constructed in the late 16th century, overlooking Kinsale Harbour. It is an important historic building, which has been substantially restored in recent times. It is open to visitors.

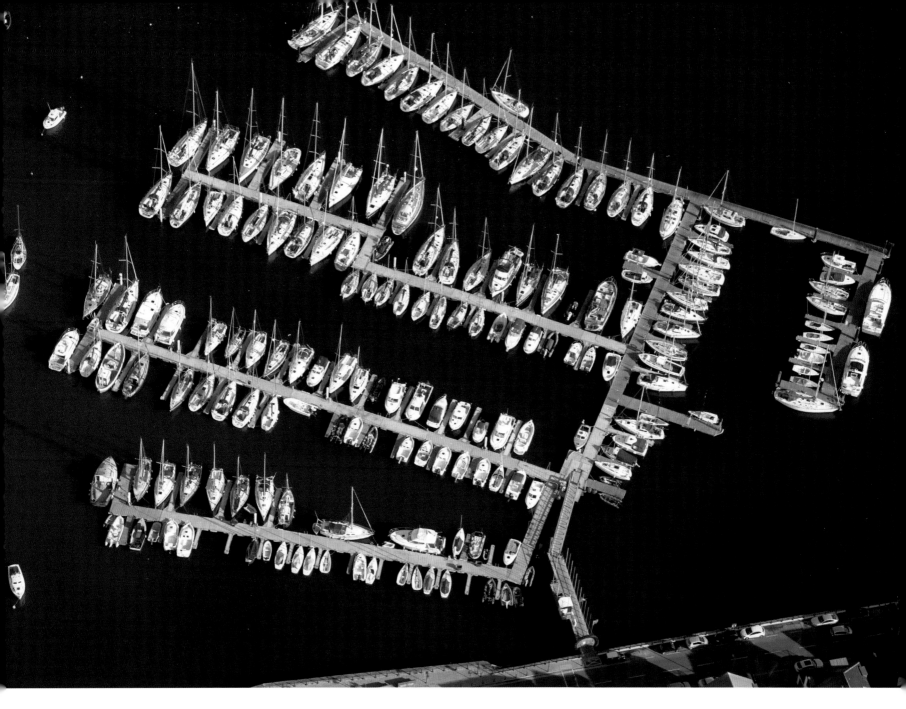

This large marina owned and operated by Kinsale Yacht Club has berths for members and visiting craft.

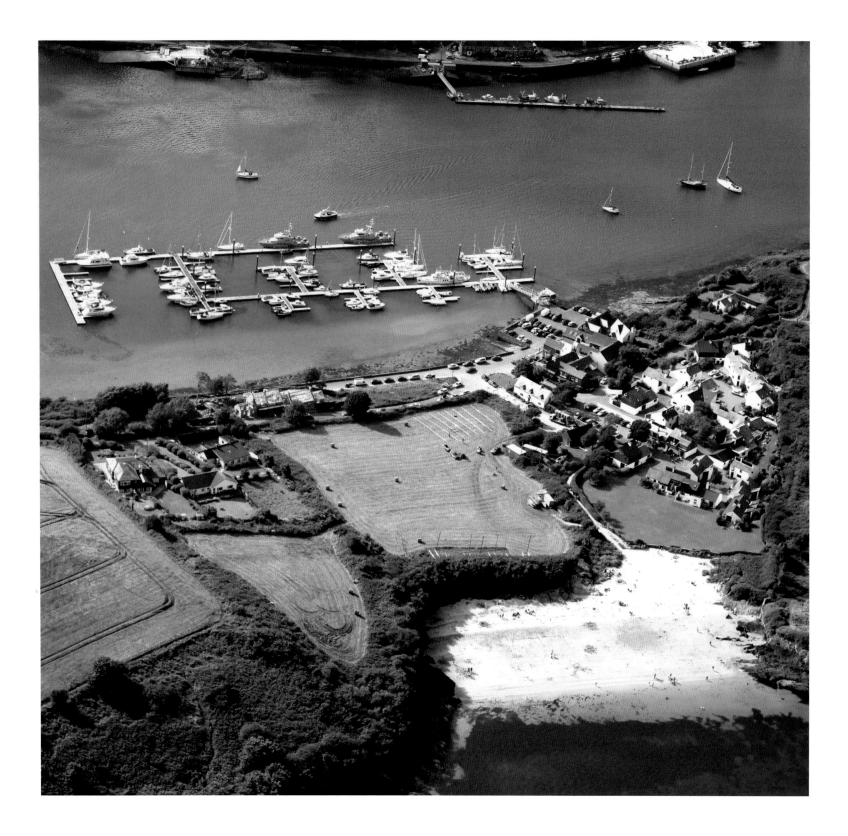

Situated on a small peninsula opposite Kinsale town, Castlepark has a sandy beach and marina.

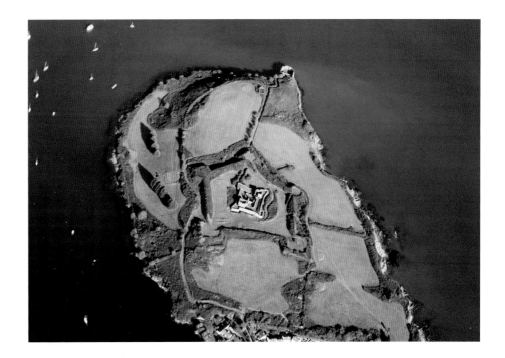

On the peninsula near Castlepark the pentagonal James Fort was built in the 16th century.

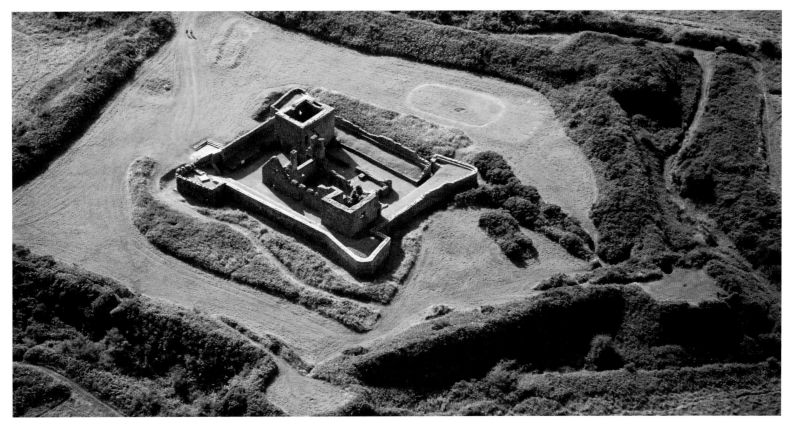

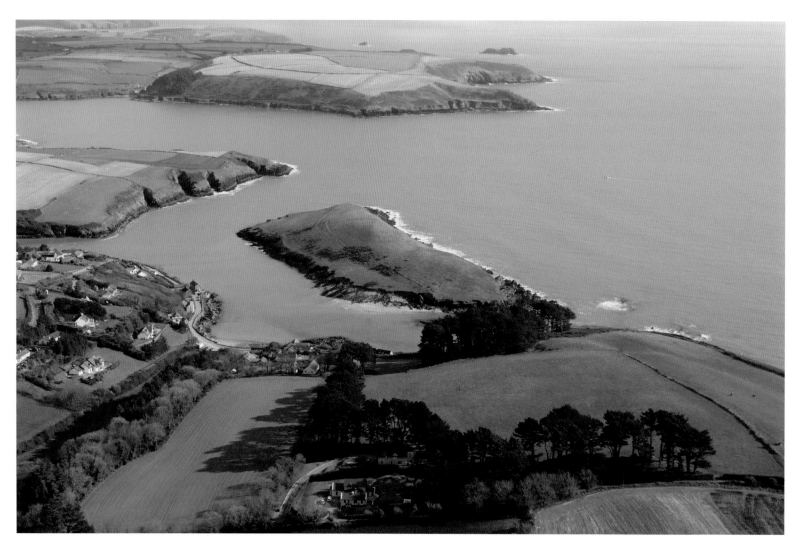

▲ Sandycove, a small natural cove south of Kinsale with an island and a small hamlet.

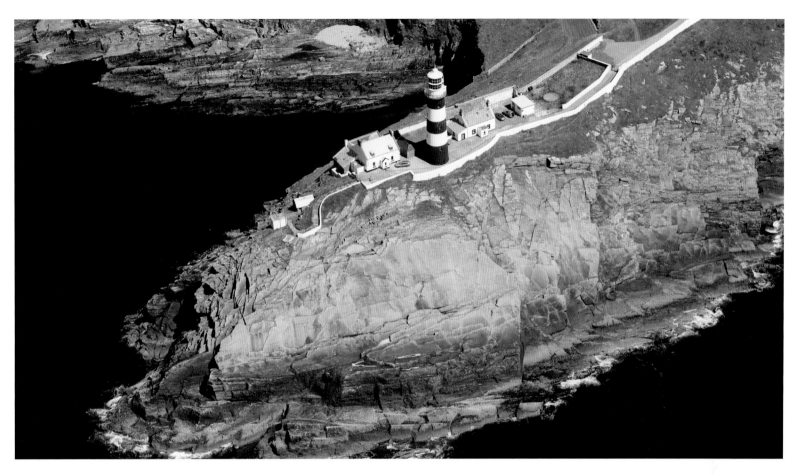

With its distinctive black and white stripes, the lighthouse on the Old Head of Kinsale has been operational since 1853. There has been a light to guide seafarers at this location since pre-Christian times.

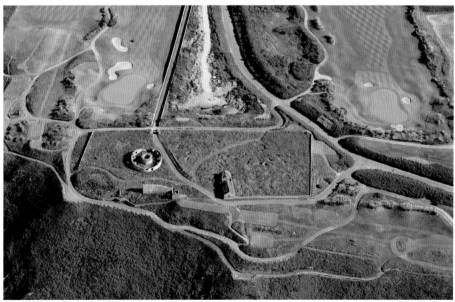

Located at the edge of the Old Head Golf Links are two former lighthouses. The circular building dates to the early 18th century; the Cottage Lighthouse (centre foreground) was built in 1610 and had a turf-burning brazier. Legend has it that navigational lights existed on this headland as far back as 1000 BC.

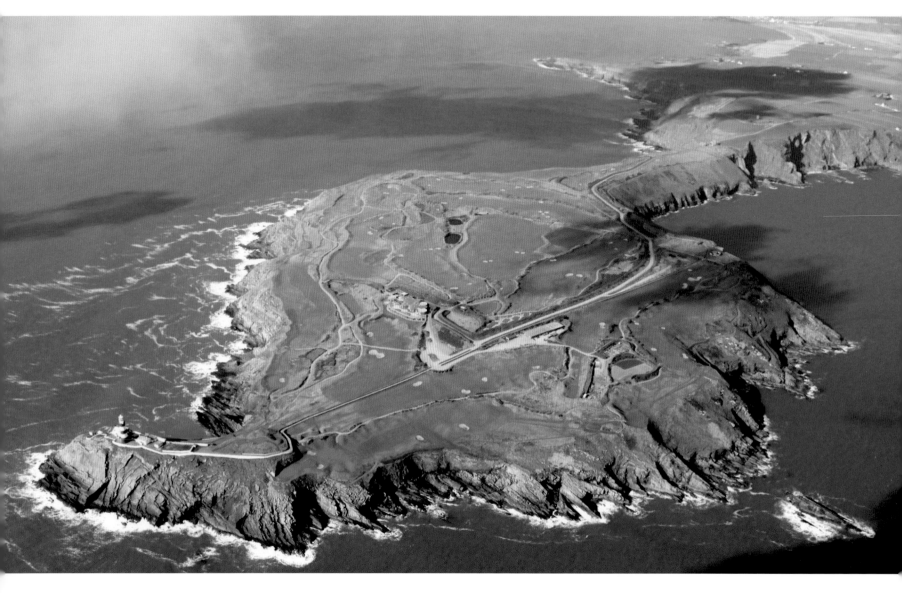

The Old Head Golf Links is rated to be amongst the finest in the world and one of the most challenging. Situated on a high, exposed promontory jutting out into the Atlantic and commanding dramatic views, this famous course is surrounded by the sea.

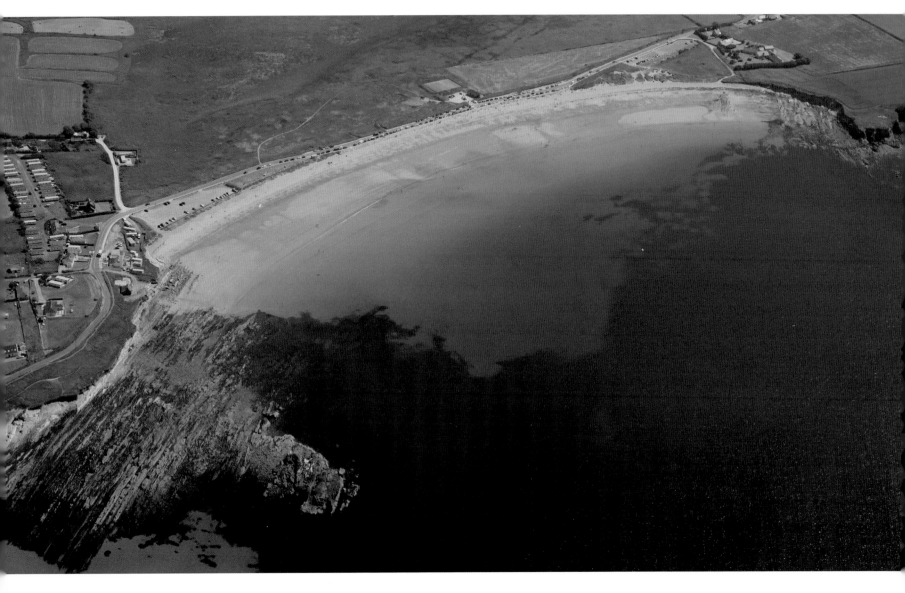

Just west of the Old Head of Kinsale lies White Strand, an expansive sandy beach popular with swimmers and fishermen. Garrylucas Marsh is visible at the top of the picture.

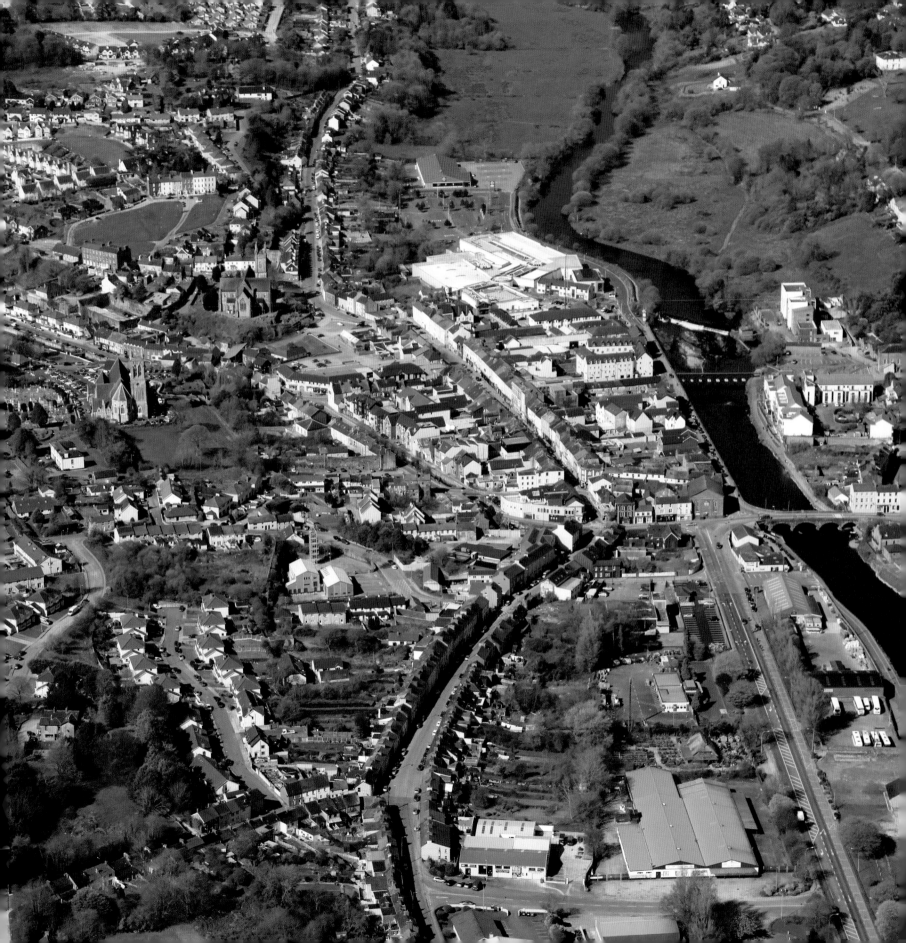

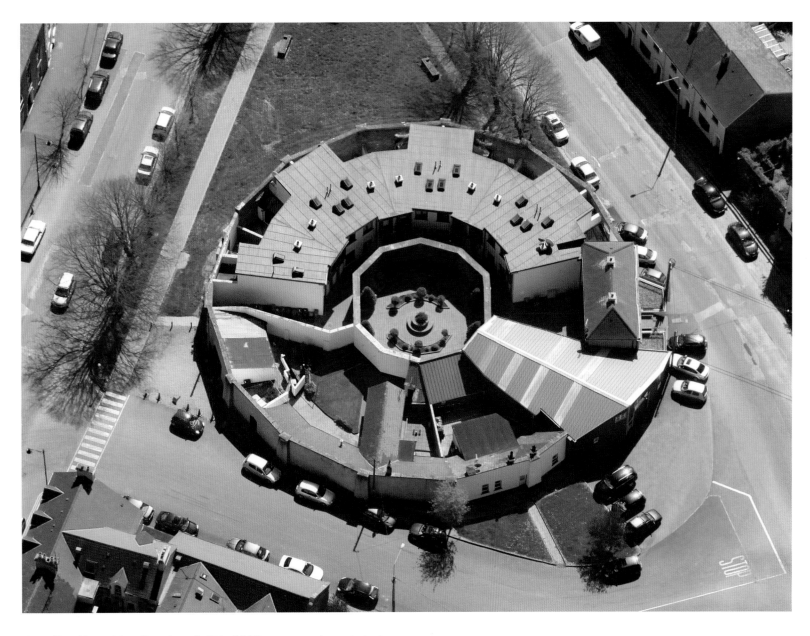

▲ The Shambles, Bandon. Built in 1818 as a meat market where stallholders sold their wares, this unusual 15-sided building is now in residential use.

◀ The large county town of Bandon is known as 'The gateway to west Cork'. In olden times it was an important crossing point on the river.

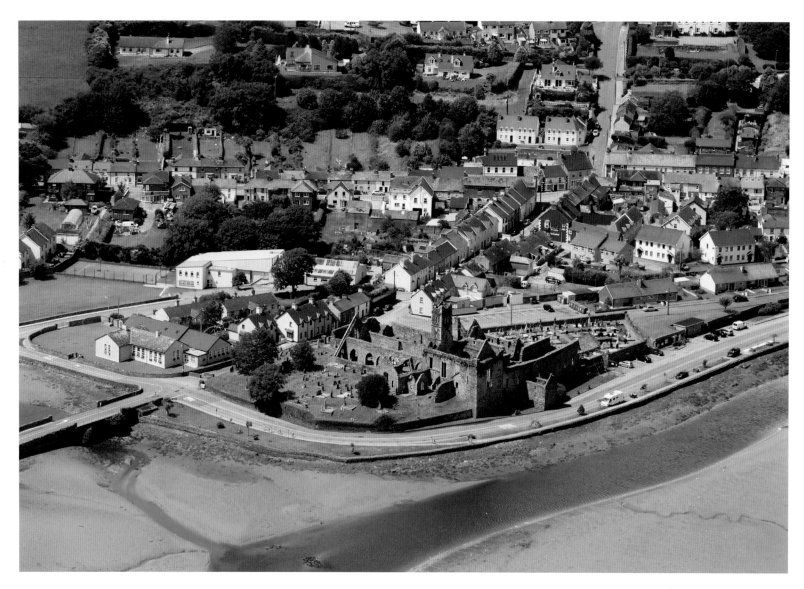

Timoleague with its brightly coloured buildings is a
picturesque village perched at the end of a long sea inlet
on the Kinsale–Clonakilty Road. The ruins of the 13th-century
Timoleague Abbey are visible in the foreground.

A lifeboat station was established in Courtmacsherry in 1825,
the first RNLI lifeboat station in Ireland.

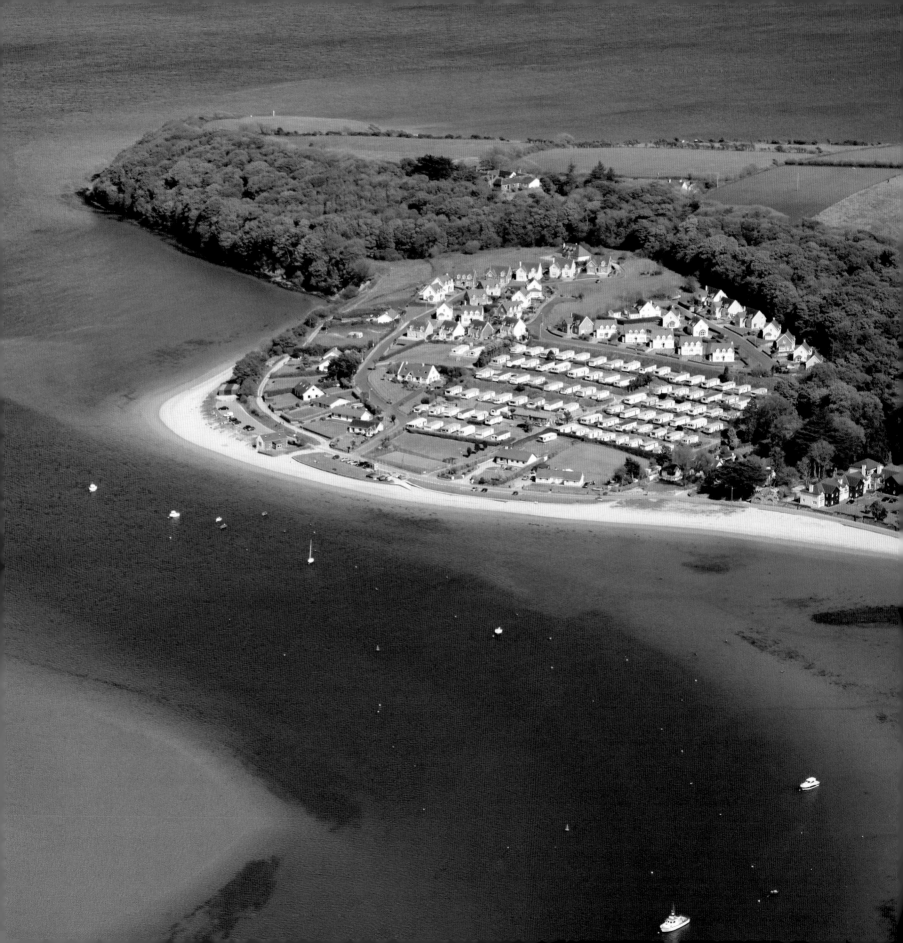

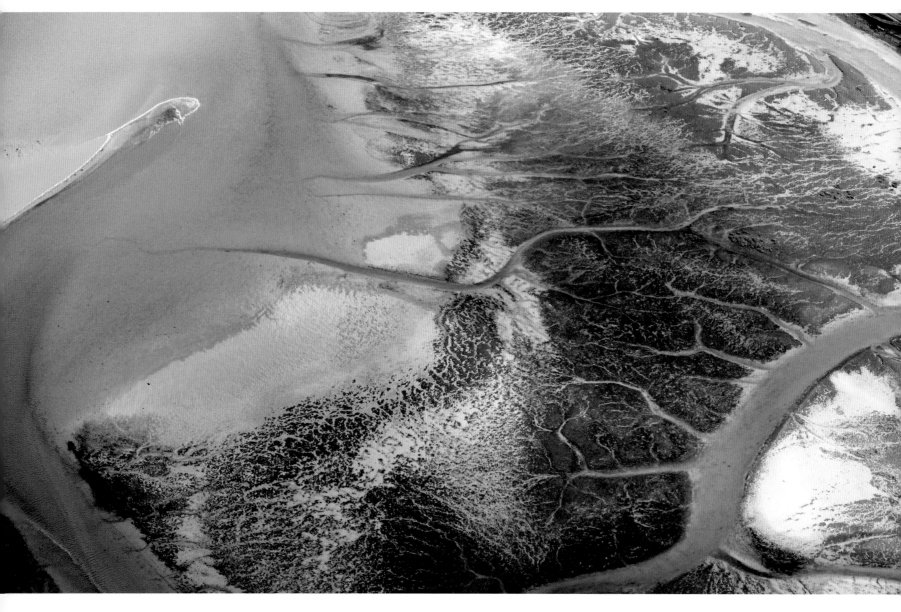

▲ Low tide reveals what lies beneath the water at Courtmacsherry.

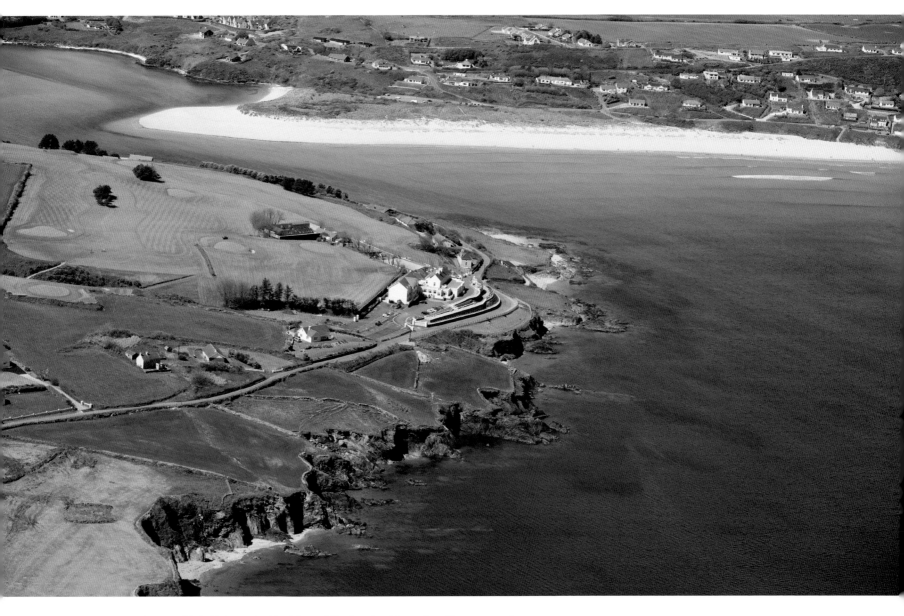

▲ Dunmore House Hotel is located in Clonakilty Bay looking directly across at
Inchydoney Strand.

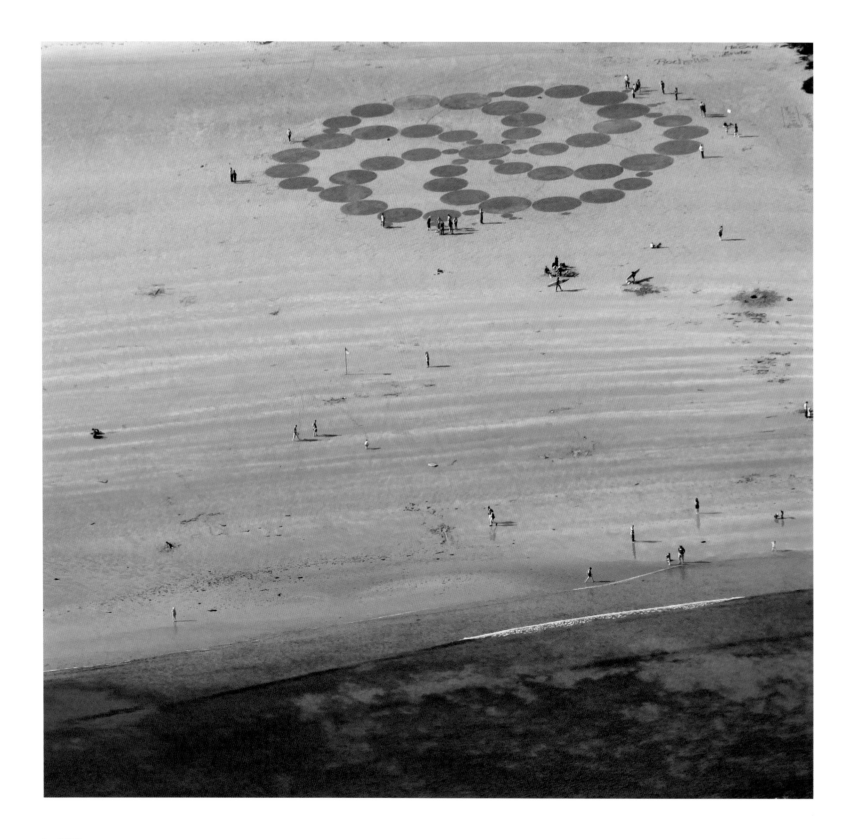

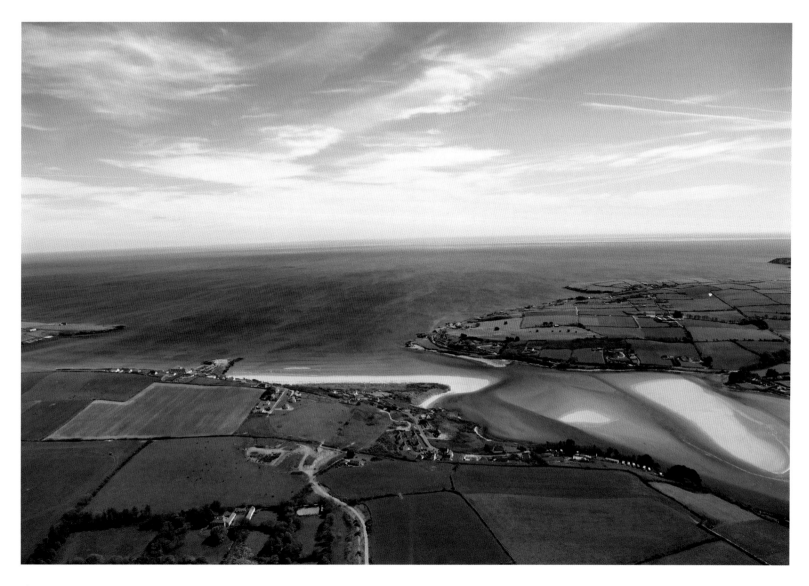

▲ Clonakilty Bay is tidal and at low tide mudflats and sandflats are clearly visible.

◀ Situated on Inchydoney Island, this large sandy beach is a favourite with windsurfers and holidaymakers. The discs are sand art images designed and executed by local artists.

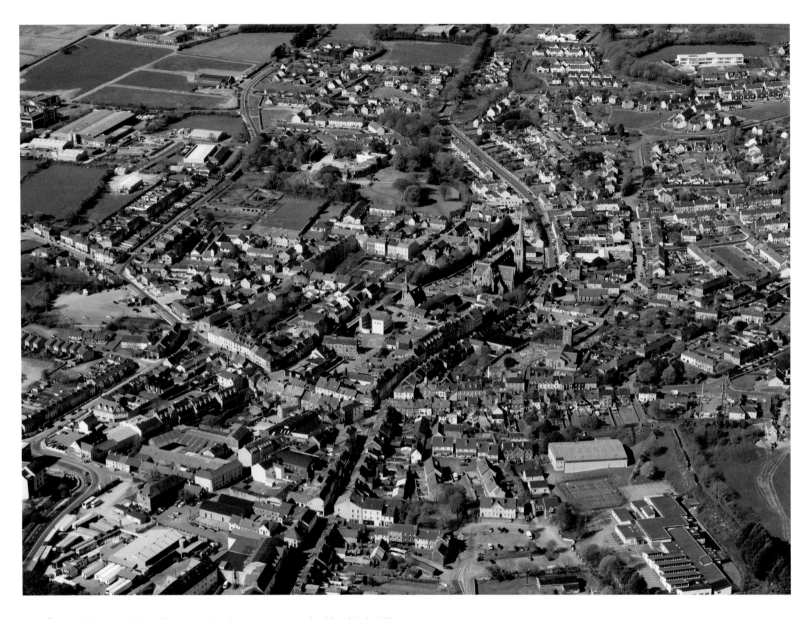

Clonakilty, an attractive country town surrounded by high hills.

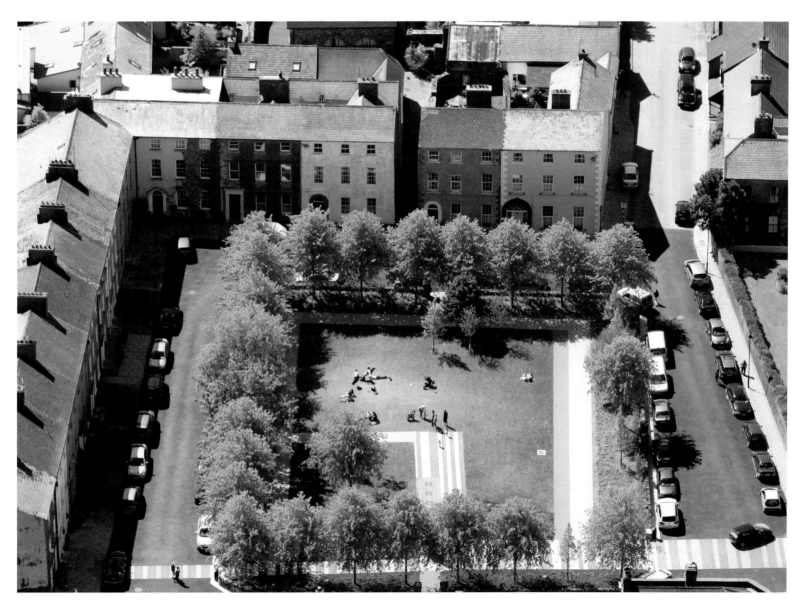

Emmet Square in the heart of Clonakilty is an elegant square of Georgian-style houses built in the late 1700s.

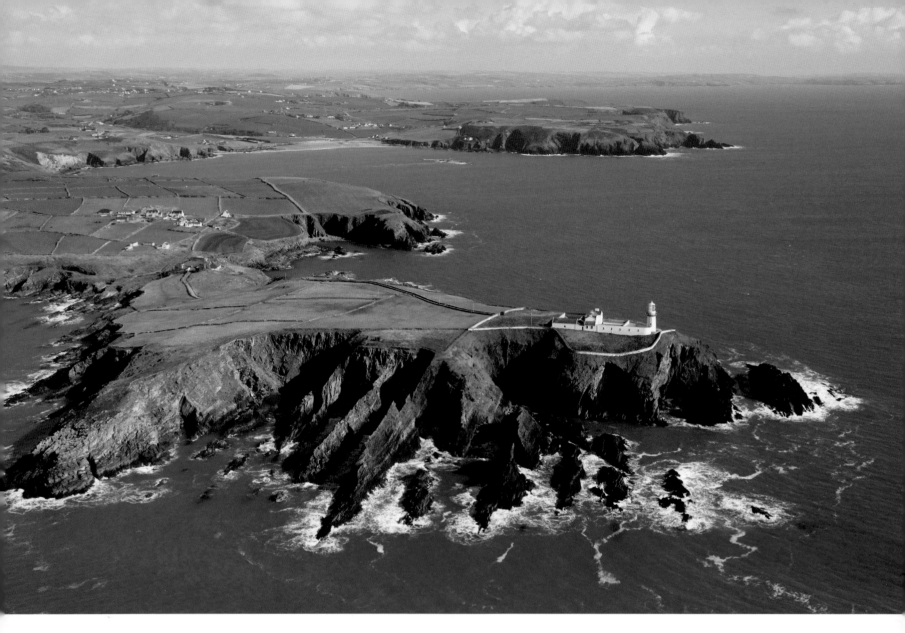

The Galley Head lighthouse is built on dramatic cliffs towering 50 metres above sea level. The light has the distinction of being one of the most powerful in Europe.

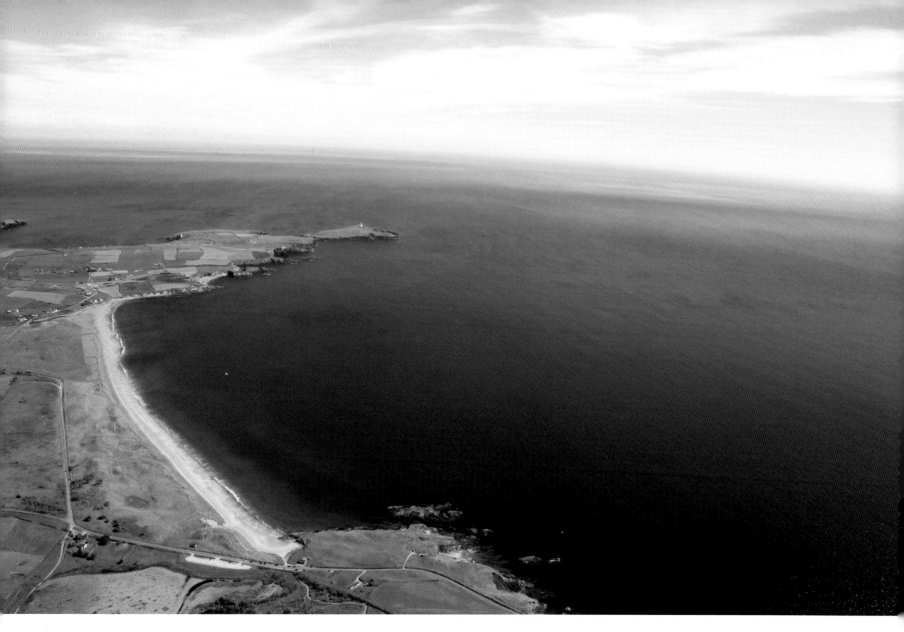

▲ A long sandy beach in west Cork, Long Strand is popular with surfers.

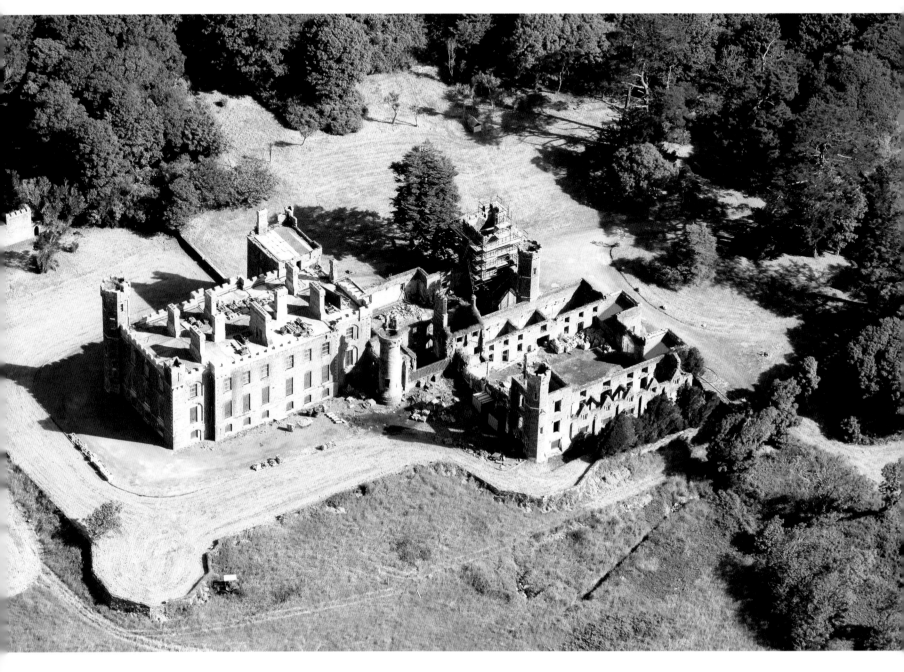

Castle Freke was built in 1780 and stands on a high hill overlooking the surrounding countryside. Some restoration works have been carried out in recent years.

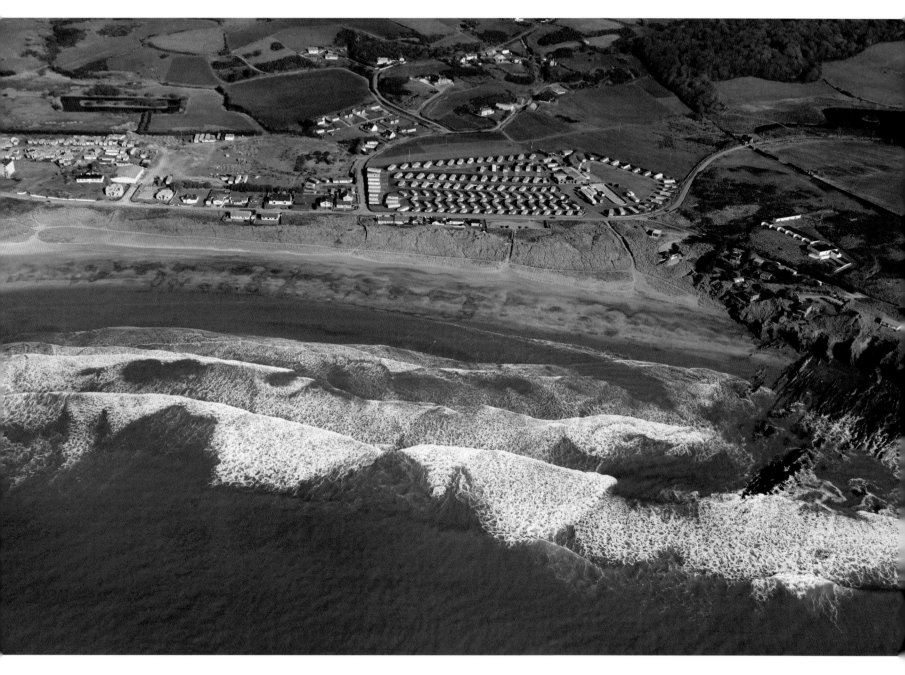

The exposed sandy beach at Owenahincha is a great surfing location with caravan and camping facilities nearby.

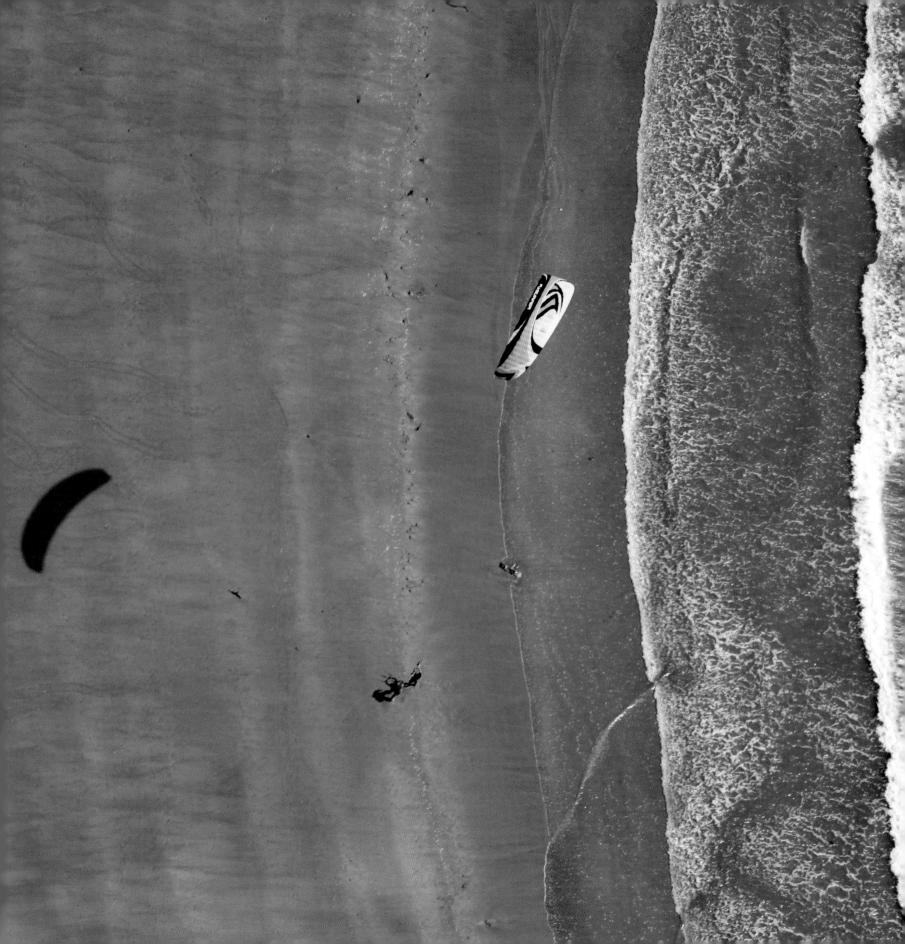

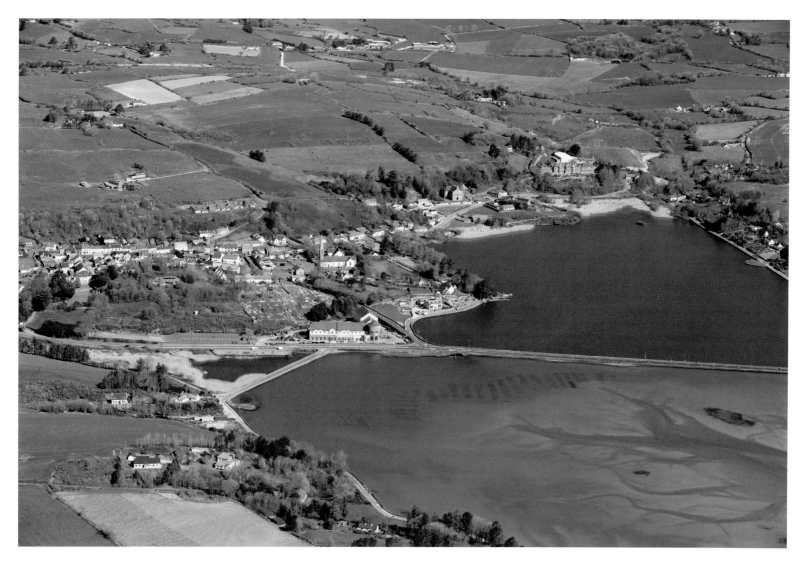

▲ Located on a shallow estuary and approached by a long causeway, the town of Rosscarbery is popular with holidaymakers.

◄ A kitesurfer prepares to take to the waves off Owenahincha beach.

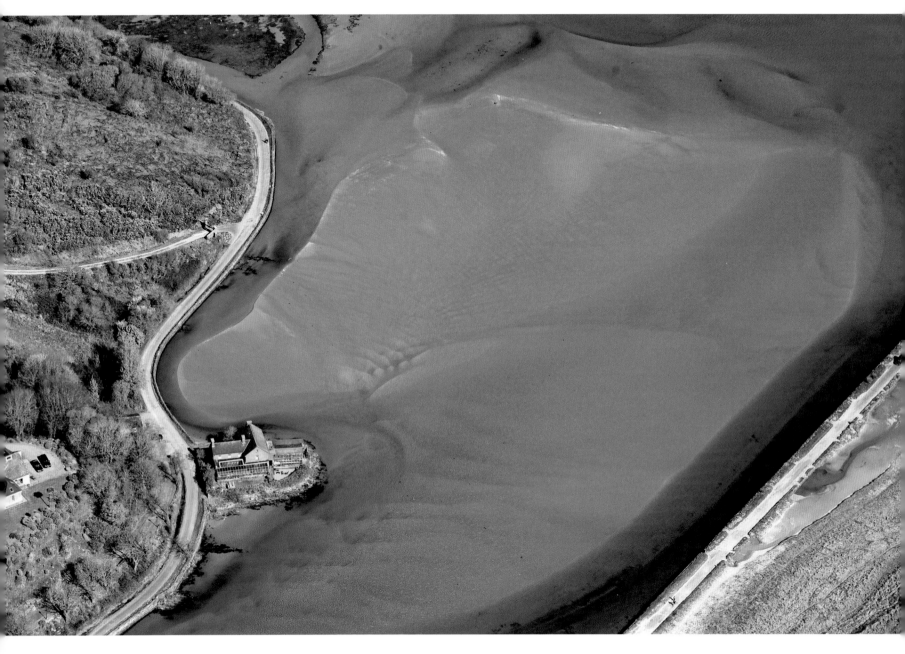

▲ A tidal area close to Rosscarbery town, The Warren is a favourite walking place and has a small beach.

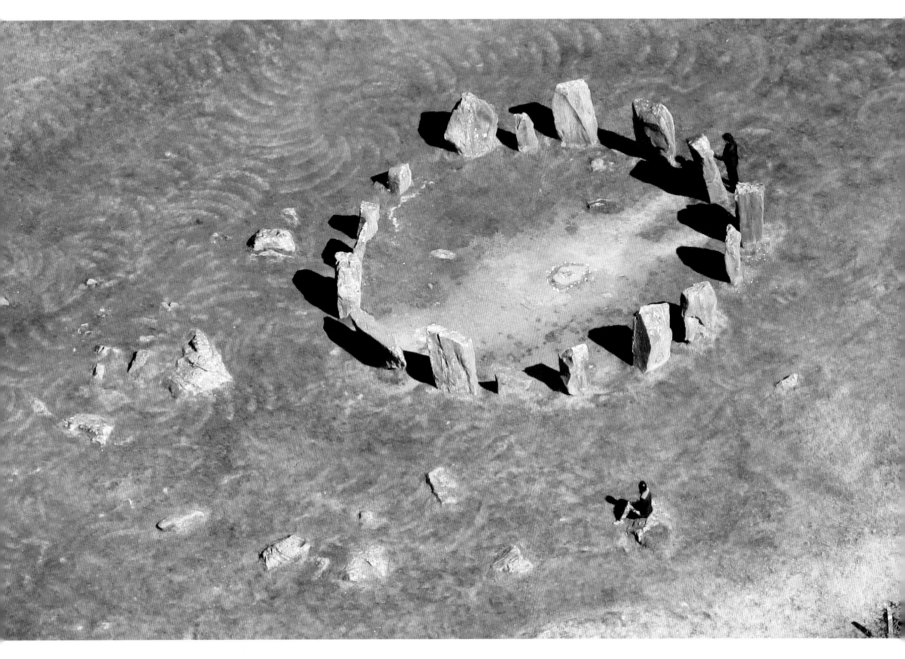

▲ A short distance from the village of Glandore, Drombeg Stone Circle is considered the best example of a stone circle in the region. Its alignment with the winter solstice sunset is one of the best astronomical orientations to be seen in a prehistoric monument in Ireland.

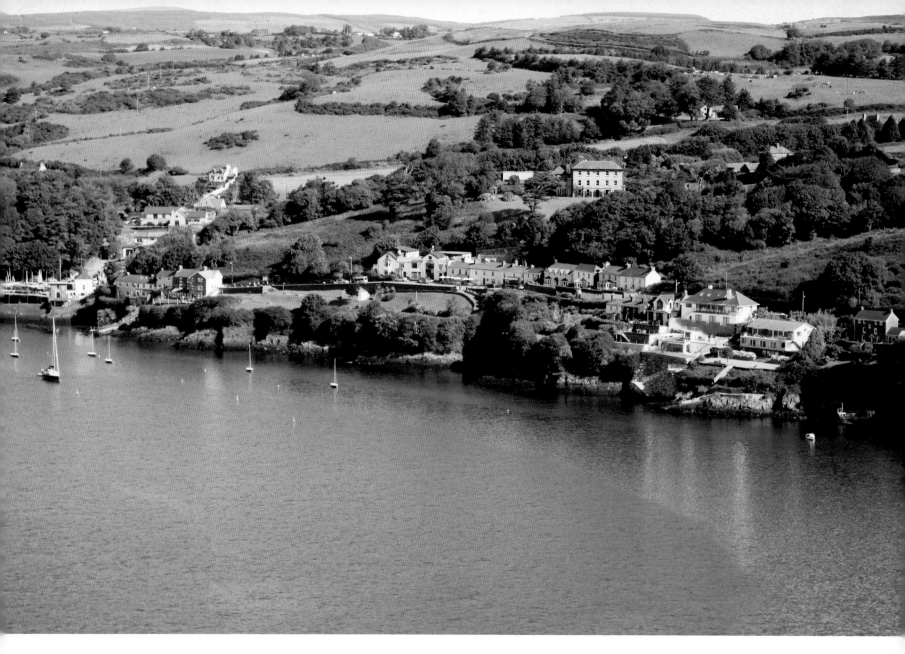

Glandore, a quiet, picturesque coastal village west of
Clonakilty, is a hive of sailing activity in the summer months
and is host to a biennial classic boats regatta.

Glandore Pier was constructed in the late 19th century. For decades
locally caught herring were salted by the pier prior to export.

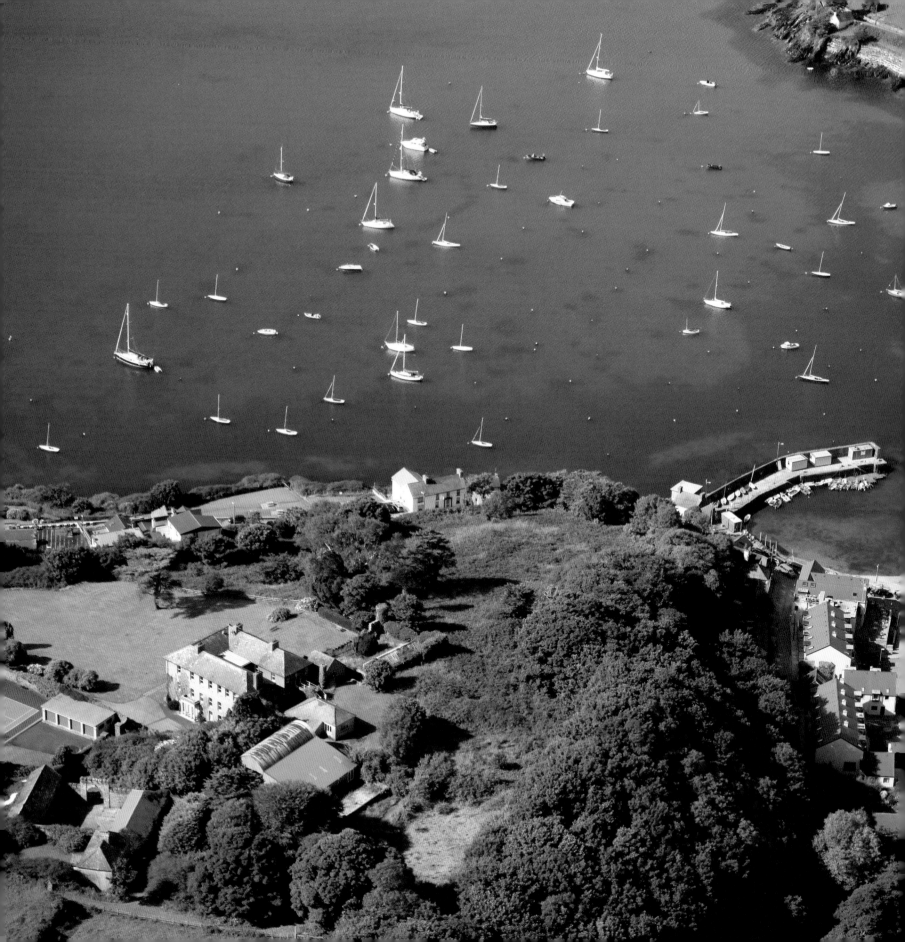

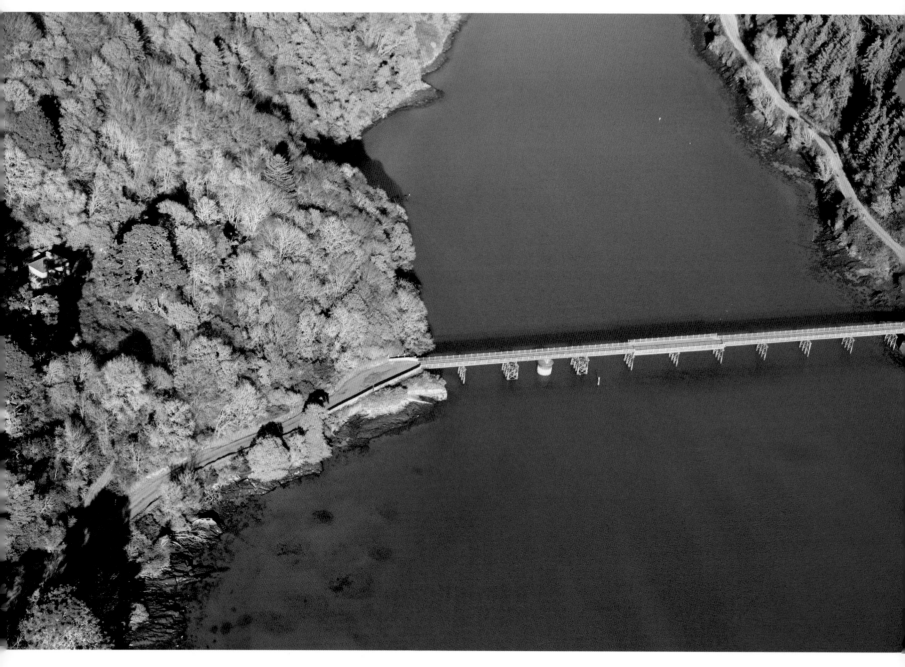

▲ The long one-laned bridge at Union Hall crosses the water from the edge of Myross Wood east to the Glandore side.

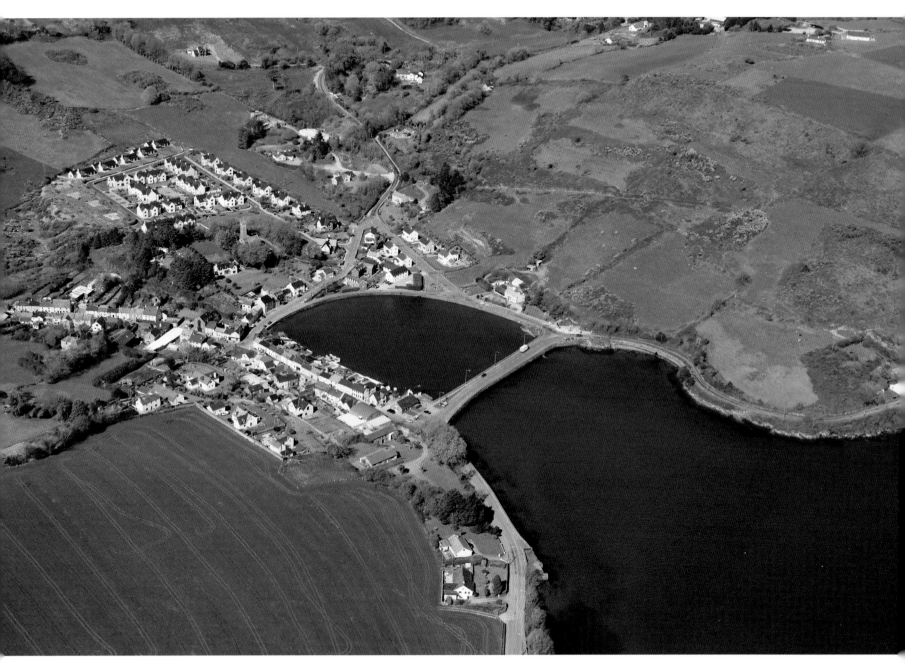

The bustling fishing village of Union Hall is located upriver from Glandore.

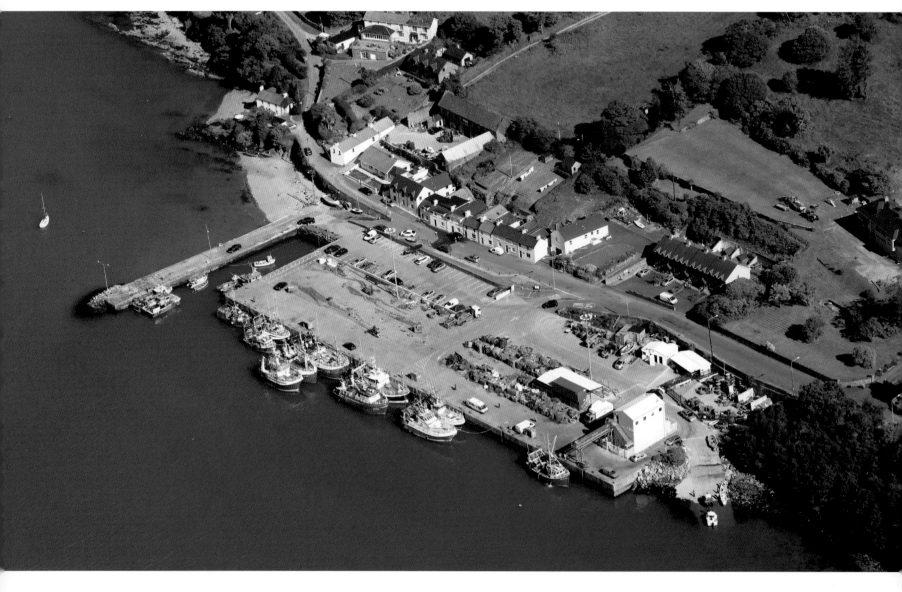

Union Hall is home to a local fishing fleet and also has its own fish-processing plant.

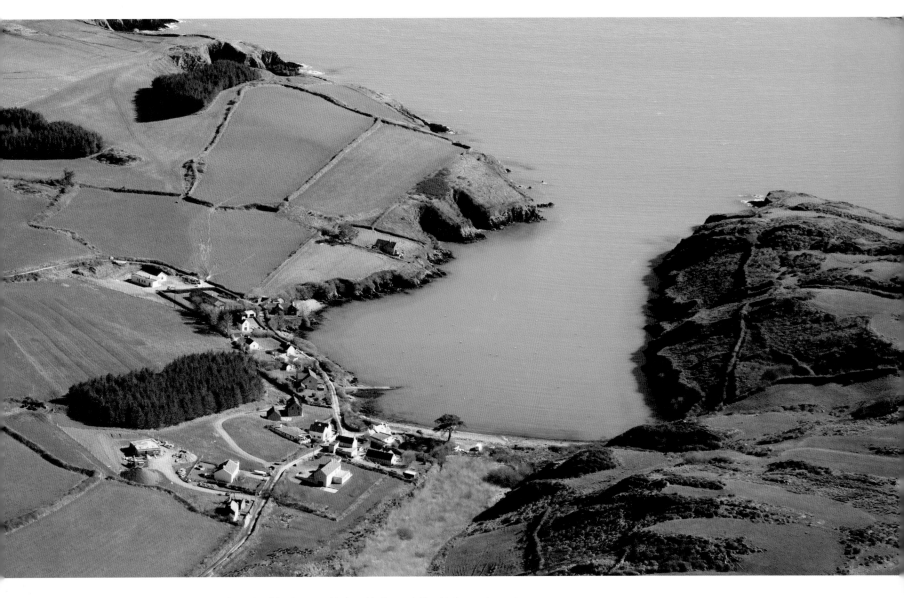

▲ Carrigillihy, a small cove located between Union Hall and Castletownshend with Rabbit Island at its mouth.

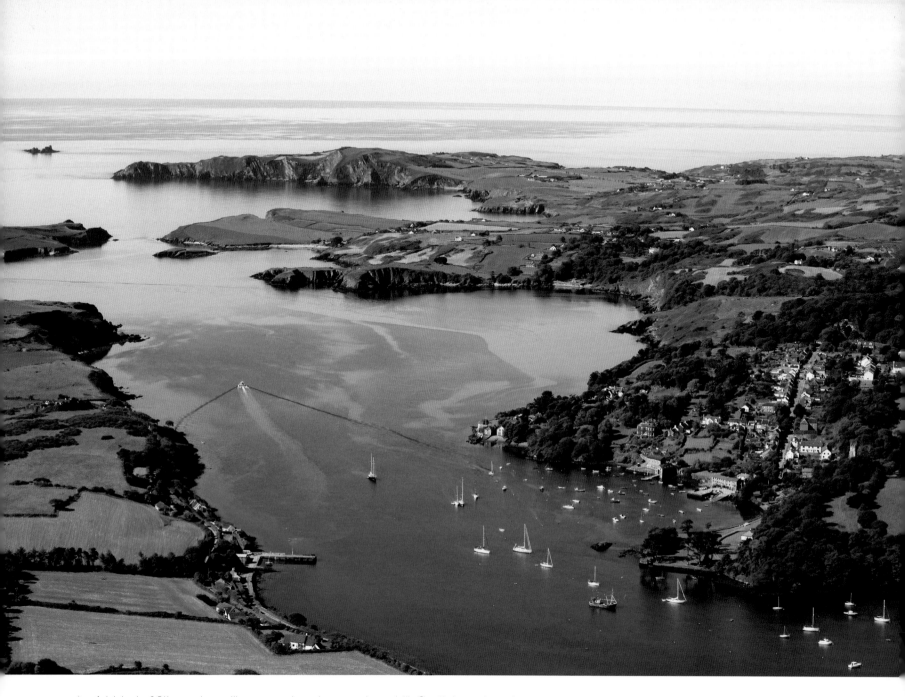

A historic 18th-century village running down a steep hill, Castletownshend
with its sheltered harbour is a favourite port of call for yachts cruising the
south-west coast.

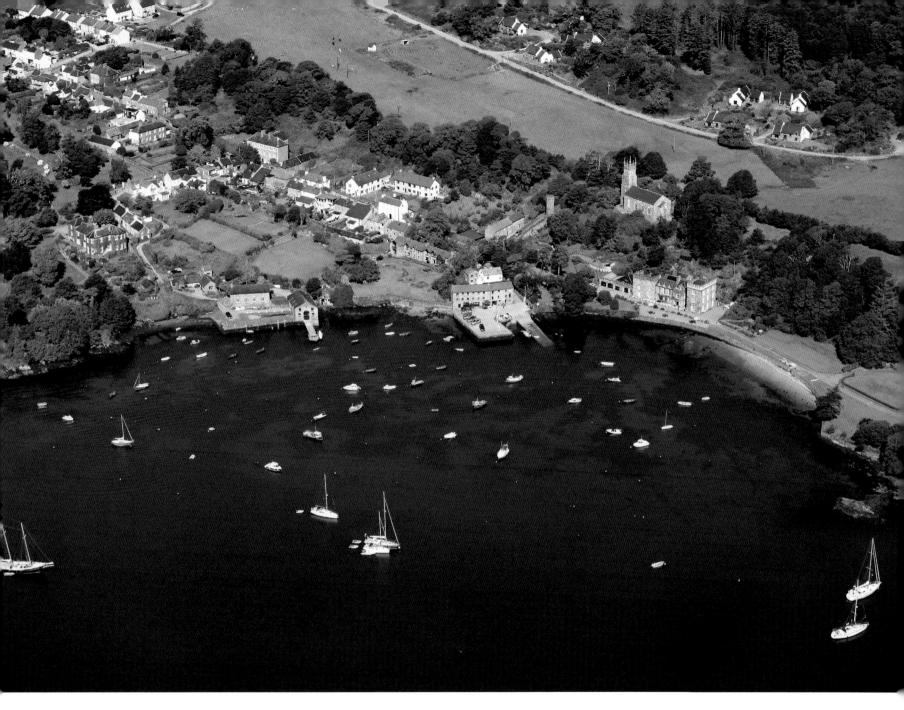

A closer view of Castletownshend's harbour with the castle and church clearly visible.

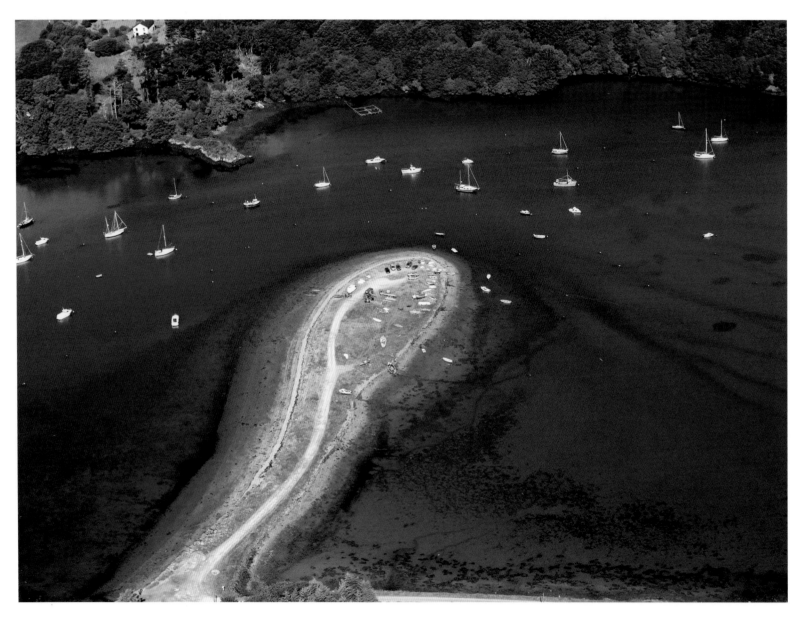

Just upriver from Castletownshend harbour this sandbar, known as The League, extends across the estuary.

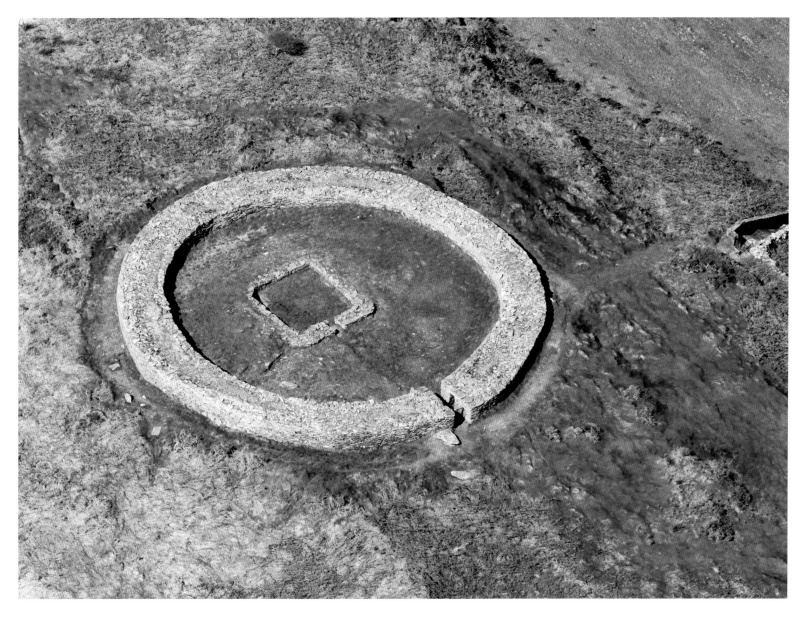

West of Castletownshend lies Knockdrum Stone Fort, an Iron Age/Early Christian enclosure which was built on an ancient venerated site. The fort was reconstructed by local people in the 20th century.

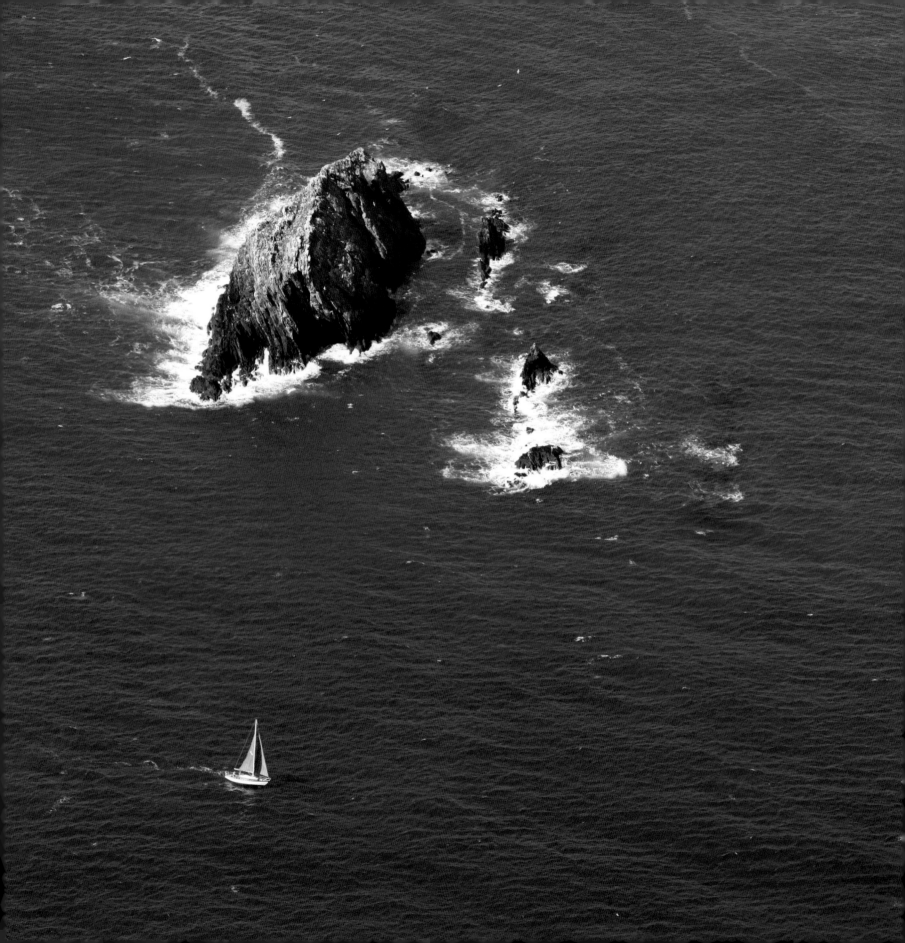

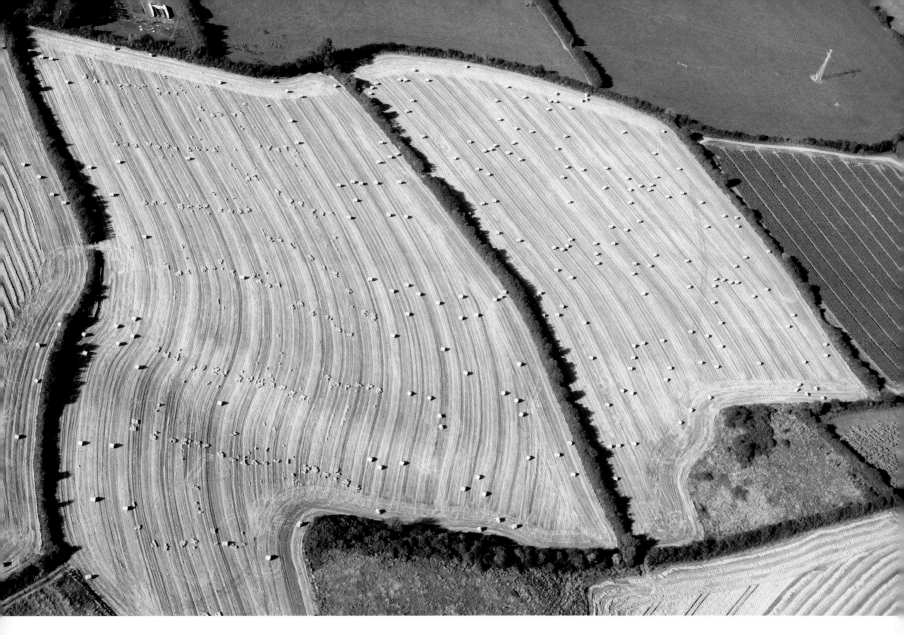

▲ Out in the open fields, baled straw awaits collection.

◄ Just off Toe Head near Castletownshend 'The Stags' are an outcrop of rocks given a wide berth by mariners.

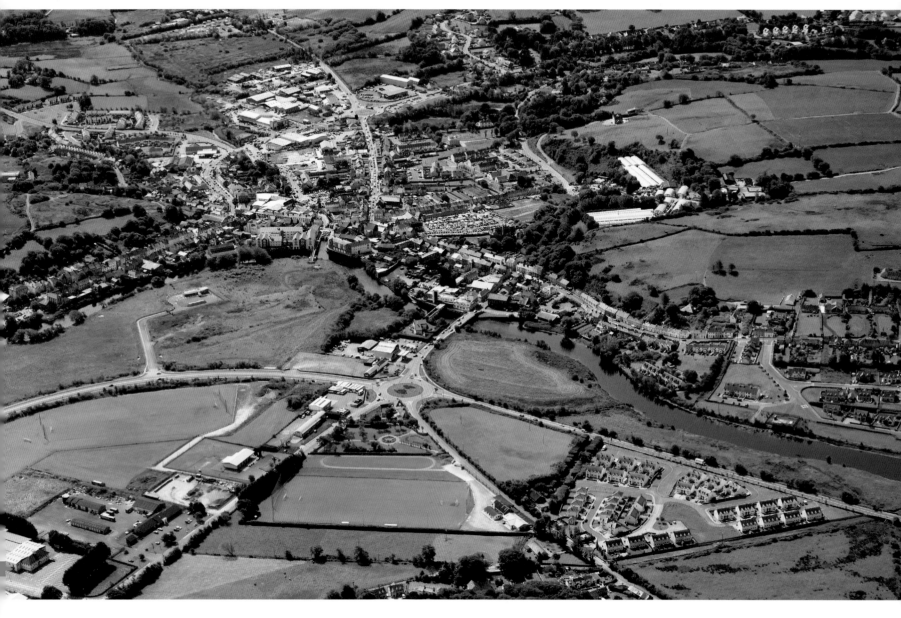

The principal town of west Cork and a former port, Skibbereen is a busy stop on the west Cork tourist trail.

▲ Greenhouses near Skibbereen. Since Roman times the advantage of growing plants under cover has been known and the first modern greenhouses were developed in Italy. Greenhouses are used intensively to cater for today's market demands.

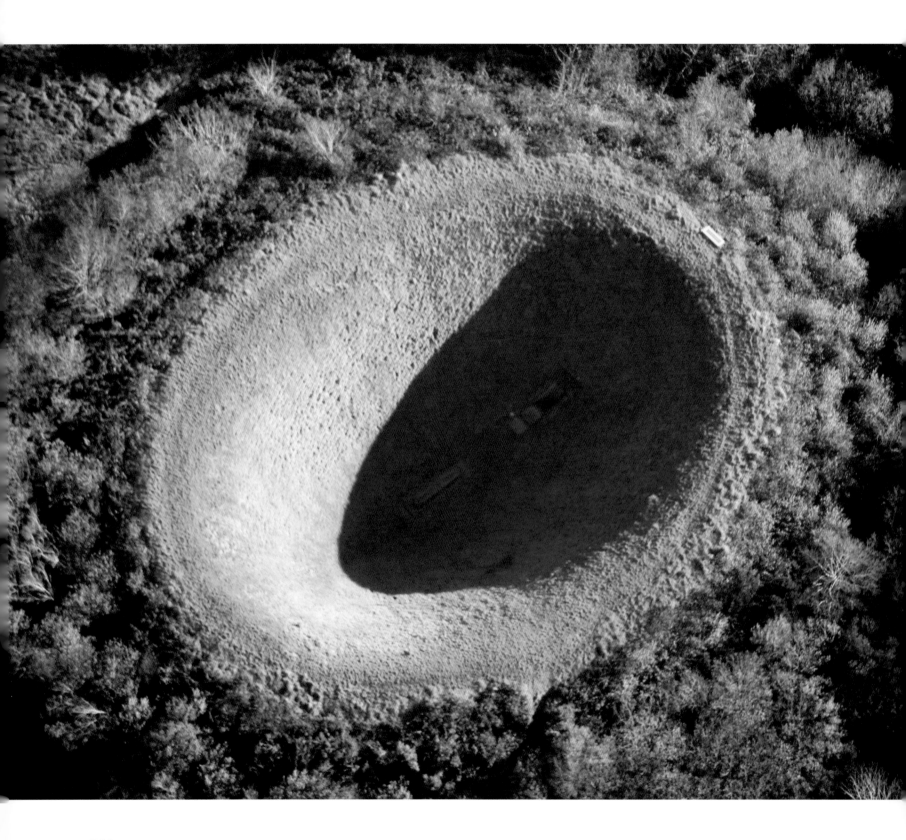

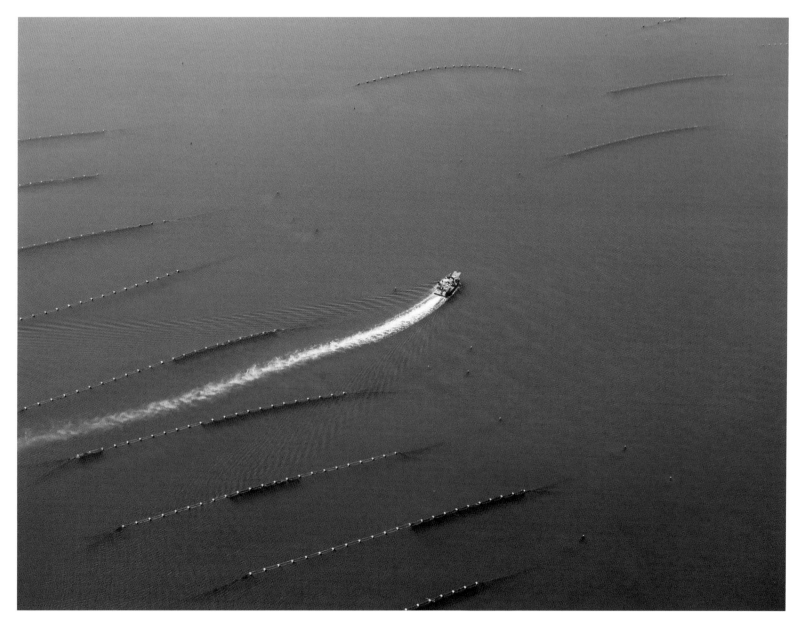

▲ Mussel farming in Roaringwater Bay. The warming influence of the
Gulf Stream makes this an ideal location for growing mussels.

◄ A land art project located in the gardens of the Liss Ard Estate
outside Skibbereen, the Sky Garden is a large crater designed
by renowned landscape artist James Turrell.

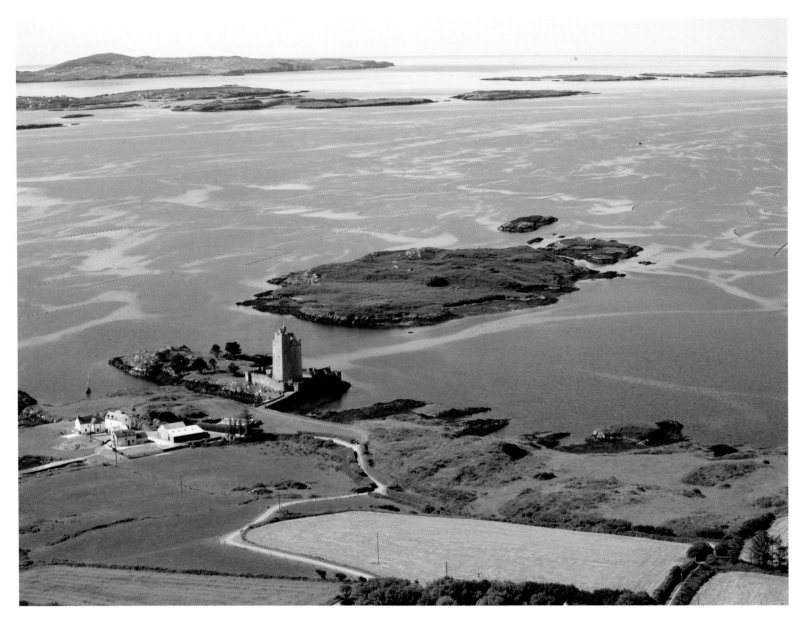

The view from Kilcoe takes in Heir Island in the centre to Cape Clear in the distance.

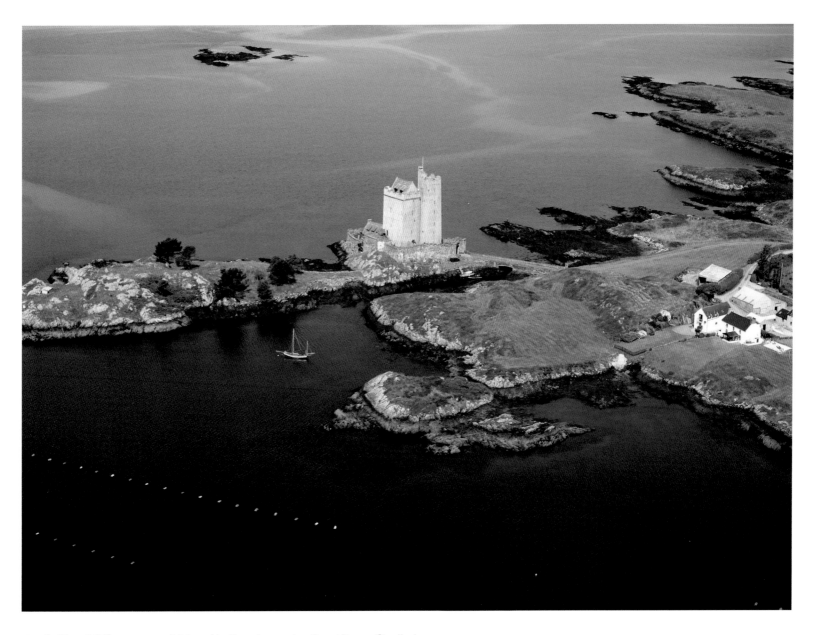

▲ Built *c.* 1450 on a small island in Roaringwater Bay, Kilcoe Castle is connected to the mainland by a bridge. The castle was extensively restored in recent years and is now a private residence.

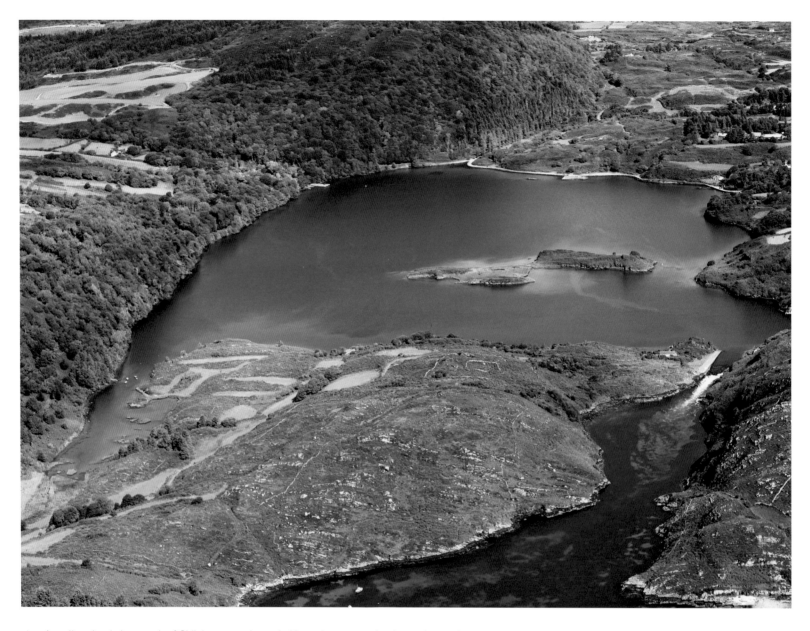

A saltwater lake west of Skibbereen, Lough Hyne is a popular beauty spot and was designated as Ireland's first marine nature reserve in 1981. The lake is fed by tidal currents which rush in from the sea through Barlogue Creek and the area sustains a large variety of plant and animal life.

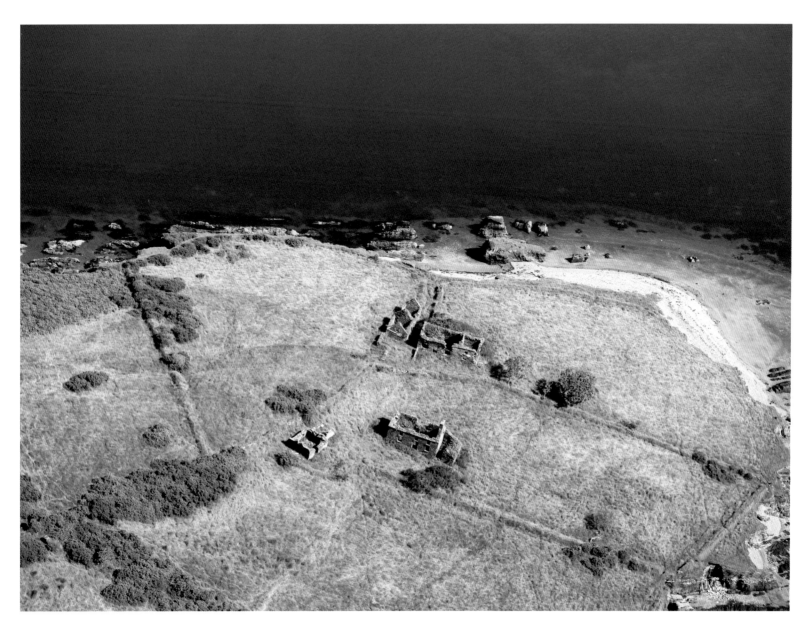

▲ Cottage ruins at Roaringwater Bay. In the past, many of the islands in the bay were inhabited. Over the years they have become depopulated due to emigration or moves to the mainland.

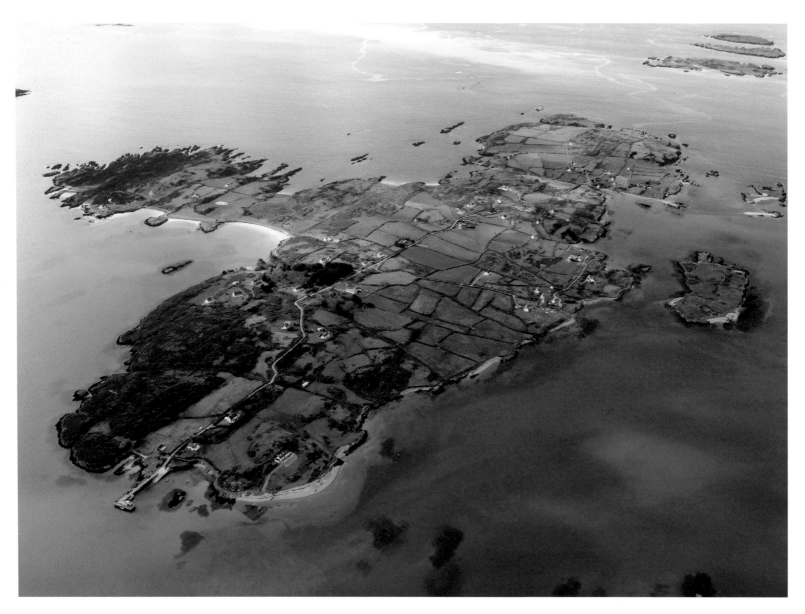

Heir Island in Roaringwater Bay has a small permanent population which increases in summertime. The island is one of 'Carbery's Hundred Isles' scattered throughout the bay and has a sailing centre and a number of small local industries.

In order to avoid rocky sections of his coastal land, this farmer cuts silage in a zigzag fashion creating patterns which resemble bunkers on a golf course.

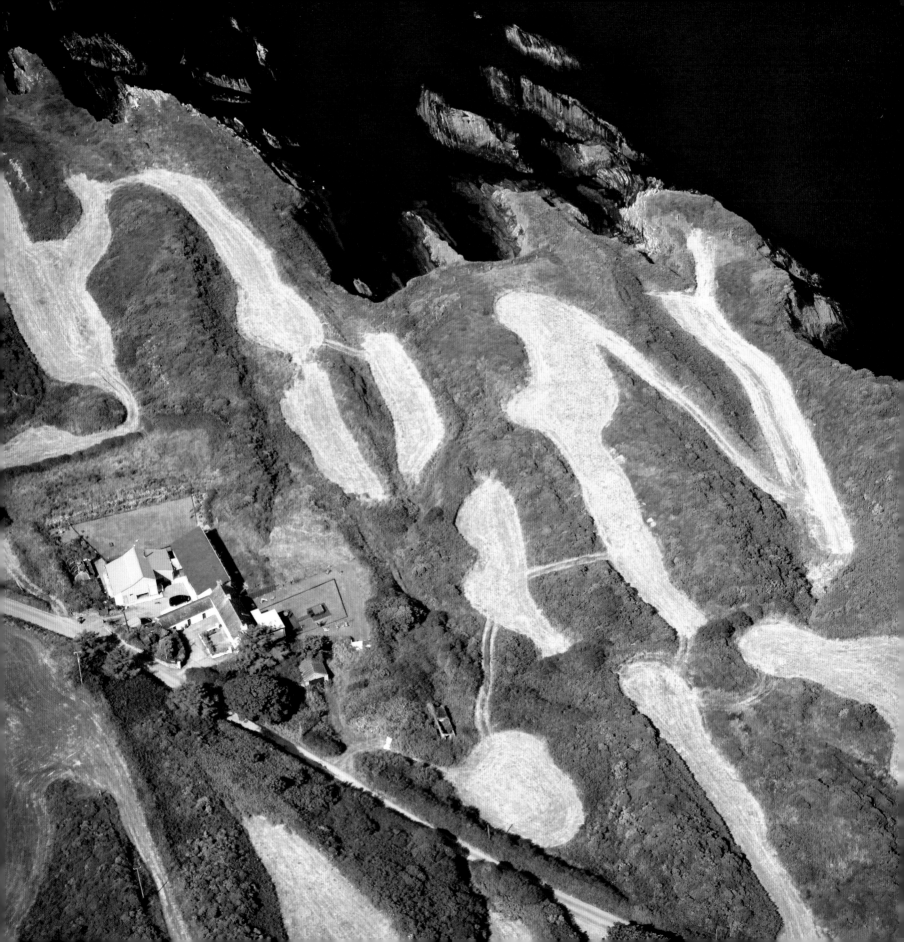

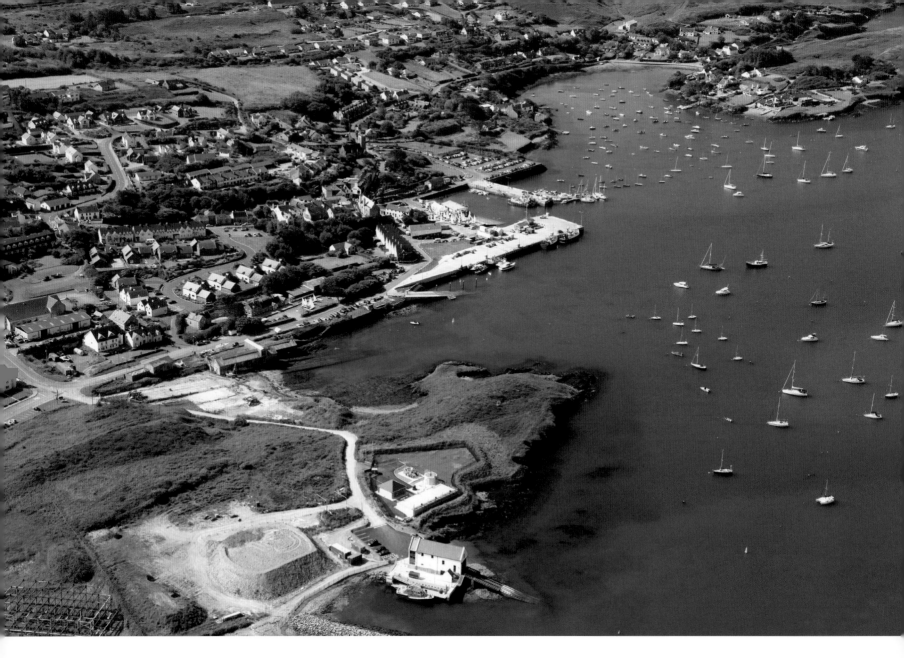

A busy coastal village on the eastern side of Roaringwater Bay, Baltimore is the main ferry port to Sherkin and Cape Clear Island. Baltimore was sacked in 1631 by Algerian pirates and many of the villagers were sold into slavery. The lifeboat station can be seen in the bottom foreground.

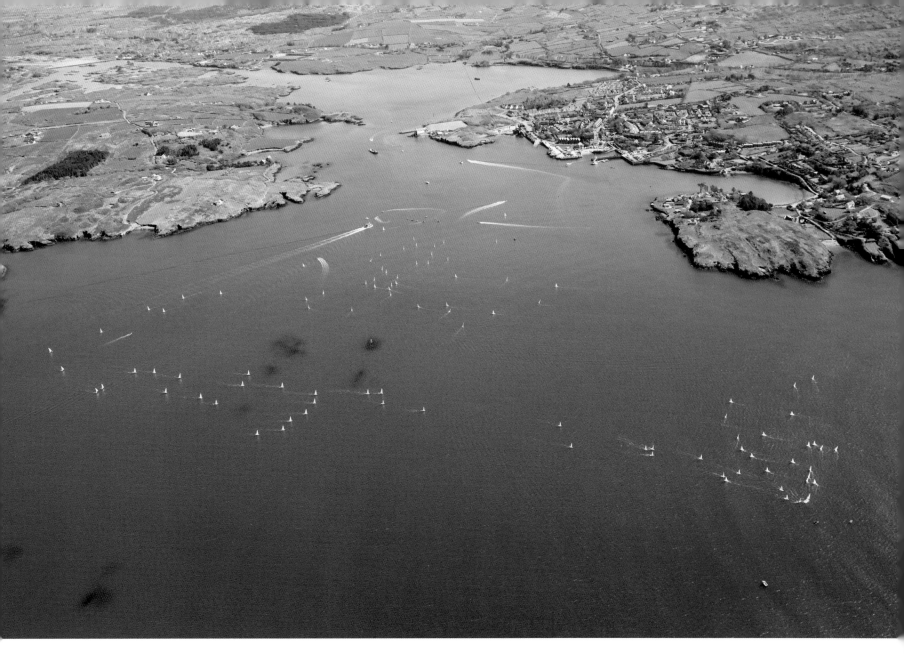

Baltimore is a renowned sailing centre and many sailing events are held here.
It is the home of the very active Baltimore Sailing Club.

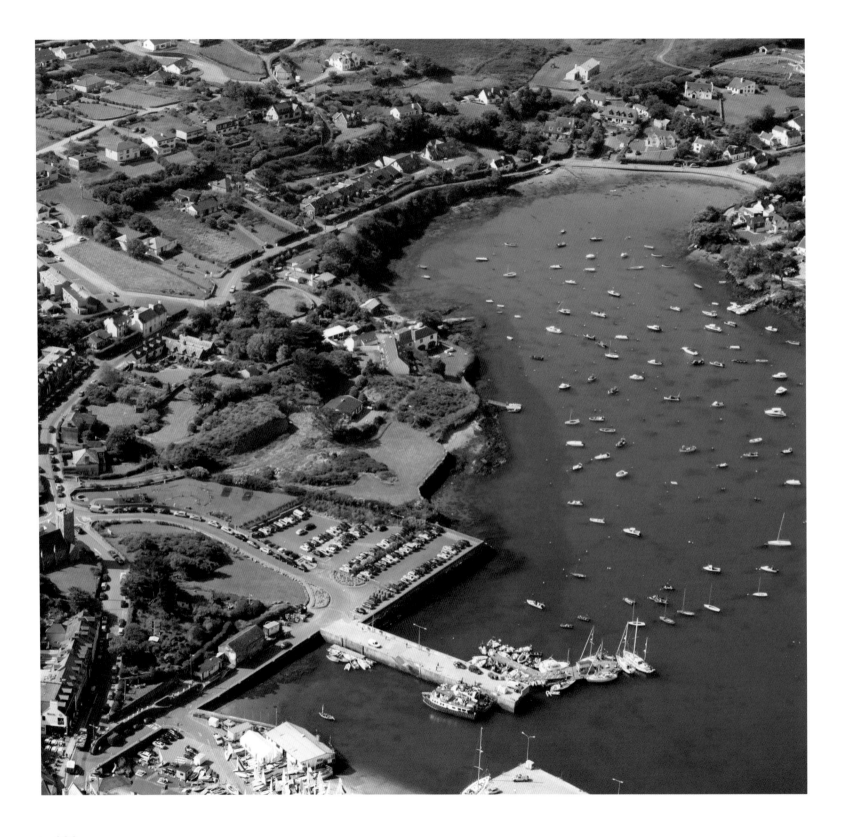

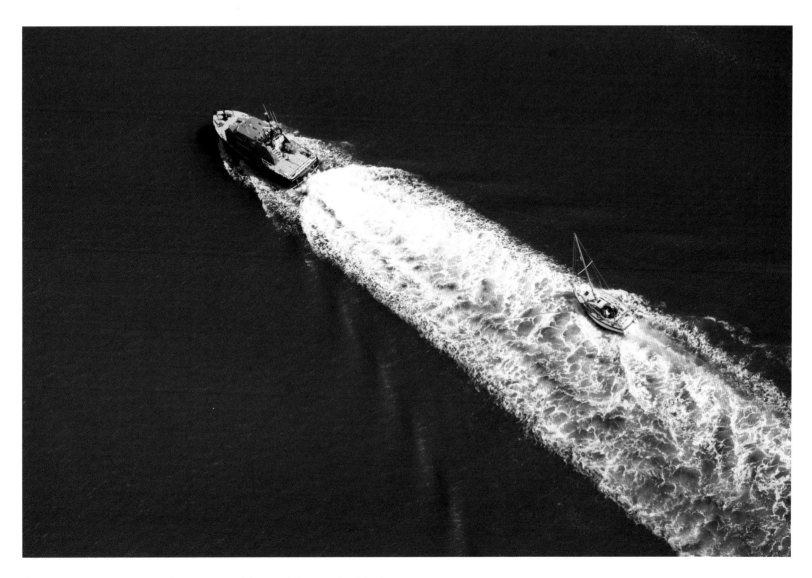

The RNLI Baltimore Lifeboat *Alan Massey* takes a disabled
yacht in tow and leads it to safety. Baltimore Lifeboat Station
was established by the RNLI in 1919 and many lives have
been saved by the bravery of its volunteer crews.

On the seaward side of Baltimore village, The Cove, as
its name implies, is a sheltered area ideal for mooring
small craft.

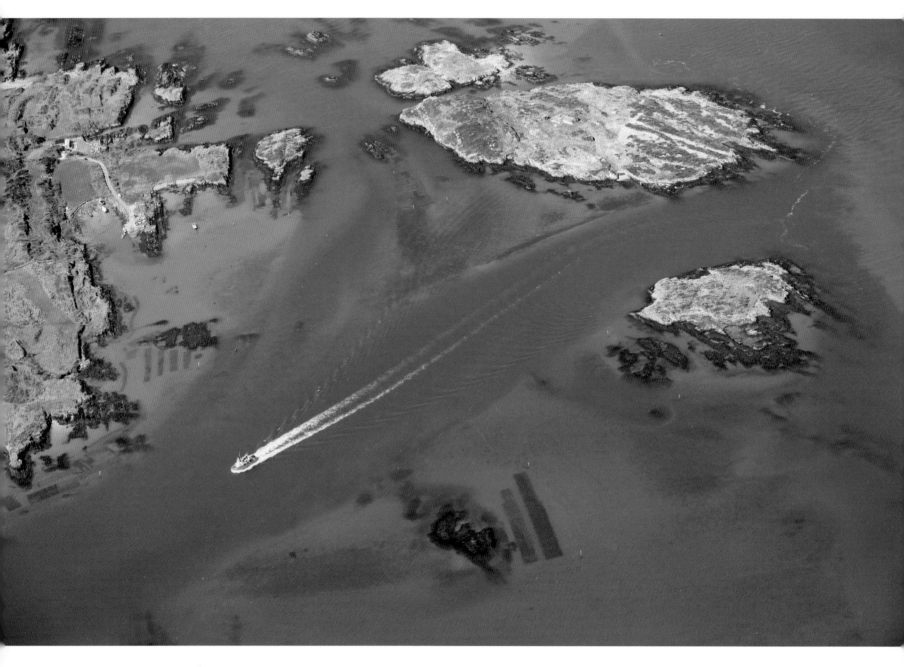

The ferry *Dún an Óir* makes its way from Baltimore to the open sea
on its journey to Cape Clear.

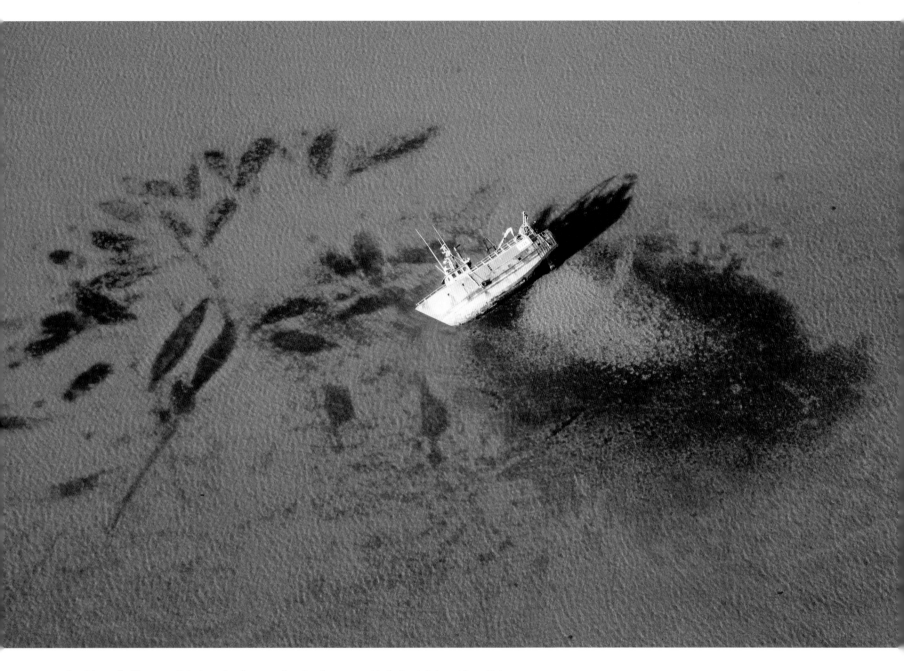

▲ Near Baltimore, this trawler lies on the bottom and is fully visible at low tide.

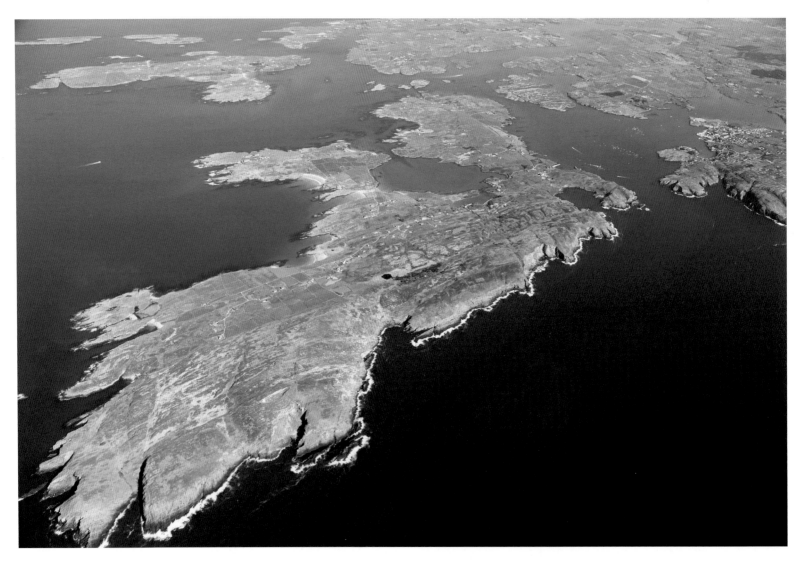

To the west of Baltimore and accessed by ferry, Sherkin Island has an active population which varies from winter to summer. In the 14th century a Franciscan friary was founded on the island and the ruins remain to this day.

Barrack Point on the southern end of Sherkin Island is the entrance to Horseshoe Harbour.

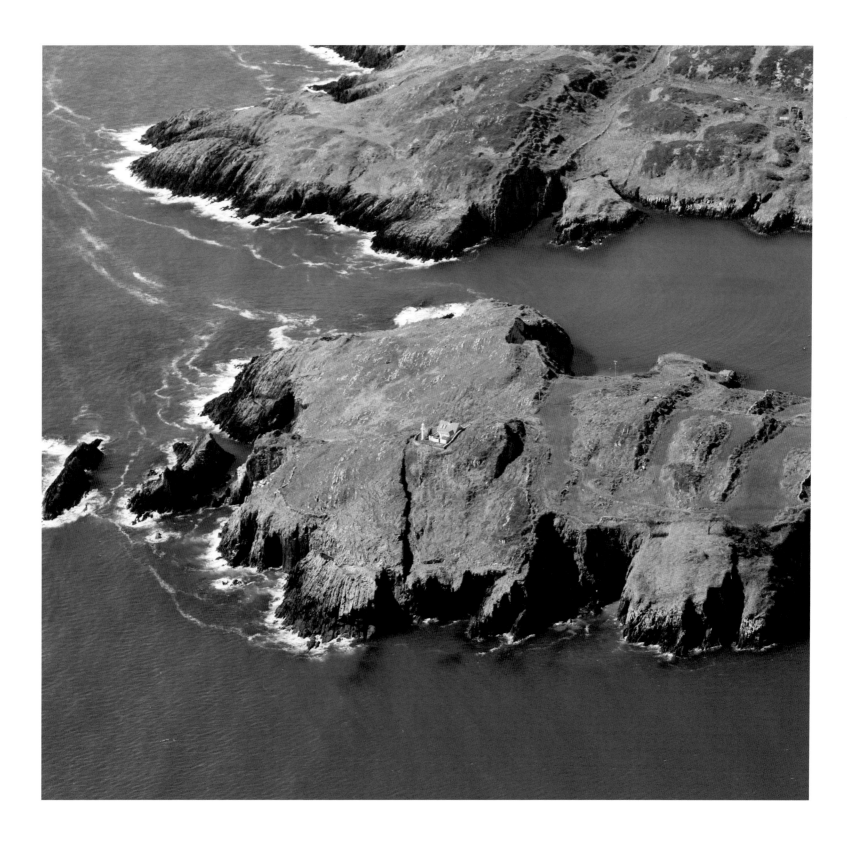

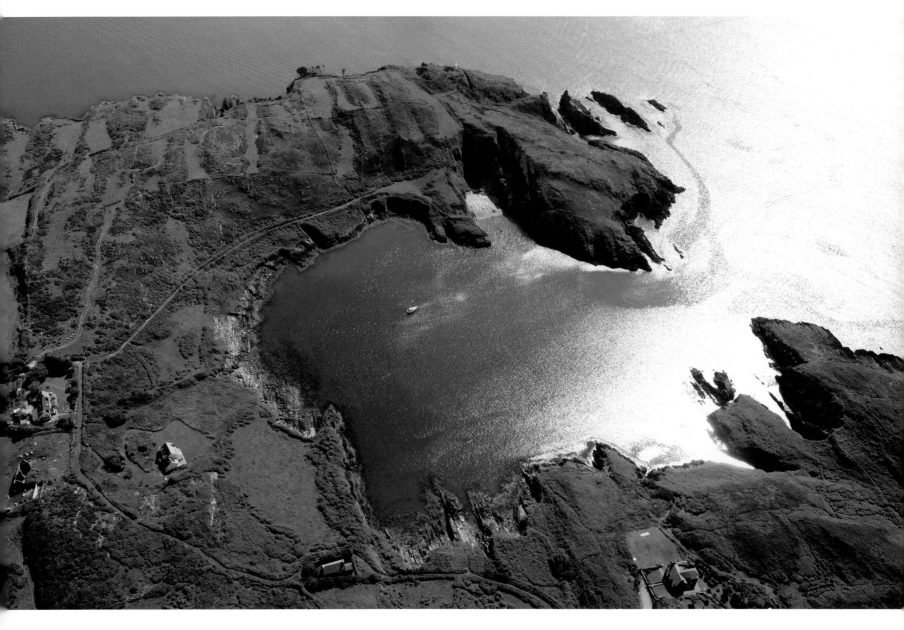

A quiet cove on the south-eastern end of Sherkin Island, Horseshoe Harbour is a favourite anchorage for visiting boats.

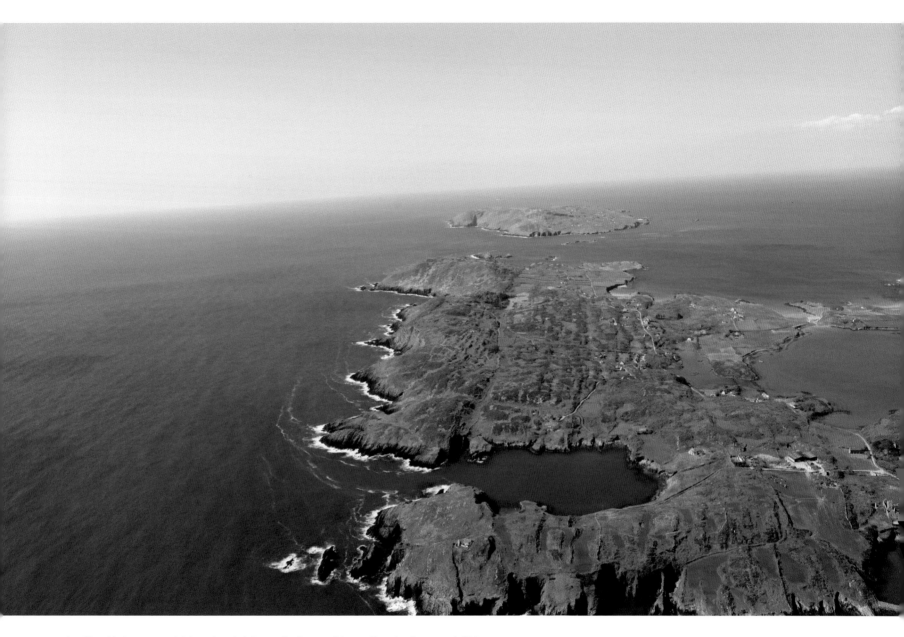

▲ Sherkin's nearest island neighbour is Cape Clear, 2km to the west. This view looks from Sherkin to 'The Cape', as it is known locally.

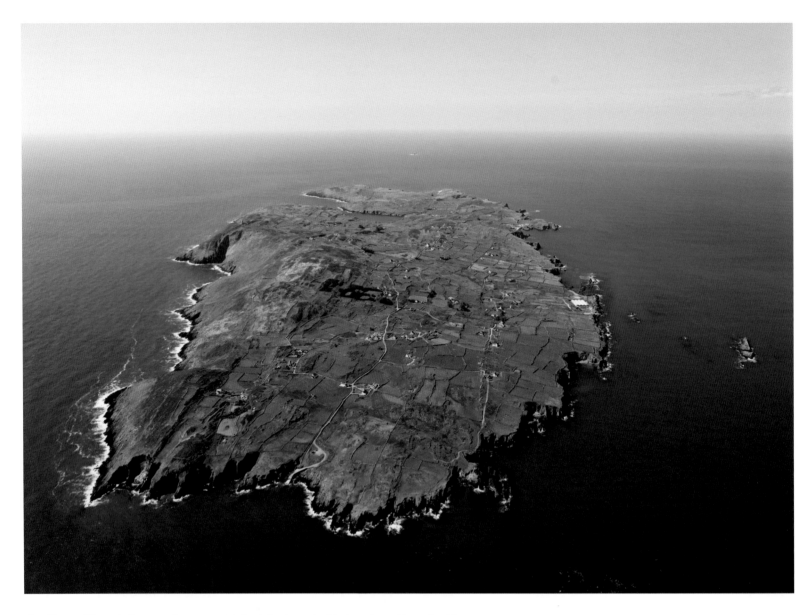

Cape Clear is the southernmost inhabited part of Ireland and is noted for its bird life. It has a permanent population of over 100 and is a 45-minute journey by ferry from Baltimore.

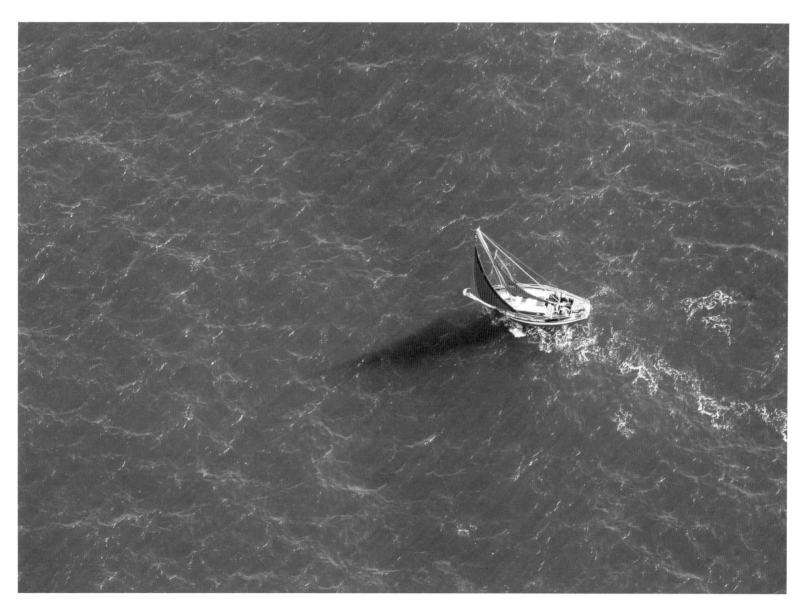

Roaringwater Bay is ideal cruising water for sailors, with many interesting ports of call, including coves, inlets and small harbours dotted throughout the area.

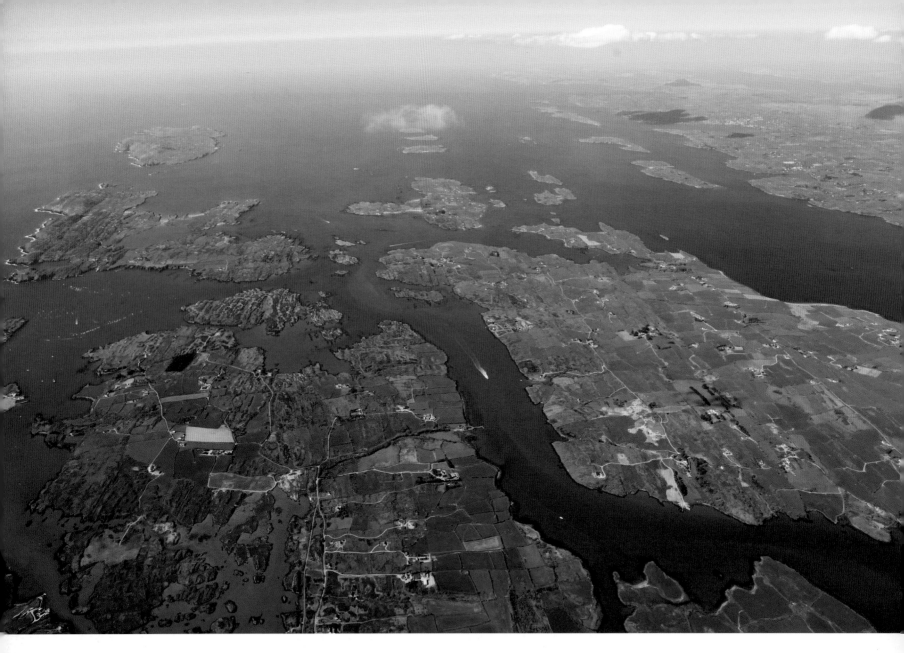

'Carbery's Hundred Isles'. Strewn across Long Island and Roaringwater Bays in the ancient Barony of Carbery are many islands of varying sizes. Some of the larger islands are still populated, but most of the smaller ones are now uninhabited. The largest of the islands are Cape Clear and Sherkin.

Schull, or 'Skull', derives its name from a medieval monastic school of which no trace now remains. Schull is a popular tourist and sailing centre and lies on the ruote west to Mizen Head.

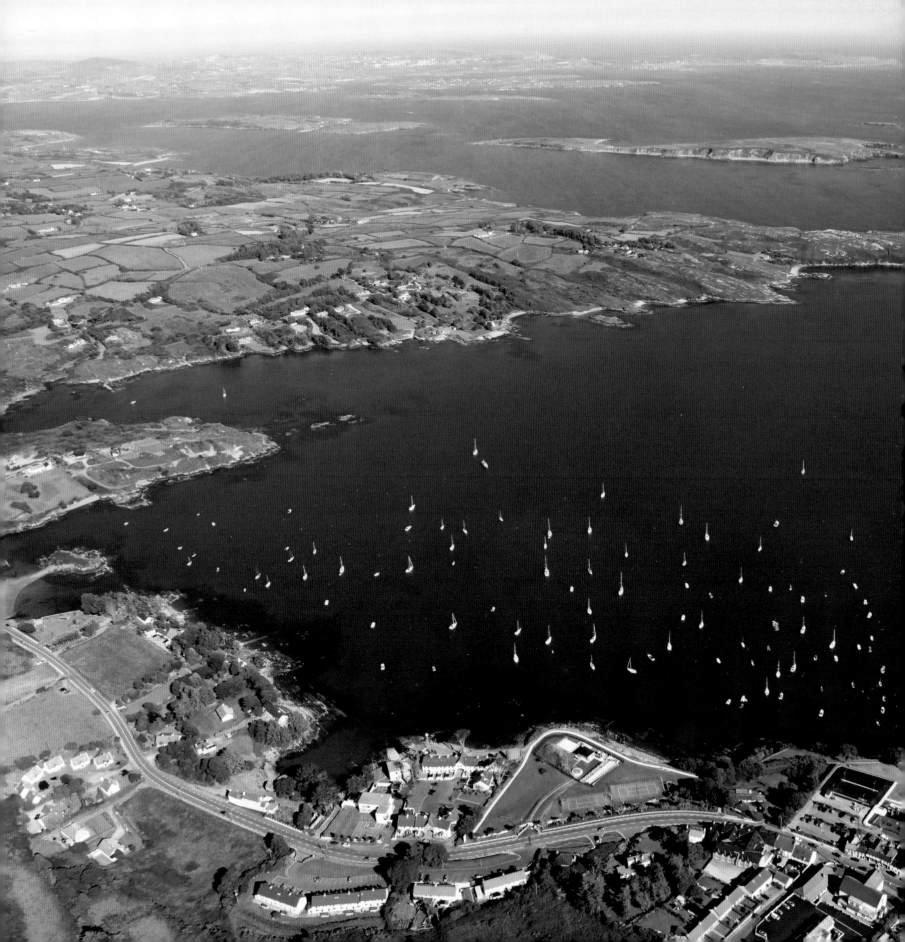

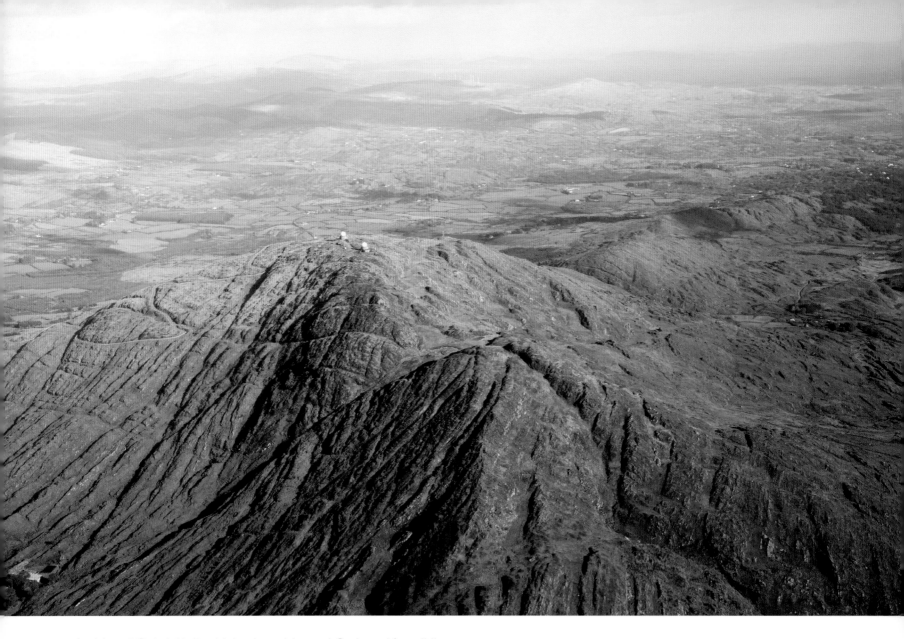

▲ Mount Gabriel is the highest peak in west Cork and from it there are spectacular views of Schull Harbour and Long Island Sound. Copper ore was mined here in the Bronze Age. The two white domes on the summit are part of the European air traffic control system.

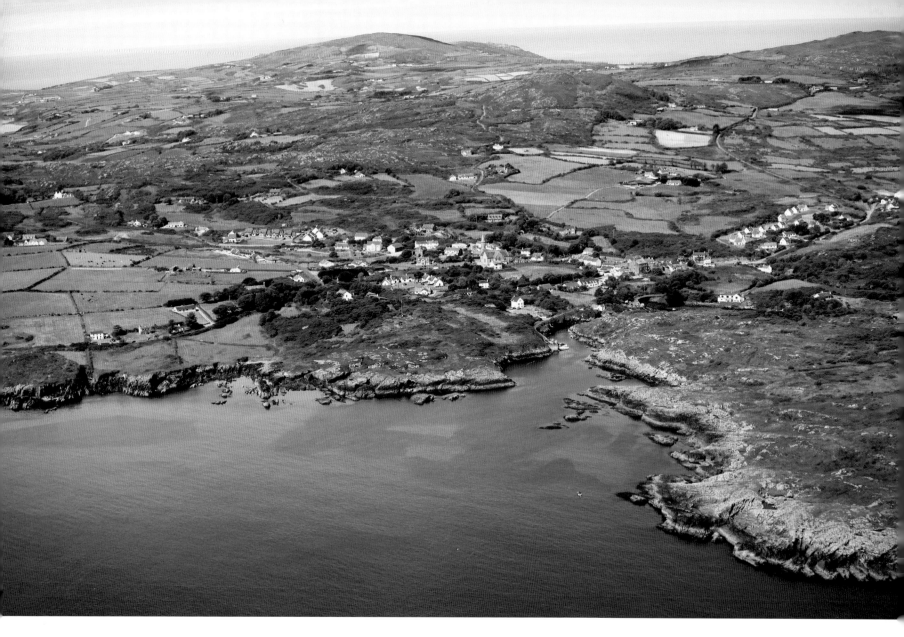

A tiny inlet barely visible from the sea marks the seaward entrance to Goleen, a village on the road between Schull and Crookhaven.

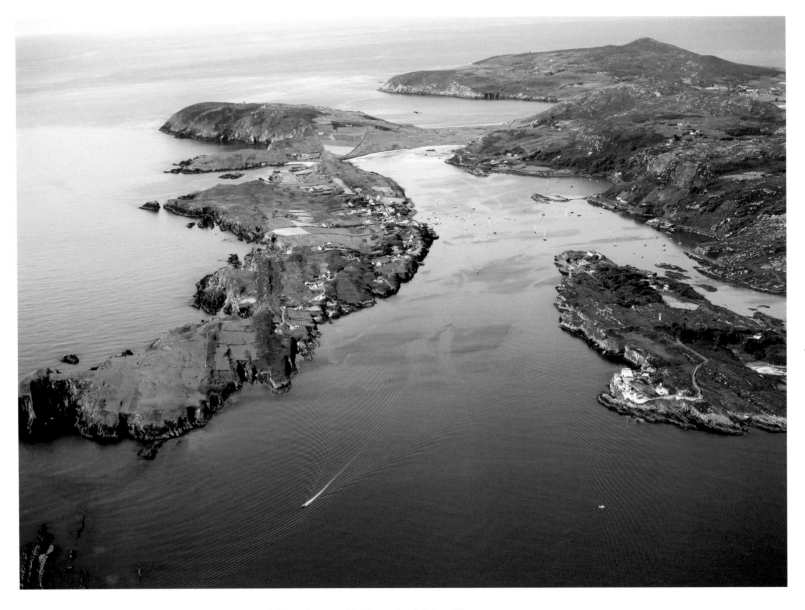

Looking to the west the wide expanse of Crookhaven Harbour is visible with Rock Island on the right-hand side.

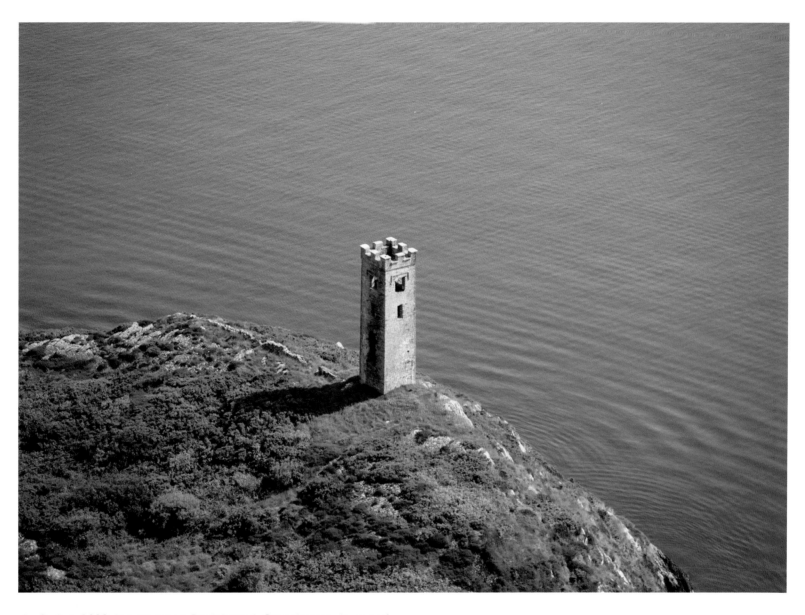

Built *c.* 1800, the tower on Rock Island, Crookhaven, is one of a network of signal towers built around the coast of Ireland to ensure a quick response in the event of invasion.

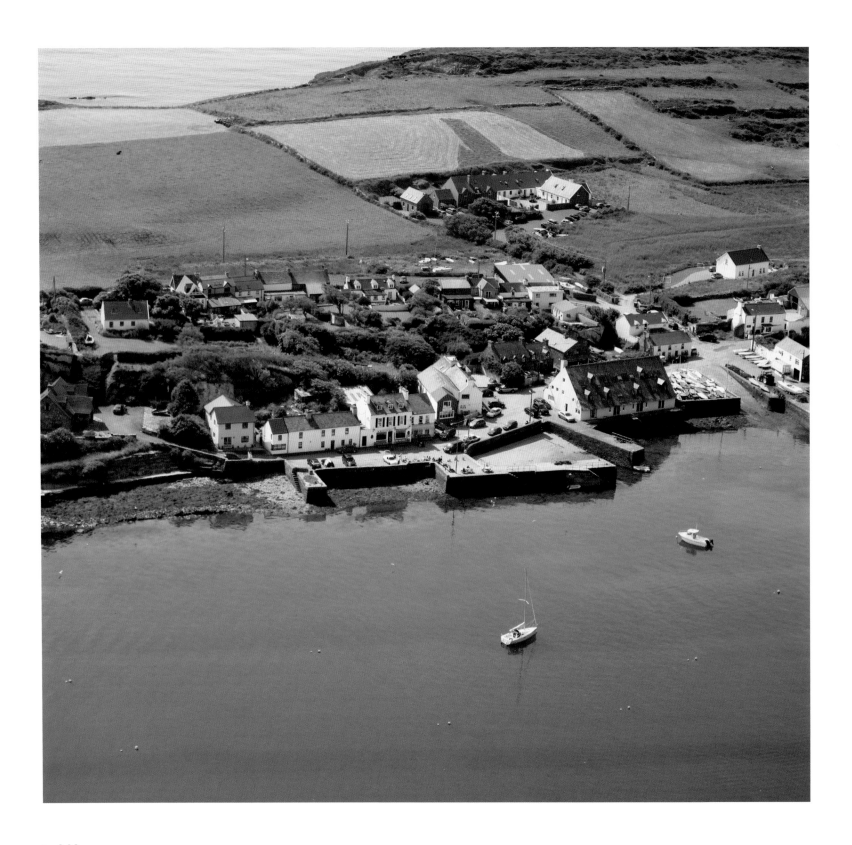

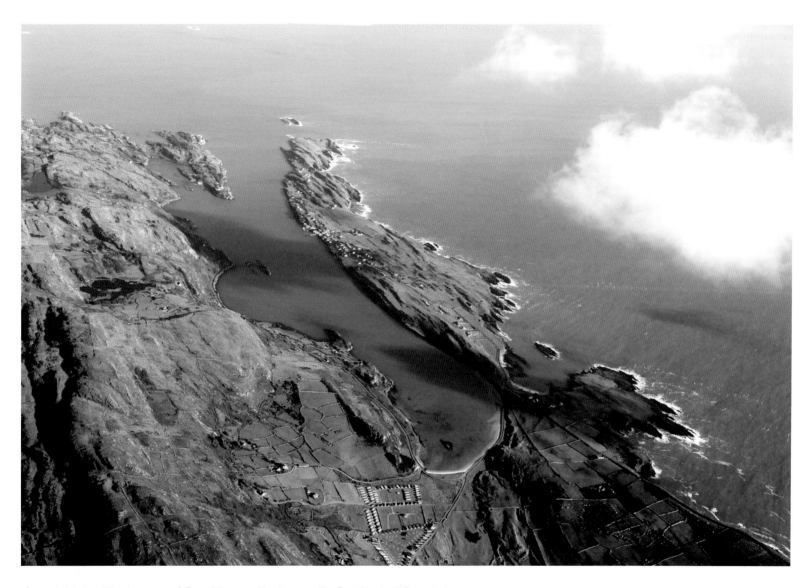

A high-altitude view of Crookhaven Harbour with Cockleshell Beach in the lower foreground.

The picturesque village of Crookhaven on the most south-westerly tip of Ireland is where Marconi began his early wireless experiments.

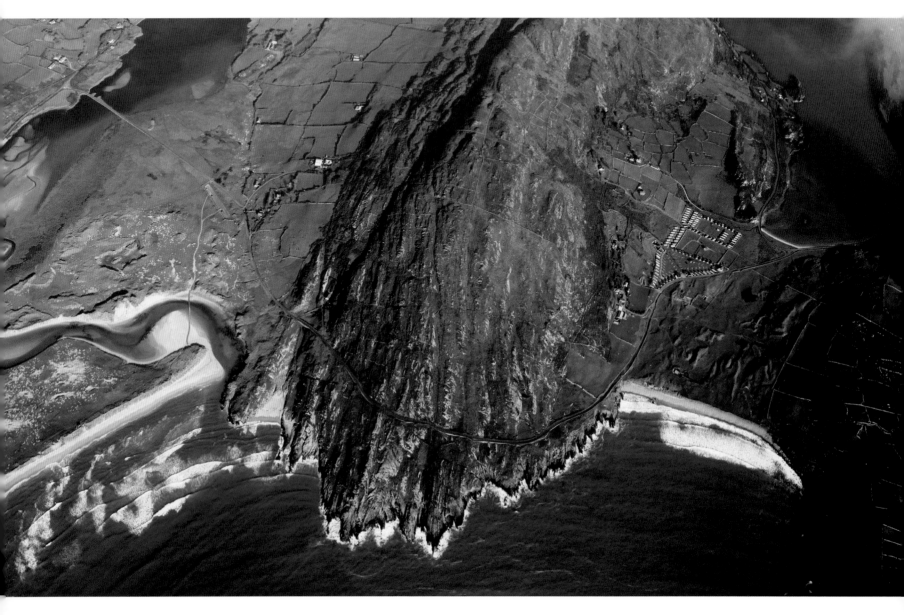

The undulating west Cork coastline: Barleycove (left) and Stony Beach (right), separated by the rocky outcrop of Lackenakea. This image was taken at a height of 8,000 feet.

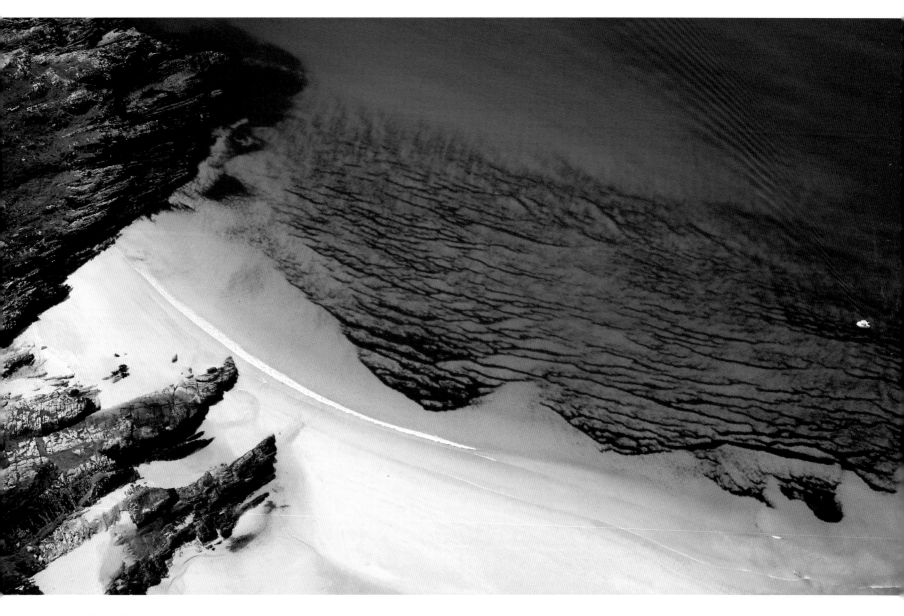

▲ Stony Beach, a quiet spot adjacent to Barleycove.

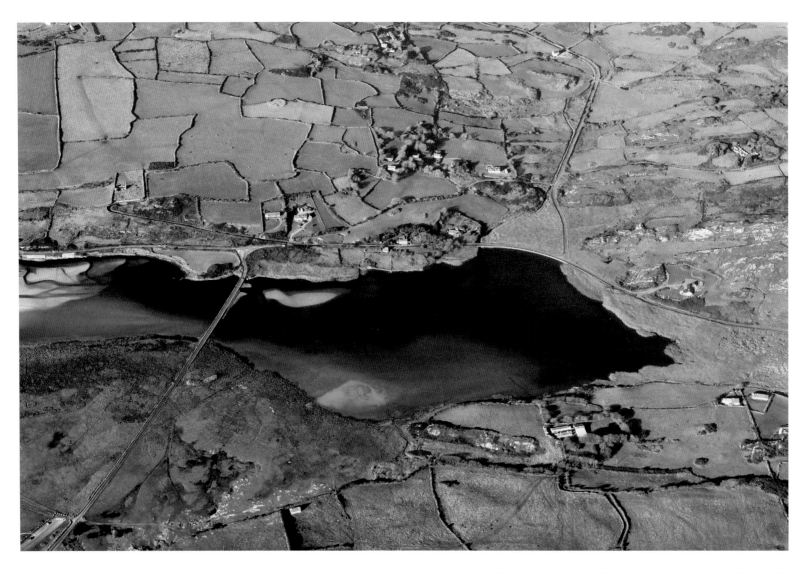

Located close to Barleycove, Lissigriffin Lake teems with wildlife. ▲

The wide sandy beach of Barleycove is a favourite tourist spot. ▶

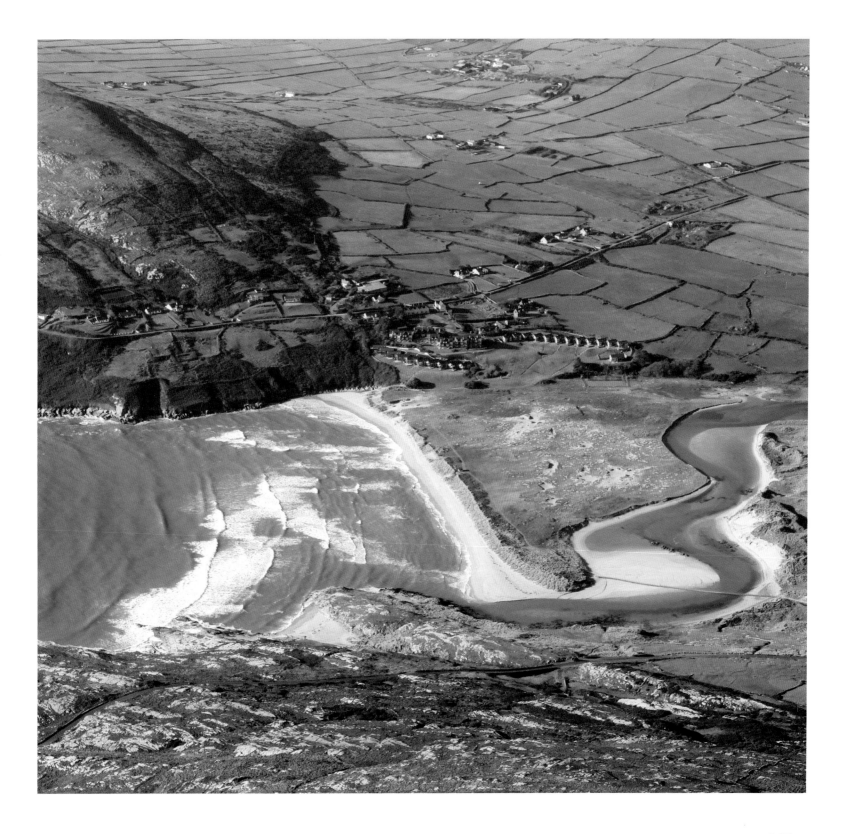

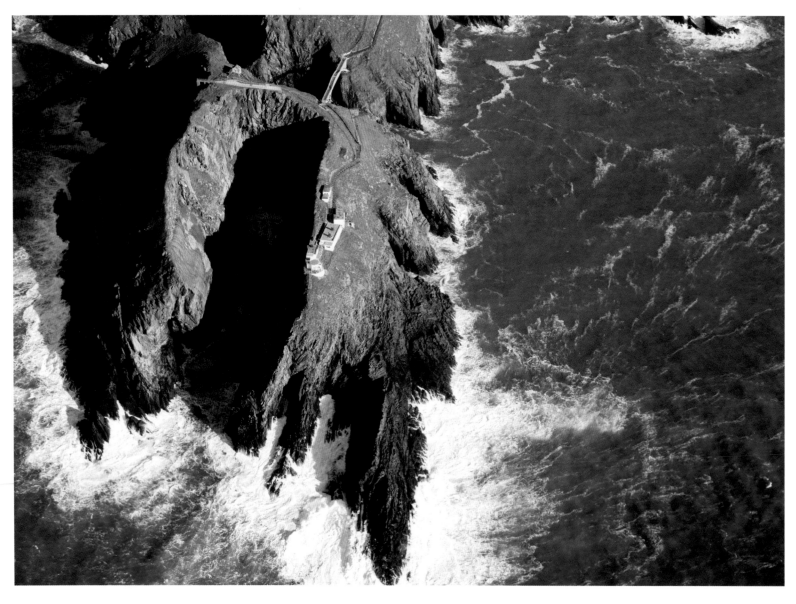

Ireland's most south-westerly point, Mizen Head is home to an Irish Lights signal station and a visitor centre.

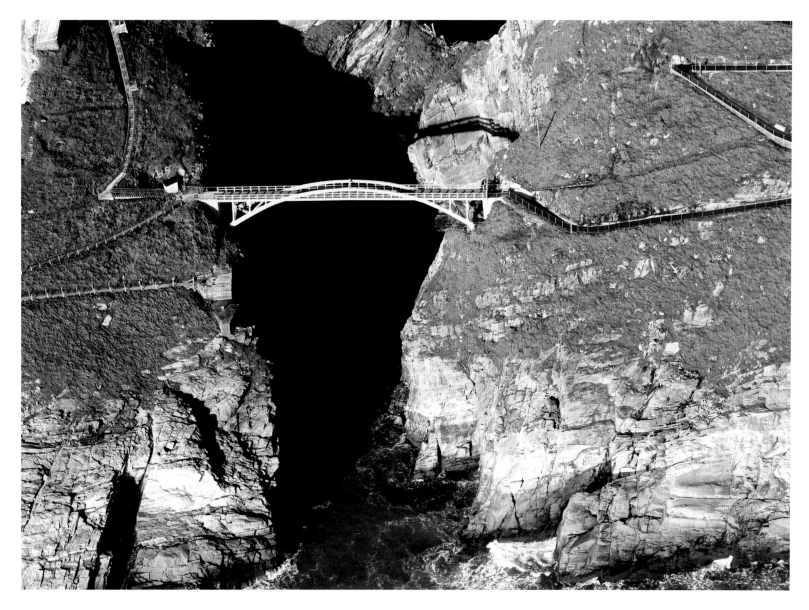

There has been a footbridge above the deep gorge at Mizen Head since 1909. The present bridge was opened in 2011.

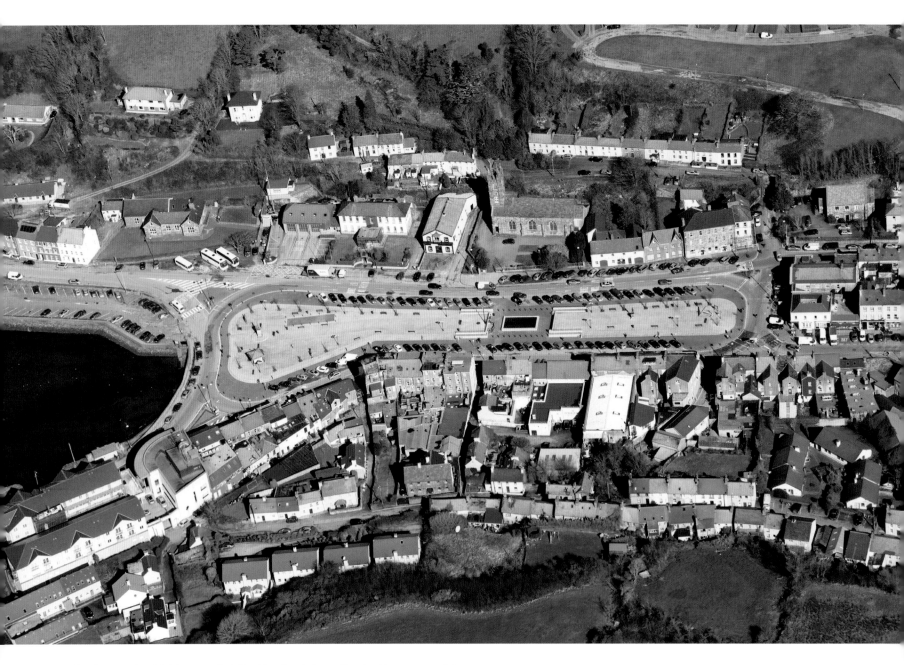

An ancient fishing port visited by fleets from Spain, France and the Netherlands, Bantry is now a busy coastal town. Whiddy Island shelters the mouth of the bay.

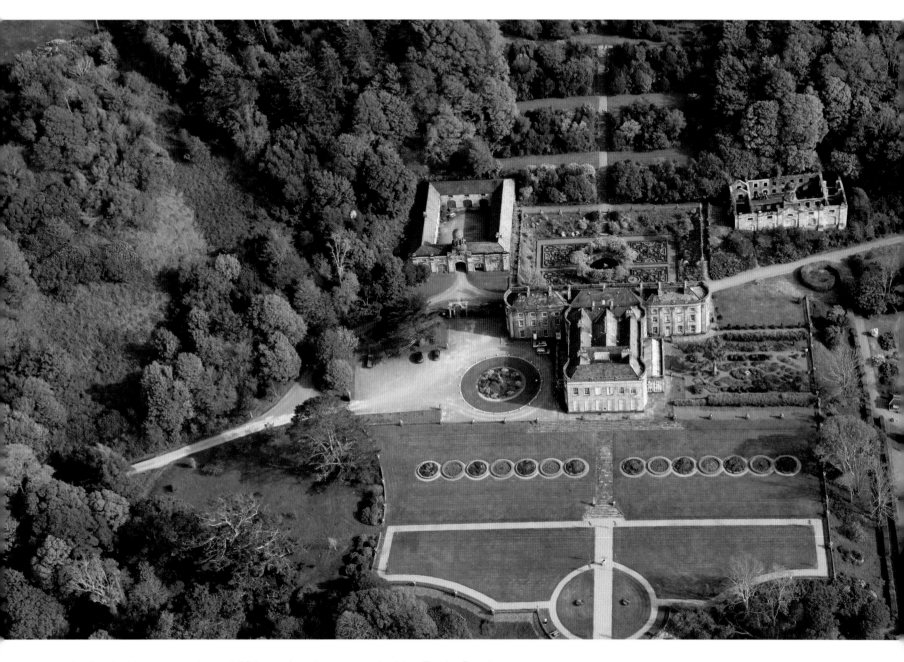

▲ Bantry House, an elegant 18th-century house overlooking Bantry Bay, has been open to the public since 1946.

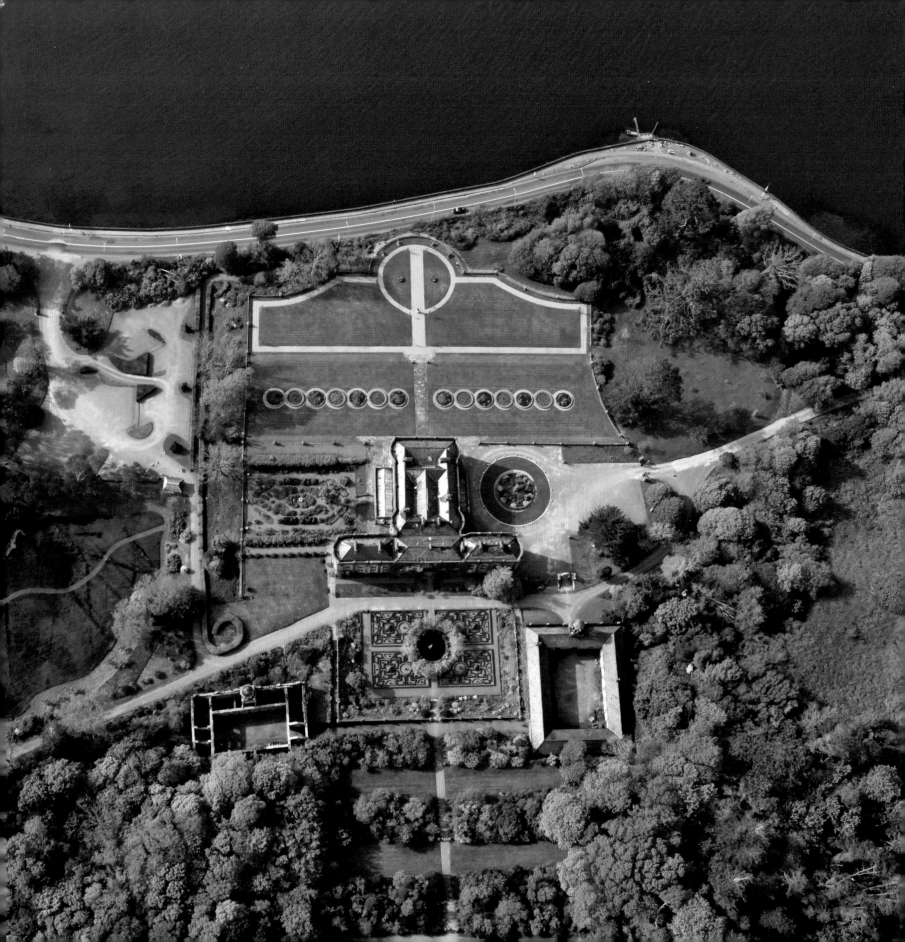

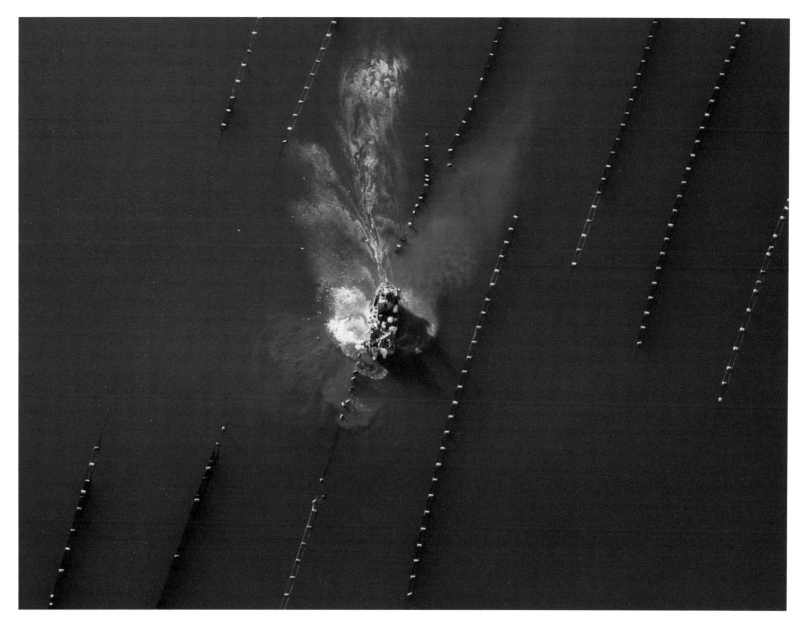

A workboat travels the mussel lines in Bantry Bay,
constantly monitoring the rafts.

The exquisite gardens of Bantry House are
impeccably maintained and feature a wide variety
of azaleas & rhododendron.

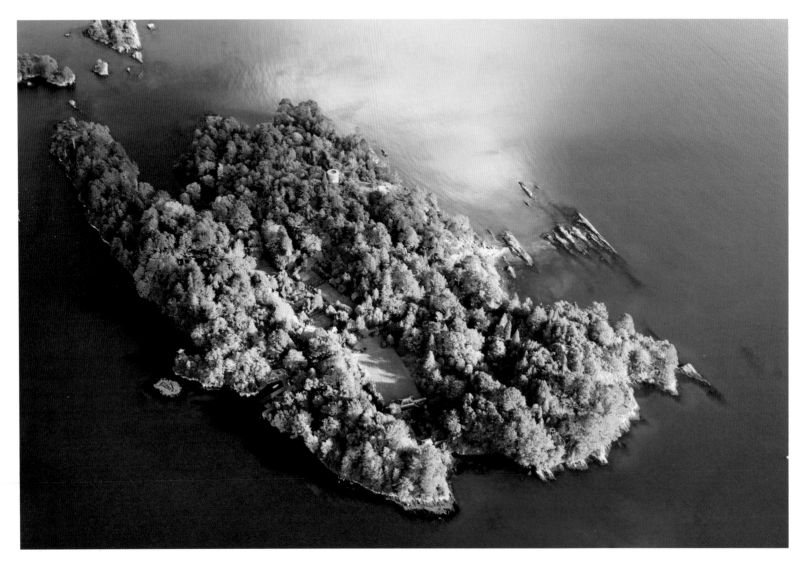

▲ Also called Illnacullin, Garnish Island lies in a sheltered location in
Glengarriff Harbour and enjoys a subtropical climate. It is famous for its
gardens, which are visited by thousands of tourists each year.

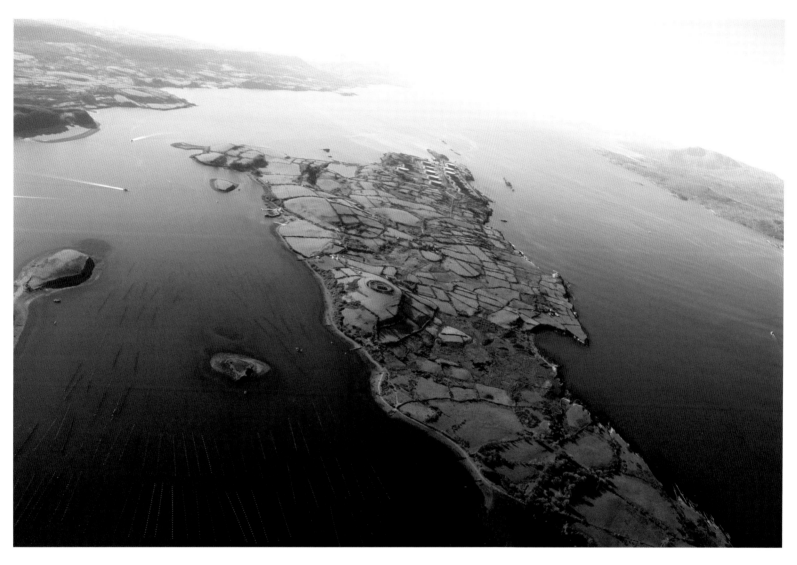

▲ Whiddy Island in Bantry Bay is where Ireland's crude oil reserves are stored and was once home to a US naval air station.

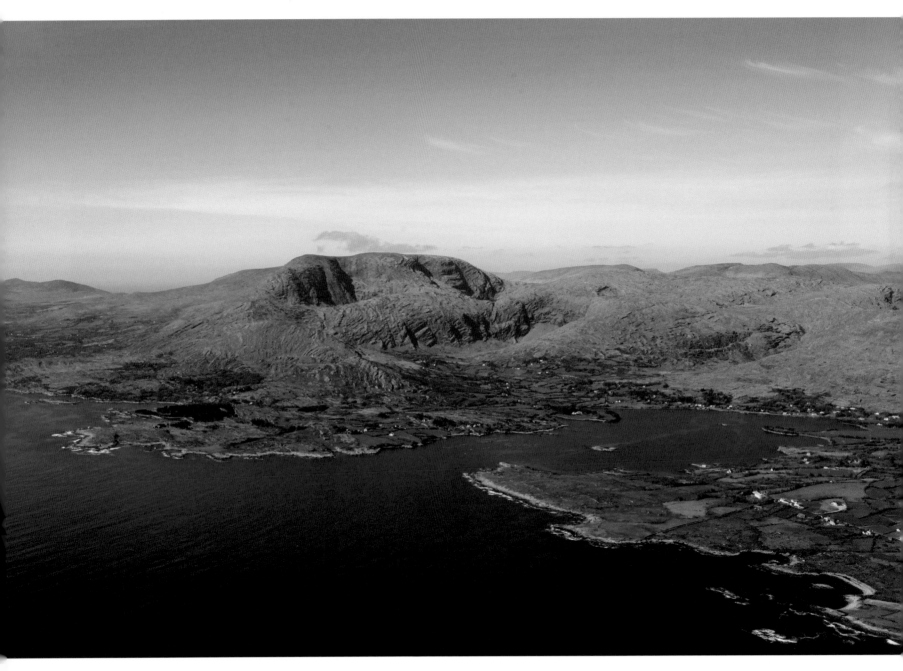

▲ Adrigole is a small village on the Beara Peninsula with Hungry Hill, the highest mountain in the Caha Range, looming in the background.

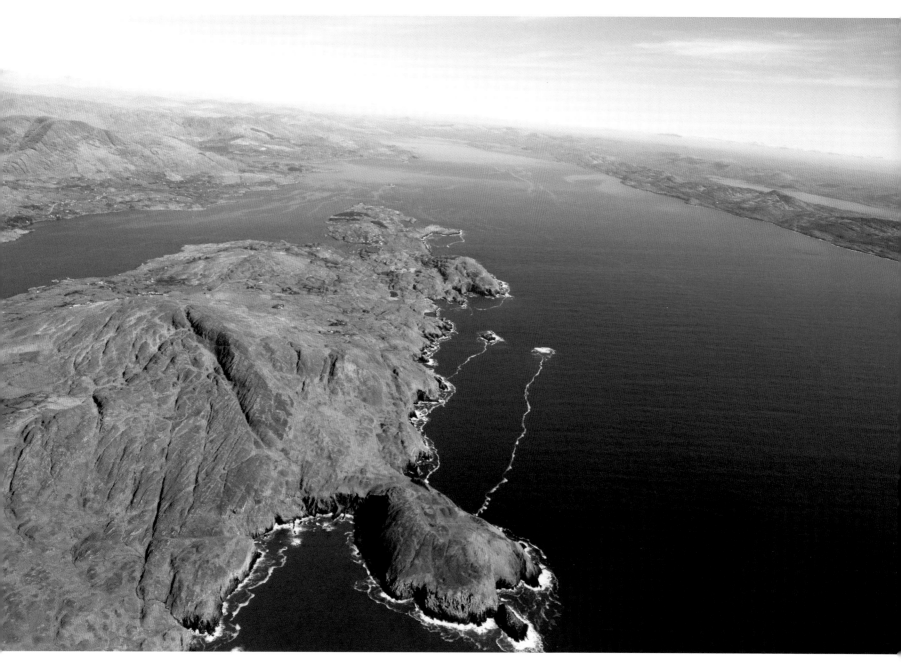

Bere Island has a population of over 200 and was once of strategic importance, militarily. It lies between Berehaven Harbour and Bantry Bay.

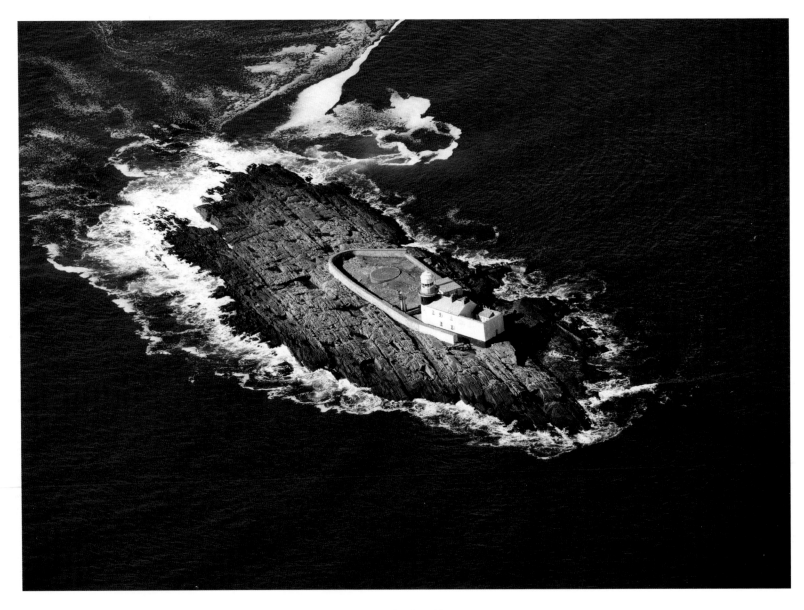

△ Roancarraig Lighthouse is unmanned and located on a small island to the east of Castletownbere. The current solar-powered beacon became operational in 2012, replacing the lighthouse built in 1847.